Printmaking in Britain

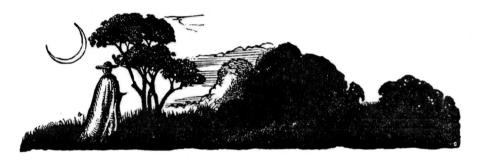

Fig. 1. EDWARD GORDON CRAIG: *Landscape and Moon* [Wood engraving; 1907; 42 × 144 mm]

PRINTMAKING
IN BRITAIN

A GENERAL HISTORY FROM
ITS BEGINNINGS TO THE PRESENT DAY

BY

Richard T. Godfrey

NEW YORK · NEW YORK UNIVERSITY PRESS
1978

DEDICATED
WITH LOVE
TO MY MOTHER AND FATHER

Published in the United States by
New York University Press
Washington Square, New York, NY 10003
© 1978 by Phaidon Press Limited
All rights reserved
Library of Congress Catalog Card Number: 78-53802
ISBN 0-8147-2973-8
Printed in Great Britain

Contents

Preface

The main object of this book is to present a factual history of prints insofar as they have contributed to the main history of British art, either in their reproductive capacity or as images conceived solely in terms of the printmaking medium. Little space has been devoted to the discussion of prints whose interest is mainly decorative or technical, such as Baxter prints or the great bulk of sporting prints, and description of technical processes has been kept to the minimum consistent with clarity. The history of prints and of book illustration frequently mingle, but with the exception of occasional forays into the latter, this is a history of separate prints. The amount of material that remains to jostle and push for attention is formidable, and, in preference to an idle listing of names, some attempt has been made to illustrate and discuss with reasonable fullness the work of at least some of the more important printmakers.

I am acutely conscious that in the brief description of such a large subject and in the selection of illustrations therefrom, the calm tread of the impartial witness must sometimes give way to subjective judgements and even prejudice. The twentieth century alone furnishes material enough for several volumes, and the question of what to exclude has been invidious. In this, as in previous chapters, an attempt has been made to mingle familiar imagery with prints that are less well known.

I hope, however, that the present volume will give some notion of the great variety and wealth of a subject that includes both the violent satires of Gillray and the exquisite wood engravings of Calvert. After a slow start, the British school has produced many talented printmakers, and at least two great ones in Hogarth and Blake, besides playing host to the varied talents of Hollar and Whistler. In such categories as the mezzotint and the satirical print, the native tradition is unrivalled. If it persuades the reader to burrow deeper into the subject this book will have served a useful purpose.

It is a pleasurable duty to acknowledge the encouragement and help that I have received during the preparation of this book. At its outset I was given much sound advice by Edward Hodnett, and in every instance that I neglected it I have regretted so doing. Amongst the friends from whose encouragement and conversation I have gained are David Bindman, Lesley Davies, Morris Eaves, Alan Howlett, William Packer, Ninette Rubinstein, Richard Schneiderman, Gillian Singer and Antonia Williams, and my family and relatives have borne patiently with my preoccupation with the subject. I am deeply grateful to my colleague Bruce Killeen for his stoical forbearance of my absences from teaching duties. Georgina Howell has encouraged me at all times, not least when my spirit flagged, and I owe her my heartfelt thanks.

My greatest debt is to the Staff of the Department of Prints and Drawings in the British Museum, where the great part of my research has been done, and where I have met with nothing but kindness and help. Frances Carey and Antony Griffiths, Assistant Keepers in the Department, have taken a friendly interest in whatever I have been studying, and have read portions of the manuscript and made valuable suggestions. My conversations with them have added immeasurably to the pleasure of my research. Peter Moore, with the charm and helpfulness with which all visitors to the Print Room will be familiar, has helped me in many ways great and small, and I am deeply grateful. Graham Brigg, Andrew Clary, Heulwen Matthews and Martin Tillier have fetched me hundreds of portfolios, and always shown a helpful spirit.

Unless otherwise stated, prints are reproduced from impressions in the British Museum, and I am indebted to the Trustees for permission to reproduce them. I am grateful to the British Library for permission to reproduce plates 1, 16, 17; to the Victoria and Albert Museum for permission to reproduce plates 35, 90, 98, 104, 105, 116, 134 and Figs 1 and 12; and to the Tate Gallery for plates 77, 78, 148 and Fig. 16. Photographs for Fig. 3, and plates 114, 121, 122, 132, 142, 143 and 147 were kindly provided by the William Weston Gallery, and I am indebted to P. D. Colnaghi and Co. for the photographs for plates 73, 70 and 130, to the Leicester Galleries for plates 127 and 128, Marlborough Fine Art for plates 146 and 150, Editions Alecto for plates 144 and 151 and Waddington and Tooth Galleries for plate 145.

Quotations from Farington's Diary are printed by gracious permission of Her Majesty the Queen.

<div align="right">London, 1978</div>

Introduction

The importance of prints in European history can scarcely be over-estimated; ranging in quality and function from the choice impression of a Rembrandt etching to the crude woodcut purchased from a street-hawker's basket, they circulated art or information to a wide audience. Historically a print may be described as an image on paper, taken by pressure from the inked surface of a woodblock or lithographic stone, or from lines engraved or etched in a metal plate, which can print hundreds or thousands of identical copies. The essence of prints is in their multiplicity. Easily transported, 'wafted abroad on a thousand wings', they could not only circulate the images of eminent men and provide copies of Raphael paintings to thousands who would never see the originals, but could equally serve as vehicles for calumnies and misinformation: Henry Stubbe considered in 1673 that Dutch satires of the English, showing them as vipers and mongrels, were sufficient grounds for war.

Prints fall into three basic technical categories: relief, intaglio and planographic. Relief prints, such as woodcuts and wood engravings, are printed from the flat surface of raised lines or areas, those parts of the design to remain white being cut away. The woodcut is the oldest member of the print family, being first extensively used in Germany at the beginning of the fifteenth century, and reaching great heights in the prints of Dürer. Woodblocks may be printed simultaneously with type, and woodcuts and wood engravings are thus closely associated with the history of book illustration.

In the intaglio processes, such as line engraving, etching and mezzotint, the action of a roller press forces the paper into the crevices and lines made in the surface of a flat metal plate, squeezing the ink from them. An intaglio print can be recognized by the characteristic imprint left by the edges of the plate. In line engraving, the first dated example of which was by the Master of 1446, the copper plate is incised by a burin, an instrument with a lozenge-sectioned, pointed end. The burin is pushed forward into the metal, while the leather pad on which the plate rests is turned in harmony with its action. Engraved line, augmented by short flicks and dashes of the burin, can achieve far greater detail and richness of tone than a woodcut. After the great achievements of such painter-engravers as Mantegna, Dürer and Lucas van Leyden, engraving became increasingly a reproductive medium in which professional engravers copied the designs of other artists. This led to elaborate codification of linear systems and marks, such as parallel lines and cross-hatching, in attempts to find a means of translating the tonal range of a painting; the manipulative difficulty of the craft required a long apprenticeship.

In an etching, however, lines can be drawn without restraint, using a steel needle

to cut through a layer of varnish or wax covering a copper, steel or zinc plate. On immersion in a solution of nitric acid, or when acid has been poured over the plate, the lines are attacked and bitten down by corrosive action while the untouched varnished area repels the acid. Etching was used by armourers as early as the fifteenth century to decorate steel surfaces, but the first dated print is *Girl Bathing her Feet* (1513) by Urs Graf. It is pre-eminently a painter's medium, since the hand may draw with perfect freedom, abjuring the systemized lines of the engraver. It was first widely practised in the seventeenth century, the supreme exponent of the art being Rembrandt.

Most print techniques were developed in the attempt to imitate the appearance of paintings or drawings. The mezzotint, invented by Ludwig van Siegen in the seventeenth century, was intended to imitate the chiaroscuro effects of paintings of the time. Unlike other print techniques it is a means of working from dark to light, the copper being worked overall with a multi-toothed instrument known as a rocker, until its surface is pitted with innumerable crevices to hold the ink. If printed in this state it would produce an entirely black print. Tones of white and grey are produced by scraping away areas, flattening them so that they will catch little or no ink.

The eighteenth century was the great age of the reproductive print, and many ingenious methods were invented to simulate the appearance of paintings, drawings or watercolours. The aim of the crayon manner, developed in France in the middle of the century, was to imitate the broken texture of a chalk drawing by puncturing the plate with small dots and flicks, using an instrument with a wheeled head known as a roulette. Stipple engraving followed from this, the whole surface of the plate being worked with etched and engraved dots and marks, a special curved burin being used to engrave short flicks. Bartolozzi and his school were the supreme practitioners of the method, which was quicker and easier than line-engraving.

Aquatint, a means of etching broad areas of tone, was likewise first developed in France in the 1760s, but flourished most vigorously in England where it was pioneered by Paul Sandby. Powdered resin is fused to the plate by heat, and the acid bites the tiny spaces left between its grains, varnish being applied to the plate where white areas are to be preserved. Varying gradations of tone are produced by carefully timing the plate's exposure to the acid. The method can result in very delicate shades of even tone, and was primarily used to imitate watercolours or wash drawings.

Aquatint was eventually superseded by lithography, which was invented by Aloys Senefelder in 1798, although it did not become fully established in England until about 1820. It is a planographic process, since the printing surface is flat. The flat surface of limestone is chemically prepared so that the marks made upon it with a greasy crayon will accept and retain printing ink, while the rest of the surface will repel it. The method allows unhampered freedom of drawing, and the printing of many impressions. Colour lithographs, the first great examples being by Thomas Shotter Boys, are produced by printing individual colours from separate stones. The artist's print represents only a small part of the history of lithography, which has been developed in many ways for commercial printing.

That juggernaut amongst nineteenth-century print processes, the photograph,

eventually usurped the reproductive role of prints, but wood engraving and steel engraving flourished for many years after its invention. The steel plate was first used in the 1820s and its greater hardness allowed the printing of large editions, and the etching or engraving of very delicate and closely laid lines. Partially as a reaction against photography, and the increasing elaboration of finish and mechanical execution in engraving, etching was revived in the middle of the nineteenth century as a medium for the direct execution by the artist of his own designs. From Whistler dates the custom of signing the print in pencil; additional evidence that it is no longer considered a mechanical product, but the original work of an artist's mind and hand.

The death of reproductive engraving by the end of the century freed the artist to explore the full creative potential of the print, creating ever new richness of techniques. The modern print, however, has become a more rarified thing than it was in the past. In the seventeenth century a plate was made to bear as many impressions as it could, and would often be taken over by successive publishers who would reissue it. In our own day, a plate, stone or screen capable of printing innumerable impressions is limited to the printing of small editions of seventy-five or a hundred, each signed by the artist. The plate is then cancelled, scored across with defacing marks. The modern print is thus intended for a small collector's market, where rarity is valued, and the print's capability as an original medium is fully exploited.

The Graven Image

The Origins of Printmaking in Britain

Nothing is less becoming to the history of British printmaking than its belated and uncouth beginnings. The earliest woodcuts, published by William Caxton and his successors Wynkyn de Worde and Richard Pynson, provide a certain dry sustenance for bibliophiles but they have little artistic value. Indeed, the term 'hack-work' has special aptness in the context of the early English woodcut.

Line engraving did not take root in Britain until the middle of the sixteenth century, and received most of its early impetus from Netherlandish engravers working in this country. It was not until the emergence of William Faithorne in the seventeenth century that Britain reared an engraver of European stature. The first etchings of any significance, Francis Barlow's illustrations to *Theophila*, were even later in appearing, being published in 1652. This having been said, there remains much that is of great historical interest, and the rude execution of most early prints does not preclude the charms of simplicity and directness.

There was no tradition of single-sheet woodcuts[1] for Caxton to rely on when he published his first illustrated book, and the woodcuts in the *Mirrour of the World* (*c.* 1481) were cut by a novice, presumably English, without even a rudimentary grasp of technique.[2] Two of these blocks also appear in *Cato parvus et magnus* (*c.* 1481), and it became the custom of Caxton and other printers to build up a stock of blocks, both imported and English, and fit them to different texts. Likewise a block could be used twice or more in a single book. Twenty-four illustrations were obtained from sixteen blocks in Caxton's *Game of Chesse* (*c.* 1483), serving to break up and enliven the text rather than elucidate particular descriptions. Nineteen Caxton books contain woodcuts, amongst them the *Canterbury Tales* (*c.* 1484), the *Golden Legend* (1484/5), and the *Subtyl hystoryes and Fables of Esope* (1484), which contains no less than 185 cuts. However crude they might have been, woodcuts helped to sell a book, and publishers met this demand by getting English craftsmen to copy illustrations in foreign books, and by importing devotional books where the illustrations had been designed and cut for the English market.

On Caxton's death in 1491 his Westminster premises and collection of woodblocks became the property of his foreman, Wynkyn de Worde, who printed new editions of a number of Caxton books. Amongst his more notable illustrated editions are *All the Proprytees of Thynges* (1495) and Malory's *Morte d'Arthur* (1498), but his

activity extends well into the sixteenth century, type from his fount being found on
a large broadside with an impressively realistic woodcut of the *Welspoken Nobody*
(*c.* 1534), known by an impression in the Huntington Library in San Marino, Cali-
fornia. No doubt such sheets were printed in quite large editions, but unlike the
illustration protected between the covers of a book, many separate woodcuts must
have had a short life, expiring fly-blown and exhausted after a few weeks tacked to a
wall.

Richard Pynson became King's Printer in 1508; he was probably a Norman and a
number of his editions are illustrated with French woodcuts. His first illustrated book
was the *Canterbury Tales* (*c.* 1490), with cuts mostly plagiarized from Caxton's edition
but including the crisp little figure of the *Knight* (Plate 1), a design of some character
and charm.

Even the best English woodcuts of the fifteenth and sixteenth centuries are sorry
things when compared with German or Venetian examples. But a solitary link with
the glories of Renaissance printmaking is afforded by the handful of designs made in
England by Hans Holbein the Younger (1497–1543),[3] although most of his work as
an illustrator was done in his early years in Basle. His first visit to England lasted
only a year, from 1527 to 1528, but he came back in 1532 and remained in England
until his death. His work as a portrait painter, and the inconvenience of sending
drawings abroad to be adequately engraved on wood, prevented him from making
many designs, but he found time for the title-border to Coverdale's English Bible
(1535), the playful little printer's mark for Renold Wolfe of *Boys stealing apples from
a Tree* (1543), and the spacious composition of *Henry VIII in Council* (Plate 2),
excellently cut by Jacob Faber and published after Holbein's death in Edward Halle's
Chronicle (1548).

Holbein's influence led to some improvement in the quality of English woodcuts,
notably in such John Day publications as the much reprinted *Actes and Monuments*
(1563) and *Queen Elizabeth's Prayer-Book* (1578). John Derricke's *Image of Ireland*
(John Day, 1581) contains twelve plates illustrating Sidney's campaign in Ireland,
seven of which are signed by an unidentified artist as 'ID' or 'FD', and are of high
quality.[4] Single-sheet woodcuts remained a small class of prints throughout the
sixteenth century, but the British Museum possesses a unique impression of a large
woodcut of the *Ark Royal*, Howard's flagship against the Armada, which must
surely have been printed in its hundreds.

Line engraving had flourished in Europe for a hundred years before its first appear-
ance in Britain in the ill-drawn little plates to Raynald's *The Byrth of Mankynde*
(1540).[5] These are probably the work of Thomas Geminus (active *c.* 1540–*c.* 1563), a
Flemish surgeon. Geminus also engraved the anatomical plates to his *Compendiosa
totius Anatomie delineatio* (1545), which he had pirated from the noble woodcuts made
by Johannes van Calcar for Vesalius's *De Fabrica Humani Corporis Libri Septem* (1541).
The title-plate (Plate 3) to the *Compendiosa* is of rather more interest than the illustra-
tions; engraved with cleanly incised outlines it shows a modest gift for ornamental
engraving which is also apparent in the little plates to his pattern book *Morysse and
Damashin. . . . Very profitable for Goldsmythes and Embroiderars* (1548). The first engrav-
ings actually by an Englishman are probably John Shute's scratchy and amateurish

plates to his *First and Chief Groundes of Architecture* (1563), but more interest attaches to the work of such foreigners in England as the brothers Remigius and Franciscus Hogenberg, Marcus Gheeraerts the Elder, Theodore de Bry and Jodocus Hondius.

Franciscus (*c.* 1540–*c.* 1590) and Remigius Hogenberg (*c.* 1536–*c.* 1588) were probably invited to England by Archbishop Parker to engrave plates for a new edition of the Bible, known as the *Bishop's Bible* (1568–9). Franciscus engraved a frontispiece portrait of Queen Elizabeth for this, and two views of the *Royal Exchange*, which anticipate the architectural views of Hollar and Loggan in the following century, have been attributed to him. Remigius stayed in England longer than his brother, but only a few plates seem to have been engraved by him, including the frontispiece to Saxton's *Atlas of England and Wales* (1579), showing the Queen as Patroness of Geography and Astronomy. Portraits of Queen Elizabeth I are among the most ambitious and interesting prints of the period, but the proliferation of prints and paintings that were offensively incompetent led to the drafting of a proclamation in 1563, urging the destruction of such images.[6] Richard Haydock alludes to such unflattering portraits of eminent people in the 'Address to the Reader' in his translation of Lomazzo's *Trattato della Pittura* (1598), objecting to 'most lame, disproportioned and unseemelie Counterfeites (as they tearme them) of their livelie persons. And if I can deterre these saucie doultes from this their dizardly inhumanitie then I could wish that Alexander's Edict were now in force againe, who forbade, that anie should carve his person, save Lysippus; or paint his Counterfeit besides Appelles.'

Marcus Gheeraerts (born between 1516 and 1521; died before 1604)[7] came to England as a refugee from Bruges in 1568, and his twenty illustrations to Jan van der Noort's *Theatre* (1568) were the first etchings published in England. They are drawn in the same fussy manner as his etchings for *Aesop's Fables* (Bruges, 1567), which Hollar and Barlow studied closely when they illustrated Aesop in their turn. His most important etchings are the nine sheets of the *Procession of the Knights of the Garter* (1576) who parade solemnly before arches in front of a Bruegelesque mountain landscape. Even more extensive is the *Funeral Procession of Sir Philip Sidney* (1587–9), engraved on thirty plates by Theodore de Bry (1527/8–98), who was in England in 1586/7. De Bry has an interesting connection with English and American history, since he engraved John White's watercolour drawings of Red Indians at the settlement in Virginia. These already endow the savages with postures of fetching classical grace, and De Bry's engravings for Thomas Hariot's *America* (Cologne, 1590) further enhance their senatorial dignity of pose.

The spirit of exploration and travel is also reflected in the great maps of the period, executed by English as well as foreign engravers. The requirements of cartography, its unemotional mapping of the minute incidents of contour and surface, were not so different from those needed to depict, unaided by chiaroscuro, the extravagances of Elizabethan costume. This may be seen in the memorable print executed in 1589 of Queen Elizabeth as *Eliza Triumphans* (Plate 4) by William Rogers (active *c.* 1589–1604); this has the distinction of being the first portrait engraving by an Englishman. By any European standards it is a naïve piece of work; the strokes of the burin are short and harsh, and Elizabeth seems to rock precariously on a costume cut out of sheet metal, but the splendour of its theme and the happy placing of the elaborate

components are full of vitality and interest. Rogers is the only engraver to reflect some of the richness of Elizabethan culture. Little is known of his life, although a background as a goldsmith is suggested by his appetite for laboriously rendered ornament. A superabundance of ornament is worn by Queen Elizabeth in the full-length portrait drawing by Isaac Oliver,[8] which Rogers had copied with relish, even adding an intricately furnished interior setting of his own invention. His gift for decoration is further apparent in the delightful floral border to the oval portrait of *Queen Elizabeth as Rosa Electa*, and in the unpublished title-plate to Moffet's *Insectorum Theatrum* (c. 1604), with its details of caterpillars, grasshoppers, spiders and moths, which he proudly signs 'Willms Rogers *Angl. et civis Londinensis*'.

The engravings of Thomas Cockson (active c. 1591–c. 1636) are heavy and dull beside those of Rogers, but his large equestrian portraits are early, though incompetent, examples of a genre that became popular in the early seventeenth century. His small oval portraits are similarly spiritless, but are again precursors of an immense class of seventeenth-century print, where countless grim faces look out from their elaborate barricades of cartouche, heraldry and scrollwork.

The early years of the Stuart period reveal no reducing of the gulf in ability fixed between laborious English hands and sophisticated foreign engravers, typified by the various members of the Van de Passe family. Renold Elstrack (1570–1625) probably studied under Rogers and his style is similarly metallic and inflexible, but his portrait of *Charles I, as Prince, on horseback* (c. 1614–15) shows vitality in the decorative curves and curls of plume, mane and tail (Plate 6). He also engraved the title-page and the majority of the plates for the *Baziliologia* (1618), a series of portraits of English monarchs which can only quicken the pulse of the dedicated Grangerizer. The *Heroologia* (1620), engraved by Willem van de Passe and his sister Magdalena, constitutes a companion set of British worthies and together they form the most extensive set of portraits engraved in the Stuart era.

Francis Delaram (active c. 1615–24), like so many of the best engravers in England, was probably of Netherlandish origin, and his technique was more sophisticated than Elstrack's, with a greater control over long curving strokes of the burin. Two of his best portraits, *Matthias de Lobel* (1615) and *John Williams* (c. 1621), are inscribed 'fecit et sculp' and 'inventor et sculpsit' respectively, showing that he was not merely a copyist. It remains a problem to determine how many portrait engravings of this period were from drawings made by the engraver, and how many were copies from existing paintings; remarkably few correlations of the second sort can be made, and identifying inscriptions do not become standardized until the time of Faithorne.

That busy family of engravers, the Van de Passes, engraved many portraits of English subjects and set a standard of competent if uninspired production that few English engravers could match. The founder member of the family was Crispin van de Passe, who was living in Utrecht between 1612 and 1637, and although he engraved a number of English subjects it is unlikely that he was ever in England. However, his sons Willem (c. 1599–c. 1637) and Simon (c. 1595–c. 1647) both worked extensively in England. The latter's work consists mainly of small waist-length portraits, title-plates and small silver medals, from which paper impressions exist. Willem engraved a number of large and ambitious plates, including the fine

equestrian portrait *George Villiers, Duke of Buckingham* (1625) and the large group portrait of James I and his Family, the *Triumphus Jacobi* (1622/4). The changing states of the latter afford an entertaining example of the seventeenth-century custom of updating an old portrait by introducing new figures, or perhaps burnishing out the existing face and replacing it with that of a different person (Plates 7 and 8). This was obviously a cheaper and more expeditious way for a publisher to meet public interest in the personality of the moment than waiting months for a new plate to be engraved.[9] Publishers sometimes tried their luck and simply changed the inscription underneath the portrait. The successive states of *Triumphus Jacobi* are a family tree come to life, babies and brides crammed into vacant spaces and the recently deceased clutching skulls.

Of the English engravers William Hole (*c.* 1607–24) deserves mention because of the interest of the subjects of his portraits and title-plates. His title-plates include those to Drayton's *Poems* (1619) and *Polyolbion* (1612–22) and *The Workes of Ben Jonson* (1616), and he engraved both title-plate and music for *Parthenia* (1612–13), which includes compositions for the virginals by Bull, Byrd and Gibbons. His portrait of *George Chapman* (1616) peering enthusiastically from the clouds of metaphysics has a vitality quite at odds with the staid and predictable portrait engravings of the time (Plate 5), and it is regrettable that it was Martin Droeshout (1601–*c.* 1652), and not Hole, who engraved the portrait of Shakespeare for the First Folio (1623).

The period leading up to the Civil War was marked by an ever-increasing demand for portrait frontispieces and emblematic title-plates of the most convoluted meaning, and engravers such as John Payne (active *c.* 1600–*c.* 1640), Thomas Cecill (active 1625–40) and William Marshall (active *c.* 1617–*c.* 1650) were seldom without employment, although their assiduity was not accompanied by any great skill. Marshall was the most productive of the three, and although he was an extremely poor draughtsman, his work is not without literary and historical interest. He engraved portraits of Suckling, Herrick and Milton, and Milton's vanity was so outraged by the goggle-eyed little portrait that Marshall engraved for his *Poems* (1645), that he composed a Greek epigram for an engraver of writing to add to the plate, abusing the hapless artist in strong terms.

More able engravers than Marshall would have been daunted by the title-plates required of them by authors whose minds overflowed with symbols and allusions, and the title-plates to Isaacson's *Saturni Ephemerides* (1633) or Wither's *Emblemes* (1635), with their heaped-up imagery of Destiny or Fate, peopled with squirming little figures, show Marshall grappling doggedly with their literary conceits. He eventually became the vehicle for perhaps the most famous English print of the century, the *Eikon Basilike, The Pourtraicture of his Sacred Maiestie in his solitudes and sufferings* (1648), issued by the Royalist press after the execution of Charles I, and so popular that Marshall engraved eight versions of it. More than any image this propagated the legend of a Martyr King, and demonstrates the great power of prints as instruments of polemics (Plate 9).

Marshall's cramped little prints are the antithesis of the paintings of Van Dyck, and, to an artist accustomed to the brilliant engravers of the Rubens school, English

engraving must have seemed like the work of mischievous children; even Hollar was not sanctioned by Van Dyck. However, Van Dyck had access to the skills of Robert van Voerst (1597–1635/6), a pupil of Crispin van de Passe, who came to England in 1628 and held the appointment of engraver to Charles I. His highly finished plate of *Charles I and Henrietta Maria* (1634) shows the skills that Van Dyck demanded and that no English engraver could match.

The work of the remaining English engravers of the period is best passed over in discreet silence; the misshapen little portraits by such men as Thomas Cross (active 1644–82) and Robert Vaughan (*c.* 1600; died before 1664) are merely evidence of the reading public's desire to have a portrait frontispiece, however bad. George Glover (active *c.* 1634–52) may be excepted from these harsh strictures, for although the quality of his work is extremely uneven, such a plate as the little full-length *Sir Thomas Urquhart* (1641), drawn 'ad vivum' and engraved in crisp sloping lines in homely imitation of Claude Mellan (Plate 10), is full of charm; Urquhart is shown stretching out his hand for a wreath for '*Armes and Artes*' with infinite complacency.

Chapter Two

A Native Tradition

The Late Seventeenth Century

The second half of the seventeenth century saw not only a large increase in the number and scope of prints published in Britain but also the beginning of a native tradition in etching, and the introduction of the mezzotint. For the first time English artists began to make prints which could be compared with those published abroad. Nonetheless, the most distinguished printmaker to work in England during these years was the Bohemian etcher Wenceslaus Hollar (1607–77),[1] who was brought to England in 1636 by Thomas Howard, Earl of Arundel and Surrey.[2]

Born in Prague, Hollar had travelled to Frankfurt in 1627 where he worked for the topographical etcher Matthaus Merian the Elder, before going on to work for print publishers in Stuttgart, Strasbourg, and finally Cologne. Here he met Arundel, then on a diplomatic mission, who wrote from Nuremberg that he had 'one Hollarse with me, whoe drawes and eches printes in strong water quickely, and with a pretty spirite'.[3] Hollar was already an artist of considerable experience, and besides his fundamental accomplishment as a topographical artist, in which capacity he had etched numerous views of German cities, he was a sensitive copyist of the work of other artists. Above all he was a man of prodigious and unflagging industry, 'always uneasde if not at work', and no artist could have better served the increasing appetite of the educated Englishman for useful knowledge of every kind. His range of subject matter was of unprecedented variety. Architecture, fashion, portraiture, natural history and landscape, formed only some of his subjects as he patiently recorded anything that his contemporaries were likely to find of interest. To this industry he added a gently variable technique that was adequate to his purpose whether he was etching a panoramic view of London or the fur of a dead mole. His friend John Evelyn wrote: 'tho' Hollar's were but Etched in Aq: Fortis I account the Collection to be the most authentiq, and usefull, extant.'[4]

He was first employed in England in copying works of art from Arundel's great collection, the unsuspected but imminent dissolution of which made the project the more well advised, and certain items, including Dürer and Holbein drawings, survive only in Hollar's etchings. As with all his work, his careful preparatory drawings meant that he could make prints from them years later if necessary, and much of the Arundel work was etched ten years later in Antwerp.

Despite his position as Arundel's draughtsman Hollar was not confined to copying;

he was also working independently, and his large two-plate view of *Greenwich* (1637) is the first dated application of his topographical skills to an English subject. As in his etching of *Richmond Palace* (1638) he peoples the view with small but acutely characterized figures, seldom failing in his landscapes or townscapes to introduce some idly wandering or chattering figures to give a scale and life to the view. Some of his finest London views were etched during his first English period, including *The Piazza in Covent Garden* (c. 1640), *The Royal Exchange* (1644), and a set of four small prints which include the *View of London from Tothill Fields*, and *The Thames from Whitehall*.[5]

Of all the inhabitants of London none were of more interest to Hollar than fashionable and comely women, and as early as 1636 he had etched the first tiny plates of what was to be published in 1643 as the *Theatrum Mulierum*, being women of many nations in their characteristic garb. In 1640 were published the larger etchings of the *Ornatus Muliebris Anglicanus*, in which costumes are worn by girls posing in homely imitation of Van Dyck's portraits. Hollar was no puritan, and delighted in rich textures and elegant feminine accessories which he recorded with lingering delectation. Most particularly he delighted in fur, and his series of *Fur Muffs* (1642–7) are some of the best-loved of all his prints. The figure of *Winter* (Plate 11) from the set of full-length *Four Seasons* (1643), wearing her furs with aplomb and ogling the spectator knowingly from behind her mask, is the most splendid of Hollar's full-length figures. The device of showing her on a foreground platform, making her tower above the background scene of Cornhill and the Royal Exchange, is derived from etchings by Callot, such as his set of *The Three Pantaloons* (1618–20), and Hollar had also looked to Callot and Bosse for the idea of fashion as a subject for prints. Both Callot and Bosse, however, were etchers using a vocabulary of lines and marks that pertained to engraving, whereas Hollar used the freedom of the etching needle, and great control over the process of biting the plate, to obtain effects of texture that were beyond the more regular syntax of the burin. Hollar was not an etcher like Rembrandt, who delighted in experiment, but a careful and methodical worker, albeit rapid, with a precise sense of what he could achieve with the medium. Richard Symonds recorded in 1659 that: 'I saw Mr Hollar etching. & he laid on the water wich cost him 4s pound. & was not half a quarter of an hour eating. it bubled presently. he stirred it with a feather. he lays on the wax with a clout & smooths it with a feather. he makes a Verge to keep in the water after it is cutt wth yellow wax & Tallow mellted together. & layd it on wth a pencil he always Stirrs the Aqua with a feather.'[6]

Hollar's first English period produced some of his finest prints. He enjoyed not merely a virtual monopoly as an etcher and topographer, but the patronage of Arundel and the felicity of congenial work. In 1641 he married a waiting woman of the Countess of Arundel's entourage called Miss Tracy, and it is possible that the pair of small etchings of 1645 showing a girl's head and shoulders from the side and from behind, are portraits of her (Plates 12 and 13). They show Hollar at his most intimate as he maps the straying curls of hair with a delicacy that is redolent of some poetic inventory of female beauty by Marvell, Cowley, or Herrick.

His work also reflects the sterner realities of the Civil War and the preceding

period. He etched plates of the *Trial, and Execution of the Earl of Strafford*, and portraits of military commanders from both camps, and continued a high level of production up to his departure for Antwerp in 1644. Arundel had moved there in 1642, but had later travelled to Padua and died there in 1646, and Hollar was thenceforwards deprived of a protector and became dependent on printsellers for his living. He had taken with him to Antwerp many drawings done in England, including views of London and landscapes, and by making etchings from these as well as by undertaking work for Antwerp publishers he ensured that the years he spent in Antwerp were fertile. Some of his most famous prints date from this period, including the set of *Shells* (*c*. 1646), and the set of *Views of Albury* (1645). These six small etchings of the land around Arundel's country seat show the gently curving contours of a landscape moulded for leisurely human perambulation; even the lettering is fitted to the sky with that delicate and unforced precision which is Hollar's particular charm (Plate 14).

Hollar returned to London in 1652. He told John Aubrey that 'when he first came into England (which was a serene time of Peace) that the people, both poore and rich did look cheerfully, but at his returne, he found the Countenances of the people all changed, melancholy, spightfull, as if bewitched'.[7] He now worked increasingly for book publishers, and contributed hundreds of etchings to the finest illustrated editions, varying from his rather stiff illustrations to Ogilby's *Aesop* (1665, 1668) to the solemn views in William Dugdale's *History of St. Paul's* (1658). An ever increasing interest in antiquarian matters made Hollar's skill indispensable to men like Dugdale and Ogilby, and he remains a precious source for any student of London's history, while the depredations of the Great Fire gave his work an additional value. In his *Parallel Views of London Before and After the Fire* (1666) he calmly surveyed the extent of the damage, signing his plate 'W. Hollar of Prage, Boh:'. Hollar was one of London's greatest chroniclers, but he was not a native Londoner and could view the city with a foreigner's mingled curiosity and detachment.

Despite Hollar's considerable reputation in his own day he was 'Shiftlesse to the World', and the indigence of his last days is legendary. He is the very embodiment of the guileless and industrious artist girt around by rapacious print-dealers and pursued by duns. In 1667 he was under the necessity of soliciting support from Charles II, who gave him fifty pounds to add to the title of 'Scenographus regius' he had been given the year before. This title he inscribed on the twelve etchings of *Tangier* (1673), which were based on drawings he had made when he accompanied Lord Henry Howard there on an expedition in 1668. The years after the Great Plague in 1665 were evidently difficult for Hollar, whose placid nature was fated to disturbance. Francis Place, who knew Hollar well, wrote an invaluable memoir of him for George Vertue in 1716. Hollar 'lived in Bloomsbury all the time of the Plague but suffer'd extreamly for want of Business, which old Peter Stent made an advantage of, purchasing several of his plates for a trifle. he told me he gave him but 30 shils for the Long View of Greenwich which very well deserved 10 or fifteen pounds. he was always indigent and had a method of working not common. he did all by the hour in which he was very exact for if any body came in that kep him from

his business he always laid ye hour glass on one side, till they were gone. he always recev'd 12d an hour.'[8]

It was not in Hollar's nature to assemble a school of pupils and assistants, and although a few minor etchers such as Thomas Neale, Thomas Dudley, John Dunstall, and Robert Pryke, have been loosely and probably inaccurately described as his pupils, only Richard Gaywood and Francis Place were influenced by him to a significant degree. Richard Gaywood (active 1653–c. 1670) etched a number of plates, including small Hollaresque portraits, and title-pages which are sometimes after Francis Barlow's designs. He was essentially a reproductive etcher, but did not always scruple to acknowledge his sources, and what small reputation he has is based on the inventions of other artists. He etched some wretched copies from Hollar's full-length *Four Seasons*, and likewise pirated Edmond Marmion's delicate plates of the *Five Senses*.[9] One of his most interesting plates is the large undated *Democritus and Heraclitus*, where the title and appropriate inscription have been grafted onto figures copied from Rembrandt's paintings of *Judas Returning the Thirty Pieces of Silver* and *A Man Laughing*.[10] This is probably the first English print after Rembrandt.

Hollar's main influence was in the establishment of a tradition of topographical and architectural drawing, and in showing the advantages of etching to those artists who wished both to multiply their designs and preserve the freedom of their original drawings. In 1652 were published the first etchings of any significance by an English artist.[11] These were twelve illustrations by Francis Barlow (c. 1626–1704) to a mystical poem by Edward Benlowes[12] entitled 'Theophila: or Love's Sacrifice'. Although a number of etchings and engravings by other artists, including Hollar, were used as illustrations, only those by Barlow, and an engraving by Pierre Lombart, were specially designed for the book. None of his etchings is signed, but their attribution goes back to George Vertue, and comparison of the numerous animals with those in his later prints puts the matter beyond reasonable doubt.[13] One of the most vigorous etchings is that for Canto II, *The Humiliation* (Plate 16), showing Theophila (a personification of the Soul) kneeling before the sacred fountain and surrounded by snapping and hostile beasts which represent the Seven Deadly Sins. A cheerful confidence in his own draughtsmanship is one of Barlow's most engaging traits, and although he worked, as did Hollar, from preliminary drawings he was more willing to exploit the directness and playfulness of line possible in etching.

Barlow is an attractive and important figure in the history of English art, and besides being the first Englishman to produce a substantial body of etched work he was the first native born painter of sporting subjects, and provided many drawings for other etchers and engravers to copy. Few prints of animals appeared in the second half of the seventeenth century in England that were not etched by him or after his designs. Gaywood, Jan Griffier, Hollar, Thomas Neale and Francis Place all etched after his sprightly drawings of birds and animals, and a confusing variety of sets of these were issued both during and after his lifetime. Hollar's etchings of the *Variae Quadrupedum Species* (1659–63) are noteworthy, as are the twelve large plates by Jan Griffier and Francis Place published by Pierce Tempest in 1687. Barlow himself etched some small and lively plates for the *Multae et Diversae Avium Species*, first published by William Faithorne in 1658. His most sustained work in etching was the illustration

of *Aesop's Fables*, an edition of which he produced in 1666. This contains 110 illustrations, as well as a frontispiece and title-page, all of which he designed and etched himself.[14] His 'Apologia' explains that he had been 'pressed on to this great Worke, some years since, by the perswasion of a much honoured Friend of mine . . . who conceiving it to sute much with my fancy, as consisting so much of Fowl and Beasts, wherein my Friends are pleas'd to count me most eminent in what I doe . . .' In a further circumlocutory preamble Barlow craves the forgiveness of the critical for having etched and not engraved his designs, begging them to consider that he was no 'professed Graver or Eacher, but a Well-Wisher to the Art of Painting; and therefore Designe is all we aim at, and cannot perform Curious Neatness without losing the Spirit, which is the main.' His etchings are distinguished by a breezy gusto, and a volume of his preparatory drawings in the British Museum[15] shows that when he began to work on the plate he could seldom resist the urge to add yet another partridge or barnyard fowl to his design. The contents of the fables required Barlow to draw a great variety of exotic beasts, but he was more at home with humbler species such as pigs, chickens, and the river birds of which he had particular knowledge. Some of his liveliest designs show tumbledown farms with broken palings, clucking fowl, and heavy-limbed clodhoppers and farmers' wives, viewed with an unsentimental eye and Waltonian relish (Plate 17).

Barlow etched intermittently for the rest of his career, but seldom signed his plates, seeming to care little if his work was recognized as being from his own hand or not. This cavalier attitude has led to some of his etchings being attributed to others, and the high standard of copyists like Hollar and Place has further confused the issue. Clearly by Barlow, however, even though it is sometimes attributed to Gaywood, is a large satire, *The Cheese of Dutch Rebellion* (1672–3),[16] etched at the time of the Anglo-Dutch Wars (Plate 18). One of the very few English satires of the century to possess artistic merit as well as historical interest, it is etched in the broad style which is also characteristic of the *St. George* (1672). It owes more to Dutch satires than to any English tradition, and the imagery looks back, probably via the medium of Netherlandish prints, to the paintings of Jerome Bosch. One of his last and largest etchings, *The Last Horse Race Run before Charles II* (1687), is the first English print to represent such a subject, and thus stands at the head of a most fruitful tradition.

Francis Place (1647–1728) was associated with both Barlow and Hollar and was a varied and accomplished etcher and mezzotinter.[17] Born of an old Yorkshire family and originally intended for the Bar, Place was more inclined to a career as an artist, and was confirmed in this by an early meeting with Hollar. He told George Vertue that Hollar 'was a person I was intimately acquainted withal. but never his disciple nor anybodys else. which was my misfortune.'[18] Nonetheless it must have been Hollar who first encouraged Place to try his hand with an etching needle, and he combined with Hollar in illustrating John Ogilby's translation of Jan Nieuhof's *An Embassy . . . to . . . the Emperor of China* (1669). Hollar contributed most of the plates, but seventeen are signed by Place and a number of the others can be attributed to him. In 1665 and 1666 Hollar had etched fourteen small plates of grotesque heads from Place's drawings, and in 1667 Place himself etched a number of similar heads

in imitation of Leonardo drawings. He was thus involved in the world of print-makers and publishers from the age of eighteen, and although it is usual to call Place an amateur, he was busily employed as a professional printmaker over the next two decades, his prints being issued by a wide range of printsellers who included Arthur Tooker, John Overton, and even Dutch publishers such as Visscher and Allardt.

The majority of Place's prints were made in the early part of his career, including six sets of small Italian views, some of these being circular views of seaports in the manner of Silvestre, and etched without much imagination or verve. More interesting is a set including the *Valley with Two Columns* (c. 1670), which is the earliest English attempt at Poussinesque landscape.[19] Place's work is full of such anticipations, and his small etching of *Water Meadows with a Distant Windmill* (c. 1680) has a *plein-air* quality rare in English etching before the Norwich school (Plate 15). Etched with small strokes and dashes of the needle it is quite at variance with Hollar's more linear method, and eschews the formula of the ruled sky. From about 1675 Place became increasingly involved with the York Virtuosi, an attractive group active in Leeds and York and centred around Martin Lister.[20] Place was nothing if not a virtuoso; a man with a consuming interest in a wide variety of subjects, with the urge to accomplishment in at least some of them, and an intellectual avidity that could range from science to art and comprehend the most important advances in each. The variety of Place's work is a reflection of the intellectual circles in which he moved. Although he is mainly remembered for his landscapes, particularly his many fine drawings, he also etched a number of fine plates after Barlow, eleven plates after drawings by Robert Thacker of the *Royal Observatory at Greenwich* (c. 1675), and fourteen plates showing 144 insects for Lister's translation of *Johannes Godartius of insects* (1682). He also etched in 1682, for the edification of the Royal Society, a small but revolting monster vomited by one Lund, a York baker. It is in this awareness of etching as an aid to knowledge that Place is a true disciple of Hollar.

Of the remaining etchers of the period few are of any importance. Josias English (active 1654–1718) contributed some plates to Nieuhof's *Embassy*, and etched a few designs from his friend Francis Clein, including a set called *Variae Deorum Ethnicorum Effigies or Divers Portraitures of Heathen Gods* (1654). Of the better known painters few deigned to etch. Isaac Fuller (1606–72) etched fifteen scratchy but vigorous plates for *Un Libro di Designare* (1654), and there is a single brilliant portrait by John Greenhill of his brother *Henry Greenhill* (1667), the solitary English homage to Van Dyck's *Iconographia*.

The middle decades of the century saw not only the beginning of etching in England, but also an increase in the number of engraved portraits sold separately by printsellers or prefixed to the books whose authors they represented. Large and prestigious engravings of Royalty or the aristocracy were thus complemented by countless portraits of divines and savants who had written books of moral or scientific edification. Engraving reflected the essential seriousness of the times, and for every engraving of a fashionable woman there exist four or five of grizzled and reproving clergymen. Female sitters awaited the blandishments of the mezzotint to redress the balance.

The finest portrait engraver of this period, and the first English engraver of more than provincial interest was William Faithorne (c. 1616–91).[21] Faithorne appears to have studied under John Payne between about 1636 and 1639, but there is small trace of this in his early engravings which are closer to George Glover in manner. The publisher of Faithorne's early prints was Robert Peake the Younger, an ardent Royalist whose sympathies are reflected by numerous portraits of the Royal Family and their followers. At the beginning of the War, Faithorne followed Peake to Oxford where the King had established his court, and from this period date a number of engravings after William Dobson which show Faithorne's early style at its most vigorous. They include portraits of *Prince Rupert, Endymion Porter,* and *Charles II as Prince of Wales* (Plate 19), and all show the influence of the French engraver Claude Mellan in their strong linear character, long curving strokes of the burin running parallel to one another in dazzling displays of virtuosity. Faithorne never quite gave way to the technical mannerisms of Mellan and his engraving of *Charles II as Prince of Wales* is worked with muscularity and tension of effect. He reduces Dobson's three-quarter-length portrait of Charles to an oval, and concentration is focused on the face, which is modelled with a whirlpool of curved lines that give the impression they have but temporarily settled on that particular definition of the face, and will shortly define it anew.

Faithorne formed part of the Royal garrison at the siege of Basing House from 1643 until its surrender late in 1645, and was then taken as a prisoner to London. He engraved a number of plates at this time including a portrait of Sir Thomas Fairfax after Robert Walker, before obtaining permission at the end of the 1640s to go to Paris where he obtained the patronage of the Abbé de Marolles. He may have met some of the leading French engravers, and although it has been suggested that he studied under Robert Nanteuil, there is no evidence for this. Nanteuil's work represents the summit of the great French school of portrait engraving. At the time, he was still a young man, and like Faithorne was strongly influenced by Mellan, whose open linear style he had not yet supplanted by his mature style based on modelling the face tonally through a subtle distribution of flicks of the burin. Faithorne did not follow Nanteuil by completely replacing line by tone, but chose to refine his earlier method by retaining a linear foundation and relieving it by tonal modelling.

In 1650 Faithorne returned to England, where he combined engraving with a printselling business, dealing in foreign prints as well as those of his own engraving. From then until 1680 when he seems to have retired, he carried on a busy and successful career. The majority of his prints continued to be reproductive, and besides his early interpretations of Dobson and Van Dyck, he worked after Lely, Greenhill, Soest and Barlow. He also worked *ad vivum* from his own drawings, and although these prints account for a relatively small proportion of his output they include some of his most interesting portraits, such as those of *Sir Robert Boyle* and *John Milton* (1670). Some of his finest plates were engraved during the 1650s and the beginning of the next decade, including the silvery-toned prints of *Sir William Paston,* and *Lady Paston* (1659), and *Sir Francis Englefield* (1661) where the delicate tracery of the face shows how he had refined his earlier manner (Plate 21). The

catalogue of his prints is an index to the intellectual life of the period, including engravings of *Elias Ashmole* (1652), *William Harvey* (1653) and *John Ogilby* (1654). Unlike Nanteuil, whose professional circumstances were more elevated, Faithorne executed very small portraits for books, and some of these such as the portraits of *Noah Bridges* (1653) or *John Bulwer* (1653) are particularly sensitive, reminding us that he was the contemporary of Samuel Cooper as well as of Lely. It is a matter for regret that Faithorne never engraved a portrait of Samuel Pepys who was amongst his regular customers. Pepys was an indefatigable print-collector, and his collection in the Pepysian Library at Magdalene College, Cambridge, gives a vivid idea of what could be purchased at the London printshops. Although it includes fine examples of Rembrandt, Van Ostade, Dürer, and Hollar, there is a huge preponderance of portraits, including more than eighty by Faithorne.[22]

Besides portraits Faithorne contributed illustrations to a number of books, engraving Francis Clein's designs for Ogilby's 1654 edition of Virgil, and etching a frontispiece to James Howell's *Lexicon Tetraglotton* (1660). Etched work is also apparent in his illustrations to Jeremy Taylor's *The Great Exemplar of Sanctity and Holy Life* (1653), and in the background of his signed but uncharacteristic portrait of Henry More, the Cambridge Platonist (1675). Faithorne also illustrated his own book, *The Art of Graveing and Etching* (1662), which is based on Abraham Bosse's *Traicte des manières de graver* (1645).

Faithorne retired from business in about 1680, but he is recorded as making crayon drawings from the life in these last years, and as late as 1684 he engraved a fine portrait of Samuel Collins. He left no school of engravers, although John Fillian had been a pupil and had engraved Faithorne's self-portrait. His son William became a mezzotinter, and the future for reproductive work from portraits lay with that seductive but less exacting medium.

The only serious rival to Faithorne was David Loggan (1633/4–92) who was born in Danzig of a Scottish father. He came to London in about 1655, having previously studied under Willem Hondius and Crispin van de Passe the Younger. He became particularly associated with Oxford University, and by 1669 had settled there and received the title of 'Public Sculptor' to the University. In this year he completed his first known commissions, being front and rear views of the *Sheldonian Theatre*, for which he was paid fifteen pounds. His main task was to engrave views of all the Oxford colleges, and these were published in 1675 as *Oxonia Illustrata*. Hollar's architectural prints had inspired a vogue for such work, and, although Loggan was an accurate draughtsman, he did not possess the delicate feeling for atmosphere that separates the topographer from the artist. Once established, Loggan employed assistants who included Michael Burghers (active 1670–1720) and Robert White (1645–1704), and they participated in the engraving of *Cantabrigia Illustrata* (1690), the sequel to the Oxford set. Burghers is also notable for the excellent plates that he drew and engraved for Robert Plot's *Natural History of Staffordshire* (1686), and for his engravings after John Baptist Medina's designs for *Paradise Lost* (1688).

By 1676 Loggan was resident in London and much of his time was spent in drawing and engraving portraits. Most accomplished of all his works are the small portrait drawings he executed in plumbago, the delicacy of which he never quite succeeded

in transferring to copper. Most of his portrait engravings are small, but he was at his best on the larger scale of the portrait done in 1675 of *Sir Thomas Isham* (Plate 23), or that of *Robert Stafford*. These show his characteristic manner of modelling the face by cross-hatching the shadows and 'pecking' the lighter parts by a flickwork which is closer to Nanteuil's method than to Faithorne's.

Loggan's death left his pupil Robert White to carry on a lonely struggle against the increasing dominance of the mezzotint. White was a busy but pedestrian engraver, mainly of portraits. These were sometimes preceded by drawings from life in Loggan's style which were reputed to be good likenesses. Best known of his portraits is that of John Bunyan prefixed to his *Holy War* (1682), and he engraved Kneller's portrait of Pepys for a frontispiece to the latter's *Memoires Relating to the State of the Royal Navy* (1690). His architectural plates include a large view of *Bedlam* (1675) and a bird's-eye view of the *Royal Exchange* (1671). His principal distinction is that he engraved the first *Oxford Almanack* in 1674, probably from a design by Robert Streeter, and this large four-plate print is a noble beginning to the series.[23]

Vertue recorded that 'in London about 1700. the state of Print Engraveing on Copper was at a low ebb. indeed Mr. R. White was still living. & did live about three years after but was declining much. & I think besides him coud not be found any Master, as one may call so in London. because none of the others had any talent in drawing.'[24] The reason for this eclipse of the line-engraver stemmed from the publication in 1662 of John Evelyn's *Sculptura: or Historie of Calcographie*, which was the first and incomparably the most tedious history of prints to be written in English, but is mainly remembered for Evelyn's obscure description of the new technique of mezzotint engraving. This had been demonstrated to him in 1661 when he wrote in his diary entry for 13 March that 'Prince Rupert shewed me with his owne hands the new way of Graving call'd Mezzo Tinto, which afterwards I by his permission publish'd in my Historie of Calcographie, which set so many artists on Worke, that they soone arrived to that perfection it is since come, emulating the tenderest miniature.'[25]

The foundation stone of the technique is Ludwig von Siegen's portrait of the *Landgravine of Hesse Cassel* (1642) where the tone is created by means of a roulette, in the use of which he was a pioneer. With this tool he could puncture the copper with innumerable small pits which could catch masses of ink to print as a dense tone of black. What Von Siegen had invented was a species of stipple engraving, and in thus grounding the plate by semi-mechanical means he had established the first principle of mezzotint without fully developing the second, which is to scrape away parts of the grounded area, removing the burr so that the burnished part will print as white. The fundamental basis of the mezzotint is to reverse the normal laws of engraving and work from dark to light, removing rather than adding tone. It was in the development of Von Siegen's first idea that Prince Rupert made his contribution to the art, and in 1657 he wrote to his cousin William VI (son of the Landgravine) that he had 'contrived an instrument which works over the whole plate with very little time and trouble'.[26] This instrument was probably some kind of 'rocker', a multi-toothed device for grounding the plate, and its use is evident in the huge plate of *The Great Executioner* (1658). Most of Prince Rupert's mezzotints,

which are mainly rather sensitive copies of tenebrist or Giorgionesque paintings, were executed in Germany, but on his return to England he provided a reduced copy of the head of the executioner from his larger plate (Plate 22) as an illustration to Evelyn's *Sculptura*. It was this print that launched the technique in England where it was to flourish as nowhere else.

It was to be a few years before mezzotints were produced in any quantity by English artists, the first dated print being William Sherwin's large portrait of *Charles I* (1669). The most accomplished of the early mezzotinters were Dutch, many of whom came to England.[27] They included Paul van Somer, Gerald Valck, and most importantly, Abraham Blooteling (1640–90), who was in England from 1672 until 1678. He worked principally after Lely, and his sophisticated technique in laying smooth grounds was important in setting a standard for English artists to follow. Once a reliable mechanical means of rocking the ground had been perfected, the artist could delegate this laborious task to assistants. With this aid many mezzo-tinters were very productive, and were given a considerable advantage in speed of execution over the line engravers.

From its earliest history in England the mezzotint has been associated with the accurate imitation of portrait paintings,[28] since its rich and lustrous blacks could imitate to perfection their chiaroscuro effects. In one respect, however, it could never supplant the line engraving: this was in the provision of portraits for books and was because the burr of a mezzotint wears out too quickly to make the printing of a large edition possible. In no other technique except dry-point does such value attach to early proof impressions, where the quality and density of black is often of in-comparable beauty. For the portrait painters it soon became a necessary professional requirement to strike up a partnership with a good mezzotinter. The advantages for the former were that the greater tonal range of the mezzotint allowed the painting to be reproduced on a larger scale than the habitual bust in an oval of the line-engraving, and that the mezzotinter did not—by the nature of the technique—have the line-engraver's opportunity of asserting autographic mannerisms.

One of the earliest and best of English mezzotinters was the ubiquitous Francis Place, of whose work in this medium Hake catalogued twenty-three plates. None are dated, but a *Tavern Scene* after Brouwer could be as early as 1667, and another early work is a *Monk Reading* after Van Dyck. Most of his plates are portraits how-ever, and two of the earliest, characterized by their small size and rather rough execution, are appropriately of his fellow virtuosi *Henry Gyles* and *William Lodge*. These were presumably of his own designing, but he worked after portraits by Lely, Soest and Greenhill, and his plate after the latter's portrait of *Philip Woolrich* (Plate 20) illustrates the especially smooth tone that Place could effect.

A more roughly grounded plate, giving the effect of a coarsely 'toothed' canvas, is more typical of many early plates including those published by Alexander Browne (active 1667–90),[29] whose *Ars Pictoria* (1675) contains the first detailed description of mezzotint technique. This is also true of certain plates by Edward Luttrell (1650–c. 1710) and Isaac Beckett (1653–88) who sometimes collaborated, George Vertue noting that Luttrell did 'many heads for him being very quick and drew better so that Beckett us'd after to finish and polish them up'.[30] Luttrell worked after Lely,

but also drew from the life as in *The Bantamese Ambassadors* (1682). Beckett scraped a large number of plates from Lely, Wissing and Kneller, one of the finest being from Lely's *Self-Portrait*, but his work is often rather flat and milky in tone.

Although portraits predominate, subject-pieces in mezzotint were by no means uncommon in the seventeenth century, and this adds a particular interest to the early years in the history of the technique. Robert Williams (active 1680–1704) made some effective copies from the Dutch pictures which had become popular during the Restoration, and his *Ideal Shepherdess* after Terborch, and *Man Embracing a Woman* after Moreelse are fine examples. Bawdy or lewd subjects, appealing to the 'lower sort of Virtuosi' were the province of the mezzotint, and in this connection a number of interesting plates were designed and sometimes scraped by Marcellus Lauron (1653–1702), who is better known for the engravings after his drawings for *The Cryes of London* (1687/8).[31] The publisher Pierce Tempest, writing to Francis Place on 9 January 1686, mentions one of Lauron's unseemly portrayals of ladies at confession: '. . . though the ladys have solely left painting Mezzotintos yet they doe sell a little especially fancy's Heads and bawdy soe I am providing 3 or four new ones Against the Terme 2 Queens a new Confession 2 Fancys after Laroone.'[32] Lauron also scraped a rather Goyaesque plate of *An Old Man being Fed with Gruel by an Old Woman*.

Bernard Lens (1659–1725) may be mentioned for a number of small subject-pieces, often from mythological pictures of a mildly erotic character, but the most interesting mezzotinter of this class is the engaging figure of Robert Robinson (active 1674–1706). Robinson was a decorative painter and a member of the Painter-Stainer's Company.[33] Although he had no great powers as a draughtsman the variety of subjects that he depicted is remarkable. Besides portraiture and still-life in a Dutch manner,[34] he set his hand to an ambitious plate of *Venus at the Mirror*, a *Classical Landscape with a Goatherd*, a very large plate of *The Bombardment of Dieppe* (1694), and two plates showing classical ruins and melancholy figures. The larger of these, *The ruin'd Temple of Diana* (Plate 24), although clumsily drawn, has an evocative and romantic quality quite foreign to English art at this period.

Lely died in 1680, a little too soon to take full advantage of the mezzotint, but Sir Godfrey Kneller became the most frequently copied painter before Reynolds. Kneller was well aware of the advantage that would accrue to his reputation by the wide-spread circulation of mezzotints after his portraits, and he was at pains to secure the services of the best practitioners. He was mainly connected with John Smith (*c.* 1652–1742), the pupil of Beckett, but was also copied by George White (*c.* 1671–1732) and the Frenchman John Simon (1675–1751), of whom Vertue wrote that '. . . for some Time when Smith differd with Sr. G. Kneller the other was carressd by him and did many good works.'[35] Smith worked from the dull portraits of Wissing and Dahl as well as from Kneller, and was an astute man of business. Besides publishing his own prints he bought up the stock of Beckett and other artists which he reissued with his own name in place of the first publisher. He had a vigorous technique well-exemplified in the rather rough texture of *Isaac Newton* (1712) and *Edward Southwell* (1708), both after Kneller, and he was adept at imitating a painterly effect. Smith carefully stored fine early proofs of his work, and the unfinished state of *Mrs. Sherard* (*c.* 1699) shows not merely a female subject representative of an enormous

class of prints, but also the importance of seeing early impressions of mezzotints and not later reprints (Plate 25).

Even more than Smith, George White, the son of Robert White, excelled at imitating the broad and facile brushwork of Kneller. A peculiarity of some of White's prints, such as *Sir Charles Wager* (1725), is his use of etched line to serve as a foundation or to pick out details. He is at his best, however, when interpreting the bravura execution of such pictures as Frans Hals's *Boy With a Fiddle* (1732), or Kneller's *Alexander Pope* of 1723 (Plate 32).

Two epochs of English painting are linked by John Faber the Younger (*c.* 1695–1756) who copied almost every portrait painter from Kneller to the young Reynolds. He scraped forty-seven plates from Kneller's *Kit-Cat Club* (1735), and his subjects included Vanderbank, Highmore, Pond, Hudson, Ramsay and Hogarth, from whose *Frances, Lady Byron* (1736) he made one of his best prints (Plate 26). He also copied Mercier's 'fancy' pictures, and the *Youth with a Port-Crayon* after Chardin shows how well that artist's pictures were adapted to translation into mezzotint. Faber was an artist of modest but consistent standards, but he kept the pulse of mezzotint engraving alive before its flowering in the hands of MacArdell and his followers later in the century.

The Age of Hogarth

The Early Eighteenth Century

The notebooks of the engraver and antiquary George Vertue (1684–1756)[1] formed the basis of Walpole's *Anecdotes of Painting in England* (1765–71) and are the main source of all studies of early eighteenth-century British art. For the history of its engraving they are indispensable, since Vertue was at his liveliest when gossiping about his own profession, his constant refrain being the hard lot of the line engraver, toiling his way to a pauper's grave. Vertue was no great ornament to his profession and admitted that his early reputation, gained by his large portrait of *Archbishop Tillotson*, owed much to lack of competition. He was the first engraver employed by the Society of Antiquaries, engraved the *Oxford Almanacks* from 1723 until his death, and produced hundreds of portrait frontispieces. His engravings are as mediocre as those of his teacher, Michael van der Gucht (1660–1725). Like Vertue, Van der Gucht had ploughed his burin over acres of copper in the interests of booksellers, into whose hands the mezzotinters had forced the oppressed tribe of line engravers. Their plates are mean in touch, without any of the amplitude and variety of stroke of French engravers like Drevet, to whom Vertue and his colleagues looked in awe. Vertue's list of engravers active in London in 1713 makes poor reading. John Sturt (1658–1730) was a busy jobbing engraver, whose *Common Prayer Book* (1717), with both text and illustrations engraved on silver plates, was an ingenious performance. Johannes Kip (1653–1722) continued the tradition of Loggan and Burghers with his dry engravings from Leonard Knyff's bird's-eye views of buildings and gardens for his *Britannia Illustrata* (1707–26).

More consequential are the neat engravings of Simon Gribelin (1661–1733) who made a reputation as an engraver of silver watch-cases before turning to copper-plate engraving in the early years of the nineteenth century. His only inventive faculty was for ornamental engraving, which he exercised effectively in the borders to the illustrations of the Earl of Shaftesbury's *Characteristics* (1712);[2] in the illustrations themselves he was working to Shaftesbury's designs. His greatest success was a set of small engravings from the *Raphael Cartoons* (1707) which had a very wide sale and stimulated the appetite of connoisseurs for larger plates, so that in 1711 Nicholas Dorigny (1657–1746) was invited from Rome to perform this task. Dorigny was knighted on the completion of the plates in 1720, and although they are undistinguished they did much to arouse a taste for the elevated art that they represented.

The project had a significant side-effect, for Dorigny imported French assistants including Charles Dupuis, Louis du Guernier and Claude Du Bosc. These three engraved a set of reductions from Dorigny's plates and undertook other prestigious tasks, such as the engraving of Thornhill's paintings in St. Paul's, and, in his turn, Du Bosc imported French engravers including Bernard Baron, and most importantly, Gravelot.

It was against this unpromising background of foreign dominance that William Hogarth (1697–1764)[3] made his debut in 1720 with a little engraver's tradecard. His apprenticeship had been served under the silver-plate engraver, Elias Gamble, and according to Hogarth had been largely wasted in the 'Narrowness' of the work involved. This meant that he had lost the chance of 'attaining that beautiful stroke on copper', which, like Vertue, he regarded as the unattainable prerogative of the French. Hogarth's assertion that '. . . fine engraving which requires chiefly vast patience care and great practice is scarcely ever attain but by men of a quiet turn of mind',[4] may be added to Vertue's breathless enumeration of the characteristics needed by an engraver: '. . . to be a good operator—he should be a sedentary rectangular circular equalateral rotation—Melographer—or—melographic Engine. or—it must be an assiduos painfull studious recluse speculative Labour.'[5] Hogarth's pugnacity and 'bold forward front' were the very reverse of these sober traits, and he set himself to remedy the exploitation of the engraver. Vertue had bewailed the lack of aristocratic patrons of engraving and the necessity of approbation by the many, but it was that circumstance which Hogarth took as the *raison d'être* for his engravings.

The South Sea Bubble, and the many satirical prints it inspired, effectively mark the beginning of an unrivalled English tradition.[6] Hogarth contributed the *South Sea Scheme* (1721), reminiscent of Dutch emblematic satires, which like *The Lottery* (1721) and *Masquerades and Operas* (1723/4), deploys the small change of engraving effectively enough. His most finished early engravings are the large illustrations to Butler's *Hudibras* (1726), unattractive but important prints containing the proto-types of a number of groups and figures in his later compositions. However, it was the *Harlot's Progress* (1733/4), a set of six prints showing the tragic misadventures of a girl arriving in London and being inveigled into prostitution, that established Hogarth as an entirely original force in English art (Plate 27). Their serious moral purpose and mass of detailed information, combined with delight in variety of pose and expression, has its counterpart in the pages of Defoe, Swift, and Hogarth's friend and admirer, Henry Fielding. The original paintings were destroyed by fire in 1755 but no doubt they contained more elegance of touch than the engravings, which are densely worked with plain but functional cross-hatching, and are heavily incised to allow for a large printing. They were immediately pirated, Elisha Kirkall's hasty mezzotints being the best known examples, and this spurred Hogarth to agitate for the legislation known as Hogarth's Act, whereby the copyright of an artist's designs was protected by law for fourteen years. Although not entirely effective, this was still a stimulus to the print trade, and Thomas Atkinson in *A Conference Between a Painter and an Engraver* (1736) recognized the new prestige of the engraver and discussed the advisability of an Academy to guide young engravers.[7]

Hogarth delayed publication of the *Rake's Progress* until the Copyright Law had

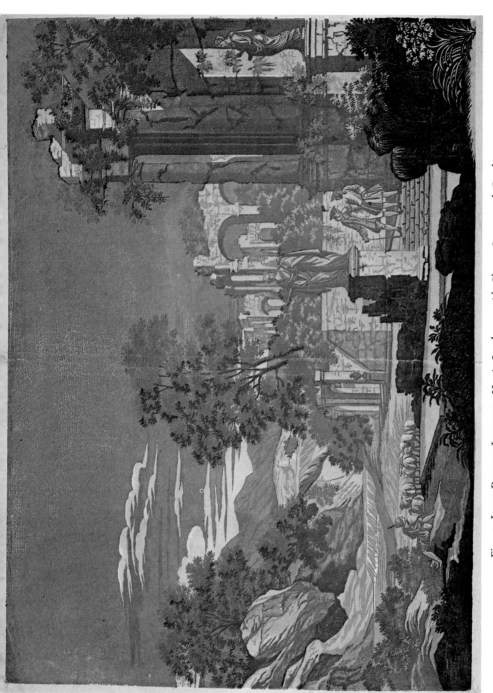

Fig. 2. John Baptist Jackson: *Heroic Landscape with Sheep, Statues and Gentlemen*
[Colour woodcut, printed from about six blocks, after Marco Ricci; 1744; 419 × 579 mm]
Jackson's six colour woodcuts after Ricci landscapes were of an unprecedented ambition in the number of blocks he used to print separate colours, anticipating even Japanese prints. He printed impressions in different colour schemes, this example being in a rather cold range of colours.

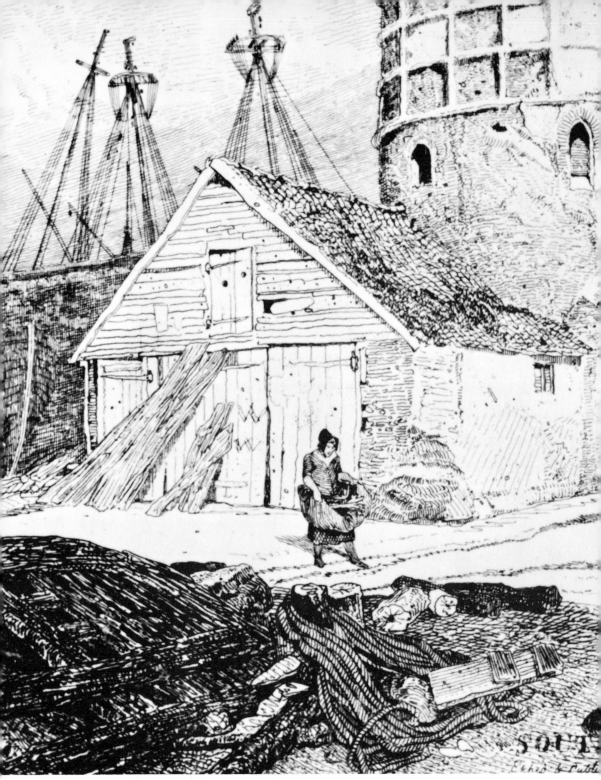

Fig. 3. JOHN SELL COTMAN: Detail from *South Gate, Yarmouth*, from 'Antiquities of Norfolk'
published in 1818 [Etching; 1812; 255 × 370 mm]

Etching allows the artist to draw onto the copper, through its protective coat of wax or varnish, with a vigorous or relaxed line and without the codification of linear structures found in line engravings. The difference between an etched and an engraved line can usually be detected by the fact that an engraved line terminates with a sharp pointed end where the burin has been lifted out of the copper at the end of its run, whereas the etched line is of a more consistent strength. Cotman here uses a lively variety of marks to depict the different textures of stonework and timber.

been enacted in 1735, but some of his finest plates precede this, including *A Midnight Modern Conversation* (1732/3) and its etched subscription ticket *A Chorus of Singers* (1732), and *Southwark Fair* (1733/4). The predominance of Hogarth's favoured medium of etching in the latter allowed him a freedom of handling with which he parades an irresistible array of figures and incidents. Engraving a large plate was a drudgery that Hogarth was increasingly eager to hand over to a reliable factotum, but in *Southwark Fair* there is an evident delight in exercising his skill on the copper. Hogarth's engravings had as their purpose the clear detailing of as much incident and meaning as could be crammed into the compass of the plate. They were meant to be read, to provide constant sources of renewed discovery and instruction. He also believed that, far from applying a 'metronomic' regularity of execution to every plate, the style of engraving should depend on the nature of the subject and its probable audience.

For *Marriage à la Mode* (1745) Hogarth required the airs and graces of French engraving, and he employed Ravenet, Scotin and Baron to engrave the plates, which were expensive and intended for an educated audience. On the other hand, *Gin Lane* and *Beer Street* (1750/51), and the *Four Stages of Cruelty* (Plate 28) of the same date were aimed with missionary (and commercial) zeal at the widest possible audience, and were executed by Hogarth in a blunt, direct style, quickly completed and designed to print in their thousands. He explained his intentions in his *Autobiographical Notes*: '. . . neither great correctness of drawing or fine Engraving were at all necessary but on the contrary would set the price of them out of the reach of those for whome they were cheifly intended'.[8] He went so far as to employ a journeyman wood engraver, J. Bell, to cut large blocks from *Cruelty in Perfection* and the *Reward for Cruelty* in an unsuccessful attempt to enter the cheapest market of all, that of woodcut broadsides. Of the prints engraved in the plain style the most exhortatory are the twelve engravings of *Industry and Idleness* (1747) where virtue, industry and a good marriage lead hand in hand to the Lord Mayorship of London, and idleness and vice lead to Tyburn and the hangman's noose. Of all his prints these lodged most firmly in the national consciousness and no doubt found their way to many a schoolroom wall.

Hogarth was persistently irritated by the public idea of him as a caricaturist, and in 1743 he etched *Characters and Caricaturas* (Plate 29), which served not only as a subscription ticket for *Marriage à la Mode* but to elucidate the difference between character as exemplified in the Raphael Cartoons, and the caricatures of Ghezzi, Carracci and Leonardo. Fielding came to his friend's aid in the Foreword to *Joseph Andrews* (1742): '. . . in the Caricatura we allow all Licence. Its aim is to exhibit Monsters, not Men; and all distortions and exaggerations whatever are within its proper province.

'. . . He who should call the Ingenious Hogarth a Burlesque Painter, would, in my Opinion, do him very little Honour; for sure it is much easier, much less the Subject of Admiration, to paint a Man with a Nose, or any other Feature of a preposterous Size, or to expose him in some absurd or monstrous Attitude, than to express the Affectations of Men on Canvas.'

Hogarth's pessimistic and despairing view of mankind is most apparent in the

black and white shades of the engravings, shorn of the lovely touch and colours of his paintings. It is most compellingly expressed in *The Cockpit* (1759) where Londoners enjoy their horrid pleasures in a claustrophobic scene where there is no humour, only clamour, greed and cruelty (Plate 30). The central figure accepting bets, the blind peer Lord Albermarle Bertie, suggests a grotesque parody of some Bosch painting of Christ mocked, but like his companions he is merely the victim of his own compulsive vice. Never did Hogarth view his fellow-citizens with such disgust; the only rational creature present is the dog on the balcony, viewing the proceedings with dismay. Hogarth terminated his career as an engraver neatly with the *Tailpiece, or The Bathos* (1764), where, amidst a scene of desolation and decay, the figure of Time expires with 'Finis' uttering from his lips, and with a will appointing Chaos as his sole executor clutched in his hand.

Hogarth's stature as a printmaker can scarcely be exaggerated. His engraving technique was functional and emphatic, and does not deserve the contempt it has often received, but his importance does not reside in any executant powers but in his realization that prints could be a democratic art, not confined to mere amusement or the portfolio of the collector, but composed of images that reached thousands of people, and could be used as a blunt instrument in the hands of the reformer or moralist.

Hogarth's example did much to stimulate an increase in the number and quality of satirical prints, but ironically he formed the butt of the most entertaining of these, which are Paul Sandby's gleeful jibes at the *Analysis of Beauty* (1753), advertised as a set of eight prints, *The New Dunciad*, in 1754. The diminutive Hogarth runs the gauntlet of Sandby's mockery in such prints as *A Mountebank Painter Demonstrating to his Admirers and Subscribers that Crookedness is ye Most Beautiful, Puggs Graces Etched from his Original Daubing*, and *The Painter's March from Finchley. Dedicated to the King of ye Gypsies*. Hogarth's support of the unpopular ministry of Lord Bute in his two engravings of *The Times* (1762) attracted a storm of abuse, and Sandby includes the figure of Hogarth, clutching a palette with 'Line of Buty' inscribed upon it, in his complex untitled satire (Plate 31) of Bute and the place-seeking Scots he had brought in his train. The composition itself is an extremely witty parody of themes found in Hogarth's *Election Series* (1755–8).

Satires of the early eighteenth century have been studied almost exclusively for their historical interest, and that shows a proper sense of priorities since they constitute a grotesque but entertaining narrative of the nation's affairs. However, among the mass of crude and hurried prints, often unsigned, a number of lively hands may be discerned, including those of Charles Mosley, Anthony Walker, Gravelot and George Bickham the younger. Gravelot delivered himself of an extremely brutal and obscene attack on Alexander Pope, entitled *And has not Sawney too his Lord and Whore* (1742), and the poet's deformity lent itself to the unkinder spirits amongst the satirists (Plate 33). Anthony Walker (1726–65)[9] is best known for his sensitively drawn and etched book illustrations, but he etched some good satires including *The Beaux Disaster* (1747) and *Britannia in Distress* (1756), which show the required ability to build up a composition with dozens of small figures; the close-up of the face awaited Gillray and his generation.

The most productive satirist of this group was George Bickham the younger (died *c.* 1769), whose father was a writing engraver famous for the *Universal Penman* (1743) and whose identity is sometimes confused with that of his son. *The Negotiators* (1740) bears the inscription 'Geo. Bickham jun In,sc,' but he is not usually so specific, sheltering behind pseudonyms and affixing his name merely as publisher to plates that he had obviously drawn and etched. Bickham plagiarized the ideas of Hogarth and Gravelot, but his etchings are high spirited if erratic in drawing, and he could display astonishing originality, as in the huge yawning head of Walpole in *The Late P-m-r M-n-r* (1743). Father and son collaborated in *The Musical Entertainer* (1737–9), a song-book with decorative headpieces largely derived from Watteau and Gravelot. It is a clumsy but spirited example of English Rococo, and full of the atmosphere of the Vauxhall Gardens. Bickham's dealings were not always respectable; on one occasion his house was searched by Government agents who seized a large number of obscene books; Bickham pleaded in his defence that 'the business of his shop is carried on by his Wife & that he never concerns himself therein'.[10]

Gravelot's influence on satires, however, is but a minor aspect of his great influence on English art.[11] He came to England in 1732 to assist Du Bosc on an English edition of Picart's *Ceremonies* (1733–7) and stayed until 1745. During this time he introduced the airs and graces of French rococo draughtsmanship through the hundreds of small book illustrations either designed and etched by himself, or etched from his designs by pupils such as Charles Grignion (1721–1810). His small illustrations to publications, such as Gay's *Fables* (1738), Richardson's *Pamela* (1742) and Theobald's edition of *Shakespeare* (1740), certainly constitute his most important work, but his industry also encompassed the lovely decorative surrounds to John Pine's engravings of the *Armada Tapestry* (1739), and the cartouches for Houbraken and Vertue's *Heads of Illustrious Persons of Great Britain* (1743–51), which constitute the main value of that tedious series. Some of the most attractive prints after Gravelot are the sets of *Male and Female Costumes* (1744–5), which were stylishly etched by Grignion, Truchy and Major (Plate 35). Grignion recorded that Gravelot was a 'designer but could not engrave. He etched a great deal in what is called the manner of Painters etchings, but did not know how to handle the graver . . .'[12]

However, Gravelot did much to propagate a French style of engraving in England by introducing both Grignion and Thomas Major (1720–99) to the studio of J. P. Le Bas in Paris. Le Bas was not a very important engraver in his own right, but his studio was very extensive and a large number of English engravers went there to acquire skills they could not have found at home. The method used in the school was to lay an extensive basis of etching, free and silvery in effect, which was then accented and finished by the burin. Compared to the laborious style of Vertue and Van der Gucht, which was Hogarth's inheritance, the Le Bas method is light and airy, with an emphasis laid on elegant drawing rather than elaborate tonal systems.

Charles Grignion spent only a few months with Le Bas, and the many book illustrations he engraved after the designs of others are still a little stiff in manner, but even so an obituarist could note that his prints 'partake of that *curiosa felicitas*— that happy carelessness of execution'[13] which was a characteristic of the Le Bas style.

Thomas Major went to Paris with Gravelot in 1745,[14] and his mastery of a light-handed preliminary etching shows all the principles of the Le Bas school, which he applied with considerable success in his stylish print after Gainsborough's early painting of *A View of the Landguard Fort* (1754). However, the most important English member of the Le Bas school was Andrew Lawrence (1708–47), who had dissipated his fortune in futile alchemical experiments and worked for Le Bas for a pittance, etching the foundation of some of his best plates after such fashionable Old Masters as Berchem and Wouwermans. Major wrote a very interesting memoir of Lawrence, which, with a choice collection of the latter's prints, is in the British Museum.

The aquatints and soft-ground etchings of Thomas Gainsborough (1727–88),[15] Gravelot's most illustrious pupil, belong to a later period, but there are three etchings, dating from about 1753–4, which show some influence from the prevailing French manner. These are the *Wooded Landscape with a Church*, *Wooded Landscape with Gipsies*, and the *Landscape with Man Ploughing*, the first two of which were neatly etched by Gainsborough and finished by J. Wood, although impressions do exist from Gainsborough's etched states alone. The *Landscape with Man Ploughing*, an extremely rare print, was apparently spoiled by Gainsborough: 'impatiently attempting to apply the aqua fortis, before his friend, Mr. Grignion, could assist him, as was agreed'.[16]

Jonathan Richardson (1665–1745) made a distinction between prints 'such as are done by the masters themselves whose invention the work is; and such as are done by men not pretending to invent, but only to copy (in their several ways) other men's works.'[17] The former category is rare in the first half of the century, though Richardson etched a few plates himself, including a few delicately drawn self-portraits of 1738 and 1739, which are serious of aspect, but are presented with a candour and economy that is a relief from the mass of formal mezzotint portraits. Similarly refreshing is Joseph Highmore's (1692–1780) little profile of *Sir James Thornhill* (1723), his only etching and his first recorded work. Adding to this small group of portraits distinguished by their unaffected realism are Arthur Pond's (c. 1705–58) *Self-Portrait*, and *Dr. Richard Mead* (Plate 37), both of 1739. The two portraits are scratched in drypoint in vigorous but heavy-handed emulation of Rembrandt.

An increasing fashion for collecting Rembrandt's etchings was exploited by Benjamin Wilson (1721–88) and Thomas Worlidge (1700–66), who produced a number of imitations and, in Wilson's case, out and out forgeries. Wilson deceived Thomas Hudson with a crude forgery (1751) of the rare drypoint 'The Companion to the Coach' then attributed to Rembrandt. Egged on by Hogarth, however, Wilson exposed Hudson in a comical episode later described in his autobiographical notes, in which he says that he invited twenty-three artists to an 'English Roast'. Hogarth sat on his right, Hudson on his left. The chief dish was a large sirloin of beef, 'decorated not with greens or with horse-radish, but covered all over with the same kind of prints' which Wilson had sold to Hudson. Hudson would not at first believe that he had been taken in, but 'Hogarth stuck his fork into one of the engravings, and handed it to him'. All those present had apparently expected Hudson to join in the

general laugh, but he 'took serious offence, and again expressed himself *un-courteously*.'[18]

Worlidge took his prints more seriously than Wilson and did not place them on the market as Rembrandt originals.[19] A pupil of Allessando Grimaldi and Boitard he spent some years in Bath practising as a portrait painter and draughtsman before returning to London in 1740. His prints are usually in drypoint, worked up in small, furry patches, good examples being his copy from Rembrandt's '*Hundred Guilder Print* (1758), *Self-Portrait Etching a Plate* (1754) and in 1765, the touching portrait of Sir Edward Astley masquerading as the Burgomaster Jan Six (Plate 38). In 1764 Worlidge had announced to the Nobility that 'if required [he] will etch any head after the manner of Rembrandt', and this is probably one of the results. Much of his later career was devoted to the drypoints for a *Select Collection of Drawings from curious antique gems . . . etched after the manner of Rembrandt*, which was issued in parts from 1754 and in a posthumous edition of 1768. His widow also reissued a large number of his plates in 1767, many in a worn condition. There is a wrong-headedness about Worlidge's application of drypoint, but the whimsical variety of his subjects and interests is not without its appeal.

Captain William Baillie (1723–1810), an amateur who engraved reproductive prints in a variety of techniques, had the privilege of an even more intimate connection with Rembrandt, since he got his hands on the original plate of the *Hundred Guilder Print* and boldly reworked it. Benjamin West told J. T. Smith that 'when I requested him to show me a fine impression of Rembrandt's Hundred Guilder print, he placed one of his own restored impressions before me, with as much confidence as my little friend Edwards attempts to teach perspective in the Royal Academy.'[20]

Paul Sandby's (1730–1809) fame as the pioneer of aquatint in England has rather obscured his earlier activity as an etcher. Not only did he etch the satires already mentioned, but also landscapes and both realistic genre and elegant figure groups in the Gravelot tradition. He is, in fact, one of the most inventive and varied of all English printmakers. His earliest etchings are a group of small landscapes done in Scotland in 1747, when he was employed as a draughtsman to the Military Survey that followed Culloden. Before he returned to London in 1752 he had etched a number of fine plates of scenery around Edinburgh and of characters he had glimpsed in the streets and villages, which seem to have been issued in small sets of six or eight prints.[21] They include a set of *Scotch Castles* (1751) and groups of landscapes, dated between 1748 and 1751, which are generally enlivened by ruined buildings, wells, or groups of acutely characterized figures. A particular strength of Sandby's landscapes is the way in which he peoples them with figures who are never mere staffage, but have clothes to wash, baskets to carry, or children to tend. In many of these plates his lifelong delight in the knotty convolutions of trees and abundant foliage is expressed by an elaborate but precise use of the needle. A number are inscribed 'etched on the spot', and one of his most vivid figure groups bears the legend 'etched from the life on board a Scotch Ship. The Cook, Captain, and mait'.

On his return to London, Paul joined his elder brother Thomas, who was Deputy Ranger of Windsor Great Park, and two lovingly worked etchings showing family groups in the shade beneath great trees probably date from this period. They may be

compared with Hayman's and Gainsborough's small portraits of sitters in a rural setting, and are another instance of Sandby's art touching a vital pulse in English art. Quite different in character are the twelve etchings of *The Cries of London* (1760), the only plates he completed from a much larger projected set. Etched with un-restrained vigour and realism they show raucous voiced hawkers earning a hard living in the mud and rain of the London street. Nothing could be further from Francis Wheatley's sentimental depiction of winsome young girls in his famous series, than the hussy shouting '*Rare Mackerel*' (Plate 36), stinking of fish, and with a dress torn and ragged with age.

One consequence of an increasing enthusiasm for Old Master drawings was the publication, throughout the century, of sets of facsimile prints, often of considerable fidelity to the originals. The first English imitations of this kind were the twelve prints in 'Chiaro Obscuro' after drawings by Italian masters by Elisha Kirkall (*c.* 1682–1742),[22] which he produced between 1722 and 1724. Kirkall had a keen interest in print techniques and developed a method of imitating drawings by the use of etching and modelling with the mezzotint rocker, and then overprinting the result with colour from woodblocks. Comparison of the *St. Jerome* after Farinati with the original drawing in the British Museum shows his success in imitating the freedom of the drawing, and the different impressions of the print reveal his habit of printing in a variety of colour schemes. Kirkall also scraped mezzotints from landscape and marine paintings by Marco Ricci, Van de Velde and Ridinger, but they are graceless things despite his attempts to enliven them by printing with coloured inks, sometimes using two colours on the same plate.[23]

Much of Kirkall's early career was devoted to book illustration, his most im-portant work being the small prints cut in white line on soft metal for Croxall's *Fables of Aesop and Others* (1722),[24] in which he deftly re-adapted Barlow's etchings. These small designs in a much reprinted book were admired by Thomas Bewick, who observed, with typical sanctimony, that they had led 'hundreds of young men into the paths of wisdom and fortitude', but Bewick was as impressed by Kirkall's technique of using white line positively, as by the book's moral purpose. Kirkall used a similar technique in a print of *Figures in a Classical Landscape* (Plate 39) where the liveliness of the surface cutting is enriched with colour printed from woodblocks.

Arthur Pond (*c.* 1705–58) was noted by Vertue in 1740 as 'the greatest or top Virtuosi in London—followd esteemd and cryed up. . . . Mr. Pond is all in all.'[25] In addition to his drypoints, Pond produced seventy prints in collaboration with Charles Knapton, in imitation of drawings, between 1732 and 1736.[26] They reproduced line drawings by etching, and pen and wash drawings by the mixture of etching with tone printed from woodblocks. The series constitutes an accurate guide to the taste of collectors, particularly that of Richardson, whose collection was most frequently used, with ample representation of Claude, Guercino, Parmigianino, Rosa and the Carracci. Some of the tints have a delicacy close to aquatint, and, with the plate-marks cut away and wash mounts applied, Vertue found it 'hardly possible to avoid takeing the prints for drawings'. After 1736 Knapton gave up etching, although he retained a business connection with Pond in publishing landscape engravings by Vivares and Chatelain. Pond abandoned the use of woodblocks and used variations

of etched line to copy caricatures by Annibale Carracci, Carlo Maratti and Pier Leone Ghezzi. Issued between 1736 and 1747, they were a vital stimulus in spreading the use of caricature, as opposed to emblematic satire, and among them is to be found the curiosity of Watteau's wry drawing of the quack Dr. Misaubin, etched by Pond in 1739.

J. C. Le Blon (1667–1741)[27] was more ambitious than Pond or Kirkall in his attempts to reproduce the full chromatic range of a painting by applying Newton's principles to the printing of the three primary colours from separate mezzotinted plates, which would mix with successive overprinting to create a full-colour effect.[28] Le Blon came to London in 1720 and took advantage of the speculative commercial atmosphere to form a limited company. This soon collapsed in bankruptcy, one of the disadvantages of the process being the length of time taken to print each impression. Despite their rather harsh effect, these large prints are extremely sophisticated, although Vertue refused to be impressed and noted sourly that 'all their prints were touch't with the pencil'. Le Blon published the process, though very obscurely, in *Coloritto* (c. 1724), with a series of sticky plates showing successive stages of printing. He failed to acquire any English imitators, however, though he had more success in Paris, whence he departed in 1732.

Some of the most impressive colour prints of the eighteenth century are the large woodcuts of John Baptist Jackson (c. 1700–c. 1770), a cosmopolitan figure whose best work was done in Venice.[29] His early years in London are obscure, but he had probably acquired some basic skill in wood engraving before he moved to Paris in about 1725. He was employed by the wood engraver Jean Michel Papillon (1698–1776), and engraved numerous headpieces and tailpieces for the Paris book trade, before he quarrelled with Papillon, who dipped his pen in acid when he wrote about Jackson in his *Traité historique et pratique de la gravure en bois* (1766). Jackson believed that Papillon's minute style in emulation of line engraving was self-defeating, and he wished to revive the bold effects of the chiaroscuro woodcut as practised by its earliest masters in Italy and Germany.

By 1731 Jackson had moved to Italy and settled in Venice, and it was there that all his most important prints were cut and published. Between 1739 and 1743 he executed a series of very large chiaroscuro woodcuts, some of them printed onto two or three sheets, after famous Venetian paintings, and these were published in 1745. They were designed in the manner of the classic chiaroscuro woodcut, using variations of two or three basic tints printed from as many separate blocks and not attempting to imitate the colours of the original paintings.[30] Jackson made extensive use of embossing, impressing finished impressions against a dry block to raise corrugations and ridges on the surface of the paper, which greatly increases their powerful effect. They are full of rude vigour, with occasional felicities in harmonizing pale green and brown tints, but the heavy drawing, particularly of faces, is not entirely undeserving of Walpole's scornful description of them as 'barbarous'.

No such criticism can be made of his next project, when in 1744 he cut woodcuts printed in colours, from as many as six or seven blocks,[31] from gouache landscapes by Marco Ricci (Fig. 2; page 33). These are Jackson's masterpieces, and are monuments in the history of colour printing; they anticipate any comparable Japanese

skills by some years. Jackson found a surprisingly congenial model in Ricci, and by skilled use of overprinting and embossing he succeeded in translating the sparkling brushwork of Ricci into the harsher medium of wood. These are very rare prints, and the complexities of the printing must have prevented a large edition, despite Jackson's assertion that the durability of wood gave his method an advantage over Le Blon's mezzotint plates.

Jackson returned to England in 1745 and Vertue expected that 'when he returns to England no doubt he will do the same sort of works here from large and Capital History paintings of Eminent Masters. by which he will meet with much encouragement and he find his advantage because such works in Wood-cutts can be soon done and well paid—which burination cannot have or expect.'[32] Instead, Jackson was employed by a calico factory, until in 1752 he announced his 'New invented Paper Hangings, printed in Oyl', for which he proposed serious classical and Claudian subjects in contrast to the prevailing taste for Chinoiserie. In the same year appeared the anonymous Enquiry into the Origins of Printing in Europe which contains information extracted from an autobiographical journal of Jackson's. In conjunction with his Essay on the Invention of Engraving and Printing in Chiaroscuro (1754), which he illustrated with eight vilely drawn colour prints, it forms the main source of our knowledge of Jackson's life. He was evidently of a combative personality, but his projects failed to make any impact on the English market. His Battersea manufactory of wall-papers folded in 1754, and he is last heard of eking out a miserable existence as a drawing master in Scotland.

The Handmaiden of Art

The Late Eighteenth Century

Throughout the eighteenth century, reproductive prints must outnumber those which were designed and executed by a single hand in a proportion of at least fifty to one. As the century progressed this trend increased, and the various techniques that were introduced were the result—not of some chalcographic self-generation—but of the desire to find more accurate means of simulating the appearance of paintings, watercolours and drawings. The second half of the century thus saw the successive introduction of the crayon manner, stipple, aquatint and soft-ground etching, to augment the existing techniques of mezzotint and line engraving. This predominantly 'servile role' of the engraver was emphasized on the Foundation of the Royal Academy in 1768 by the exclusion of engravers from membership, to their bitter fury and chagrin.[1]

Their anger was the more marked since over the previous decade English engraving had reached an excellence that had previously been confined to France. Its new-found independence stemmed largely from the immense success of William Woollett's engraving from Richard Wilson's dramatic landscape *The Destruction of the Children of Niobe*, published by John Boydell in 1761 (Plate 40). The background of landscape engraving from which Woollett had emerged is suggested by Fuseli's description of 'the last branch of uninteresting subjects, that kind of landscape which is entirely occupied with the tame delineation of a given spot; an enumeration of hill and dale, clumps of trees, shrubs, water, meadows, cottages and houses, what is commonly called Views. These, if not assisted by nature, dictated by taste, or chosen for character, may delight the owners of the acres they enclose, the inhabitants of the spot, perhaps the antiquary or the traveller, but to every other eye they are little more than topography.'[2] This may be taken as a severe but not inaccurate description of the work of engravers such as Samuel Buck (active 1721–79), P. C. Canot (1710–1777), James Mason (1710–c. 1780), François Vivares (1709–80) and J. B. Chatelain (1710–71), whose prints often bear a fulsome dedication to the owners of the house or lands they depict. Samuel Buck, with his brother Nathaniel, engraved dozens of clumsy views of towns known as 'Buck's Views', whose interest is wholly topographical and historical. Vivares and Chatelain are important not merely as engravers in a light French style of views enlivened by cheerful figures posturing amongst picturesque declivities, waterfalls and grottoes, but for their prints after Gaspar

Poussin, Patel, Claude and Rosa. They combined to engrave Claude's *Landscape with a Rural Dance* (1742), one of the earliest engravings after Claude to be published in England (the first were in Pond and Knapton's *Imitations*). Vivares engraved seven more prints after Claude between 1757 and 1770, the finest being *The Pamphili Palace* at Rome (1764). Vivares and Chatelain both also worked from their own drawings, Chatelain etching a number of little landscapes for drawing books, while a very good example of Vivares' invention and style is *A View in Craven, Yorkshire* (Plate 41), which he engraved in 1753.

William Woollett (1735–85) was a pupil of John Tinney and his earliest engravings are bill-heads, watch-papers and other humble perquisites of the jobbing engraver.[3] His early plates include *Eight Views of Oxford* (1755) after John Donowell, and a number of large engravings of the well-clipped and ordered grounds of country estates, which are executed with more feeling for substantial masses of tone than the engravings of either Vivares or Chatelain. He extended his range in 1760 with a large engraving from the *First Premium Landscape* by George Smith of Chichester, and by an ambitious plate from Claude's *Temple of Apollo*. This was published by John Boydell (1719–1804), who had started his career as a very mediocre landscape engraver, but who became the main publisher and Master of Ceremonies of the English school of engraving. Like Hogarth's industrious apprentice, he received his reward in the Lord Mayorship of London. He commissioned Woollett to engrave *Niobe* so that he could export the print to France in order to counteract the large number of French prints he imported—in particular Lerpinière's engraving from Vernet's *Storm*—and the phenomenal success of this venture established his fortune.[4]

As much praise attached to the skill of Woollett's engraving as to Wilson's grand conception. Woollett had developed the full range of his technique, establishing the broad principles of light and shade with an extensive preliminary etching, consisting mainly of the wriggling 'worm-lines' in parallel rows, which form a particular feature of his work. This first etching of the plate was followed by further bitings of more delicate lines, laid in the spaces between the first ones. This was followed by extensive engraved work over the whole plate, the faces of any figures in the design being left to the last strokes. The printing of a first etched proof was a very tense moment, and Woollett would sometimes hide a first impression in a cupboard until he had mustered sufficient self-possession to examine it. In a number of subsequent prints he employed John Browne to etch the first state, always acknowledging his help in the inscriptions.

Woollett's method was not concerned with the virtuosity of fine strokes, but rather with an attempt to translate the full tonal range of a picture, to find black and white equivalents to its various 'tints' and sonority of chiaroscuro. It almost completely superseded the lighter, more draughtsmanlike style of the French tradition embodied by Grignion. Woollett was greatly admired by French engravers; when Raimbach visited Bervic in 1802 he found 'His apartment in the Louvre was hung round with Woollett's finest landscapes, of which he spoke in raptures as *miracles d'harmonie*.'[5]

Woollett's eight prints after Wilson form the largest category of his work, though

he engraved six after George Smith of Chichester, a forgotten landscape painter of Claudian orthodoxy. Woollett's services were eagerly sought by painters intent on a public reputation; Thomas Jones recounted of his picture of a Storm, that 'My friend Woollett with an ardour of inclination, immediately engaged to engrave a print from it, and I began to flatter myself with hopes that my Reputation would be established, and spread abroad through the Medium of that celebrated Engraver, as my Master, Wilson, had in some degree, even his fame extended by the admirable Prints of this artist after his Pictures—witness the Niobe . . . nobody was better enabled to make a young landscape painter known—than Woollett. . . . To him therefore did I look up for help—But little Woollett, as if satiated with the character of being the first Landscape Engraver in the world, must needs try his hand at historical subjects, and having succeeded in his first Essay (The Death of General Wolfe) beyond everybody's—and perhaps his own expectations—abandoned land-scape, and devoted himself to History.'[6]

Thomas Jones's loss was Benjamin West's gain, for the huge success of *The Death of Wolfe* established his reputation. West is a central figure in the history of English engraving, for he understood that history painting could only be subsidized by the sale of engravings, and was at pains to cultivate the friendship of the best engravers. He even undertook the pious but futile duty of chairing a public meeting to discuss the erection of a monument to Woollett in Westminster Abbey. He was punctilious in encouraging engravers and correcting proofs, and they relished this sense of partnership rather than the servitude expected of them by other painters. A com-mission to engrave a large historical work by West was a mark of their professional eminence, and a connection that was usually lucrative. In some cases it would be the engraver who suggested a subject for West's brush: thus James Heath called on West shortly after the Battle of Trafalgar and suggested that West should paint the death of Nelson and that they should make a partnership of the ensuing publication of an engraving from it. This proliferation of popular engravings after West did not always redound to his advantage; he told Farington that Lord Elgin visited his studio and 'seeing the pictures of Genl. Wolfe and the Battle of La Hogue said he had the fine prints which were engraved from these pictures and He asked West *who painted them*. West sd. he had met with other instances of like ignorance.'[7]

Woollett's great reputation was almost equalled by that of Sir Robert Strange (1721–92), but it is difficult to think of any engraver whose work is now so un-valued.[8] He scorned engravings of the work of his contemporaries and dedicated himself to elevating the taste of Britons by large prints from the most august Italian painters, such as Raphael, Guercino, Reni and Sacchi. The documentary value of these prints has long since been usurped by the camera, and they do not have even the value of contemporaneity with their models to commend them. He is usually remembered for his virulent opposition to the Royal Academy, and for the unusual distinction of fighting for the Pretender at Culloden and yet living to receive a knighthood from George III.

Strange studied for six years with Richard Cooper in Edinburgh, but his real training came in the studio of Le Bas in 1749, where he learned the use of pre-liminary etching and also of the 'dry-needle' which he used for especially tender

lines, strengthening its pointings with the burin. On his return to London in 1750, Strange issued prints after Guido Reni's *Magdalen* and *Cleopatra*, and engraved other works by Italian masters in English collections, before determining in 1758 to go to Italy 'to engrave some of the works of these great masters before they are quite defaced'. From 1760 until 1764 he travelled in Italy making careful drawings to be engraved at a later date, the first fruit of these labours being a pair of engravings from Raphael's *Justice* and *Meekness* (1765).

Strange's prints are austere and high minded, yet their silvery tones, and delicate lines coursing round the turn of an arm or a face, are often of some beauty in their clarity of exposition. Strange believed that the elevated nature of his subjects should be translated with a probity of technique that expressed both moral and formal beauty. To Strange, as to Blake, the lower status of stipple engraving or mezzotint lay not merely in their greater ease of execution, but in the intrinsic inferiority of modelling with dots, or scraping out highlights, to incising a clear and expressive line.

His fury and feelings of persecution at the exclusion of engravers from the Royal Academy was therefore intensified by the exception made in the case of Bartolozzi, who was not merely a foreigner, but a stipple engraver. He expressed his feelings in the intemperate language of *An Enquiry into the Rise and Establishment of the Royal Academy of Arts* (1775), snidely alluding to the President's fugitive pigments in the remark that 'Since the memorable aera of the revival of the arts, in the fifteenth century, I know no painter, the remembrance of whose works will depend more on the art of engraving than that of Sir Joshua Reynolds.' Much of his subsequent career was spent in Paris, where he was greatly admired, but he was finally reconciled to the English establishment by his engraving of West's *Apotheosis of the Princes Octavius and Alfred* (Plate 42), a subject calculated to appeal to the King's sympathies. He presented impressions to the King in 1787, and was immediately knighted, the first engraver thus honoured since Dorigny.

A trilogy of great line-engravers is completed by William Sharp (1749–1824), who possessed an even more sophisticated technique than Woollett and Strange, combining dot-work with all the refinements of preliminary etching and fine stroke-work.[9] He was quickly recruited by West, and his first major plate is from *Alfred the Great Dividing his Cloak with the Pilgrim* (1782), but his remarkable skill and variety of tone is even more evident in his portraits of *John Hunter* (1788) and *Sir William Curtis* (1814) after Reynolds and Lawrence respectively. West insisted on the dignity of line-engraving for his melodramatic *King Lear* (1789) for Boydell's Shakespeare Gallery, and Sharp's engraving (Plate 43) is the most successful of the whole series. He was strongly associated with the American artists in London, engraving huge plates from Trumbull's *The Sortie from Gibraltar* (1799) and Copley's *Siege and Relief of Gibraltar* (1810), and the history of the latter illustrates the dangers that faced the artist who over-reached himself in a publishing venture. Copley exhibited his painting in a pavilion in Green Park in 1791, where details of the subscription to the print were available. It was expected to take ten years to complete, but in the event Sharp did not complete the etched state until 1804, and the engraving was not published until 1810, nineteen years after the exhibition and twenty-seven

after the Siege itself. Many of the original subscribers were dead, and a large number of the survivors did not trouble to collect their prints. Copley, who had rashly acted as his own publisher, was left with over 600 prints on his hands, and suffered the mortification of Sharp posting a man on his premises to collect the money due to him as it was paid in by the trickle of customers.[10]

Copley was more fortunate in his dealings with James Heath (1757–1834), whose large and brilliant engraving of the *Death of Major Pierson* (1796) took a mere eleven years to complete (Plates 44 and 45). Large engravings such as this represented the most prestigious aspect of an engraver's employment, but there was endless employment to be had in small portraits and book illustrations. Heath engraved dozens of small plates from the graceful designs of such artists as Stothard, Smirke and Westall, for publications like Bell's *British Poets* (1776–83) and the *Novelist's Magazine* (1780–1785). Stothard's ceaseless industry must have produced enough drawings to keep a score of engravers in work for a lifetime.[11] The elaborate systems of cross-hatching and dot and lozenge evolved by Heath, and the high finish of his plates, represent a stage in the development of increasingly mechanical and systematic techniques which culminated in the dull machinery of Victorian steel engravings. Anthony Pasquin (the pseudonym of John Williams) had his own opinion of Heath's prints: '. . . his mechanical knowledge is unquestionably high; but should the period occur when truth shall be in general request, such laboured, ungendered, silky, unnatural nothingness will be consigned to the shrines of Cloacina, while the Muses sing the requiem of imposture.'[12]

A bolder style of engraving was practised by John Keyse Sherwin (1751–90), who studied under the stipple engraver, Bartolozzi, but engraved in line with some virtuosity. He is recorded as engraving some of his portraits directly onto the copper from the life, a feat of extraordinary skill. He engraved a number of his own designs, including *The Happy Village* and *The Deserted Village* (1787) and the large *View of Gibraltar with the Spanish Battering Ships on Fire* (1784), which are of very modest accomplishment. Of more interest is his portrait of *William Woollett* (1784) which shows his open, rather metallic line, and the boldness of stroke for which he was admired (Fig. 13, page 108).

The most energetic sponsor and publisher of prints of the period was John Boydell, under whose aegis many of the most ambitious English engravings of the century were published.[13] He issued engravings and etchings of every description, and also bought up old plates and republished them. His most ambitious project, however, was the Shakespeare Gallery, for which he commissioned and exhibited paintings on Shakespearian themes from the leading painters of the day, where the profit was to come from the sale of both large and small engravings. A set of one hundred large engravings was issued in 1804, but they were badly received, the mediocrity of most of the paintings not being improved by their ponderous translation into line or stipple with no marked distinction in the application of these techniques to a light or a serious subject. Only Francis Legat's (1755–1809) engraving after Northcote's *Children in the Tower*, and Sharp's *Lear*, seem to have been generally approved. This failure to satisfy the home market probably contributed as much to the ruin of the project as the war's destruction of the vital export trade in prints,

and Boydell was forced to sell the pictures by lottery. Incomparably the finest print connected with the undertaking was James Gillray's unsolicited squib, *Shakespeare— Sacrificed; or—The Offering to Avarice* (1789) with its joyous parodies of the portentous High Art of Barry, Fuseli and Northcote (Fig. 7; page 70).

John Faber was almost alone in preserving the continuity of the mezzotint in the period between Kneller and Reynolds. In 1755, Jean Rouquet drew attention to its decline: 'Painters of some reputation, as well as those who have none, equally strive to signalize themselves this way; they engrave one or more of their portraits in Mezzotinto, under different sorts of pretences, while their real motive is to make themselves known. But the engraver takes everything that offers, so that he is as often the publisher of ignorance as of abilities. Besides, this kind of work is so very incorrect at present, that bad painters have a very good opportunity of imputing their own inabilities to the ignorance of the engraver. But the painter's name is at the bottom of the plate, he reads it with a secret satisfaction as he runs thro' the collections in printseller's shops; this is a public testimony of his existence, which in other respects is perhaps very obscure; and that is all he wanted.'[14] It was not merely the painter who wished to be brought to notice in this way; the subjects of the portraits were in no way averse to seeing themselves smirking complacently from the print-shop windows, and many portrait plates were published at the expense of the sitter or his family.

In 1754, however, the first mezzotints by MacArdell after Reynolds had appeared, inaugurating the greatest period of the mezzotint. Reynolds had returned from Italy in 1752, and had settled in London by the following year. The first mezzotint from his work was not long delayed, being the half-length of *Lady Charlotte Fitzwilliam*, scraped by MacArdell and published by Reynolds himself in 1754, and it is significant that he chose to appear before the public for the first time with one of his lovely portraits of children.

No class of reproductive print has so close an association with a particular painter as that of the mezzotint with Reynolds.[15] The principles of his style were ideally adapted to translation by the medium, and one may speculate that in some cases his predilection for broad effects of light and shade was partially conditioned by the requirements of the mezzotint. Although stipple and line engraving were expected to be exact and detailed translations of a picture, Reynolds required greater breadth of handling from the mezzotinters; he is recorded as finding that Edward Fisher '[was] injudiciously exact in his prints . . . and wasted his time in making the precise shape of every leaf on a tree with as much care as he would bestow on the features of a portrait.'[16] In contrast to Reynolds, Gainsborough cared little if his pictures were engraved or not, and their free handling made them an engraver's nightmare. Whether in line, stipple or mezzotint, prints after his work are invariably unsatisfactory, the worst of all being Dupont's mezzotints.

James MacArdell (*c.* 1729–65) is the most brilliant member of that curious phenomenon in British printmaking, the Irish group of mezzotinters, whose founder members were John Brooks (active 1730–55) and Andrew Miller (active 1738–63).[17] Brooks learned mezzotinting during his residence in London in about 1740, and on returning to Dublin in 1741 took with him Andrew Miller, a pupil of Faber. They

both scraped a few mediocre plates in Dublin, but Brooks the teacher is more important than Brooks the artist, and he trained a number of engravers who were greatly to surpass him. They included MacArdell, Richard Houston (c. 1721–75), Richard Purcell (c. 1736–65) and Charles Spooner (active 1749–67), who constituted but the first few in a long line of Irish engravers who made their way to London. On Brooks' return to England in 1747 he brought MacArdell with him, and the latter had already established himself and scraped a number of fine plates before he formed a connection with Reynolds.

MacArdell's thirty-seven plates from Reynolds' work are fairly evenly divided between male and female subjects, although the softness of mezzotint has always been considered more suited to portraits of women or children. He was by no means solely devoted to propagating the cause of Reynolds, for two of his finest plates are after the full-length portraits of *Mary, Duchess of Ancaster* (1757) by Hudson, and *Lady Coke* (1762) by Ramsay. Most of MacArdell's prints from Reynolds are half-length or three-quarter length, a brilliant early example is *Mrs. Bonfoy* (1755), which perfectly exemplifies his sensitive feel for the transitions between soft and firm contours, and for subtle lighting (Plate 46).

Richard Houston probably settled in London at about the same time as MacArdell, and also worked frequently after Reynolds, as well as Cotes and Zoffany. Like MacArdell, who copied Lely and Rubens, Houston worked after old masters, his particular object being the paintings of Rembrandt, and he scraped rather heavy mezzotints of *The Syndics*, *The Man with a Knife* and the etching of *Burgomaster Jan Six*, the print in which Rembrandt came closest to mezzotint effects. Among Houston's subject-plates are *The Death of Wolfe* (1772) after Edward Penny, and a number of fancy-pictures by Hayman and Mercier of such harmless subjects as *The Elements*, *Times of Day*, *Innocence and Pride*, where the themes are embodied by wide-eyed and seductive young women. These prints anticipate the huge popularity of such decorative subjects some twenty years later.

Purcell and Spooner are not of much account, many of their plates being copies from MacArdell and Houston; Purcell was extensively employed by Robert Sayer, and some of his prints are signed with the pseudonym 'Charles Corbutt'.

While Edward Fisher (c. 1730–85) gives some justification for the criticism by Reynolds in his over finished portrait of the *Ladies Yorke*, he was still entrusted with some of Reynolds' finest pictures, which he translated with the strength of drawing seen in *David Garrick between Tragedy and Comedy* (1762) and *Hope Nursing Love* (1771), one of Reynolds' first 'fancy' pictures (Plate 47). Two more Irishmen of equal competence were James Watson (c. 1739–90) and John Dixon (c. 1730–1804), the former obtaining notably dense and rich qualities of black, and the latter following the familiar pattern of publishing a few plates in Dublin before coming to England in about 1765, and making his name by working after Reynolds.

Thomas Frye (1710–62) devoted much of his life to the management of a china manufactory at Bow, but in 1760 he published a set of twelve prints, supposedly in imitation of Piazzetta, remarkable for their vast size and dramatic use of a close-up viewpoint (Plate 49). They give the impression that Frye, not content to view his sitter from a polite distance, has invaded the model's throne, and practically rested

his drawing board upon their knees. They are not without jarring errors of draughts-manship, but their dramatic lighting and startling immediacy of vision is of great originality within the context of the portraiture of the time. They have the air of fragments from a larger picture, and, as Benedict Nicolson has pointed out, this is what they became when Joseph Wright adapted some of the figures to his use in *The Orrery* (1768), and *The Air Pump* (c. 1767/8).[18]

Although Wright made no prints himself, the dramatic chiaroscuro of his candle-lit scenes could hardly fail of successful translation to mezzotint. William Pether (1731–c. 1816), a pupil of Frye, was a close friend of Wright and scraped some of the most effective of all mezzotints from such pictures as *Drawing from the Gladiator* (1769), *The Orrery*, and, in 1771, *The Farrier's Shop* (Plate 51). The last named print has a special value, for the original picture has been lost, and is known only by Pether's mezzotint which is worked with great delicacy and perfectly suggests the romantic melancholy of Wright's theme.

Johann Zoffany also favoured the mezzotint, and his theatrical subjects were frequently reproduced in the medium, a good early example being *David Garrick in the Provok'd Wife* (1768) by John Finlayson (c. 1730–76); this is but one of a multitude of portrait engravings of David Garrick, who probably sponsored some of them himself for their incomparable publicity value. The largest number of prints after Zoffany were the work of Richard Earlom (1743–1822), and *The Academicians of the Royal Academy* (1773), and *The Porter with a Hare* of the following year (Plate 50) must have served to keep Zoffany's name in the public eye while he was away in Italy.[19] Earlom also copied a number of Zoffany's pictures after the latter's return from India in 1789, attempting such large and ambitious plates as *Colonel Mordaunt's Cock Match* (1792) and *Lord Cornwallis on his Mission to Hyderberg* (1800). The requirements for successful interpretation of Zoffany were precisely those that Reynolds is said to have condemned in Fisher—an attention to detail over all parts of the picture—and to this end Earlom sometimes used the addition of etched line. Earlom's most influential plates were those in a mixture of etching and mezzotint from Claude's *Liber Veritatis* (1777), which in spite of their inadequacy were widely circulated and frequently reprinted. He was far more various in his choice of subjects than most engravers, scraping large and brilliant plates from subjects as different in character as Van Huysum's flower-pieces and Hogarth's *Marriage à la Mode* (1796).

By the 1770s the monopoly of the Irish was being challenged by many skilled English craftsmen, notably Valentine Green (1739–1813), whose richly toned plates from full-length portraits by Reynolds showing beauties presiding with luscious aplomb over acres of parkland (Plate 52) have always been among the most sought after mezzotints. Green did not form a connection with Reynolds until 1778, and his reputation had been founded on large historical subjects after West, such as *Regulus Returning to Carthage* (1771) and *Hannibal Swearing Emnity to the Romans* (1773). He had also scraped fine subject plates from Joseph Wright and Barry. Green was a faithful supporter of Barry and of the related cause of large history paintings, and although he was a printmaker he regretted the reliance of such projects on the sale of engravings: '. . . this patronage is unique, it belongs only to ourselves; and in addition to its other merits is likely to produce this farther brilliant effect, namely,

Fig. 4. WILLIAM PETHER: Detail from *The Farrier's Shop* [Mezzotint after Joseph Wright; 1771; 497 × 347 mm; see also Plate 51]
In a mezzotint, the engraver works from dark to light, scraping out highlights from a surface that has been uniformly roughened by the rocker. It is ideally suited to representing candle-lit subjects or night scenes, and thus Joseph Wright's pictures were translated into the medium with little loss of their atmosphere and effect.

Fig. 5. WILLIAM BLAKE: *The First Book of Urizen*, copy D, plate II [Relief etching, printed in colours; 1794; 146 × 105 mm]

the making Marchands d'Estampes of our first men of Genius, and reducing the study of their Professions to Connosseurship in proof impressions of Engraving.'[20]

The proliferation of proofs before letters, or proofs with etched lettering only, or other 'rarities', became an important aspect of the print trade and a vital perquisite to the engraver, contributing much to 'the advantage and respectability of the profession, by holding out inducements to connoisseurs and lovers of rarity, to form collections of choice exemplars.'[21] Walpole noted that many mezzotinters did not add the lettering until the plate was beginning to show signs of wear, and engravers and publishers slaked the desires of collectors by issuing proofs far in excess of the limited number guaranteed. So keen was the demand for Woollett's proofs immediately after his death, that faked examples were created by the simple device of masking over the lettering when the plate was printed.

There is small point in describing the subtle variations in style and feeling for tone between the large number of able engravers who worked at this time. Romney was well served by John Jones (c. 1745–97), who specialized in male portraits, and by James Walker (1748–1808), a pupil of Green, whose translation of Romney's handling of contours is sometimes a refinement upon the originals; *Lady Isabella Hamilton* and *John Walter Tempest* are choice examples. Any list of the great mezzotinters of this period, whose work shows in varying degrees a feel for brushwork and broken surfaces, or for a glossier finish, must include the names of Thomas Watson (1750–1781), William Dickinson (1746–1823), William Doughty (died 1782) and Robert Dunkarton (1744–c. 1817). The mezzotint was almost entirely an English speciality, known abroad as the 'English manner', and both Walker and Charles Hodges (1764–1837) were tempted to take their skills abroad, Walker spending eighteen years in St. Petersburg and Hodges spending most of his life in Amsterdam.

Perhaps the most refined exponent of mezzotint was John Raphael Smith (1752–1812), who was also a stipple engraver and one of the most important print dealers of his day; both Turner and Girtin found their first employment in colouring prints from the Smith manufactory.[22] Smith made prints of a uniformly high quality from all the usual models: Reynolds pre-eminently, but also Wright, Hoppner, West and Opie. They show a remarkable adaptability to the character of the paintings, and a sensitivity to the gentler ranges of tone suited his work best when treating tender feminine subjects, to which he was led by both personal inclination and a commercial sense. Brilliant examples of his portrait subjects are *Mrs. Musters* (1779) after Reynolds and *The Gower Family* (1781) after Romney, and his virtuosity found a particularly good subject in the capacious lawn sleeves of *Richard Robinson* (1775), also after Reynolds.

From 1775, Smith was increasingly active as a publisher, both of his own work and that of others, notably his friend George Morland. He was a prime force in creating the great boom in mezzotint and stipple prints, often printed or hand-coloured in sugared tints, of lightweight fancy subjects, idealized cottage scenes, fluffy landscapes inhabited by young girls in moods of sentimental reverie. These were a considerable article of commerce, and Smith 'inundated France with English coloured prints; and it has been said, that he who first opened the market there—closed it too; for not confining himself to the traffic for money, he sent cargo upon

4

cargo, of prints of all descriptions, and took part of the amount in merchandize—
and amongst other commodities, received vast imports of claret, Champagne, and
other wines.'[23]

Smith's most able pupil, William Ward (1762–1826), was the brother-in-law of
George Morland and copied a large number of his pictures of animals and rustic
genre in both mezzotint and stipple (Plate 53).[24] The great vogue for Morland was
at its height in 1788, and William Blake was among the scores of engravers employed
to cope with the demands of foreign and English dealers, applying himself re-
luctantly to stipple engravings of *The Industrious Cottager* and *The Idle Laundress*.

James Ward (1769–1859), younger brother of William, is best remembered as the
painter of *Gordale Scar, Yorkshire* (1811–15), but in his early career he was a mezzo-
tinter of outstanding ability. He studied briefly under Smith before spending a few
years working for his elder brother, engraving a number of Morland subjects. He
also worked from his own paintings, and the *Tiger Disturbed whilst Devouring its
Prey* (1797), with its bristling animals and shattered landscape, shows the hectic
romanticism admired by Géricault and Delacroix (Plate 55).

From its first use in the 1760s, stipple engraving became something of an English
speciality. Like mezzotint it is a tonal process, designed to imitate paintings and
endow them with a tender softness of modelling. For engraved lines it substitutes
clusters of dots and flicks produced by a mixture of etching and engraving, and
utilizing the roulette, the punch, and a special curved burin for flickwork. The use
of dot-work for subtle modelling of flesh was not new, and had been used by Guilio
Campagnola (*c.* 1482–after 1514), Ottavio Leoni (*c.* 1576–after 1628), Jean Morin
(*c.* 1590–1650) and even by such humble practitioners as the seventeenth-century
engravers John Fillian and William Dolle. Stipple engraving, however, extends this
limited use of dot-work to the entire surface of the plate.

It developed naturally from the crayon manner, devised in France during the
1450s by Jean Charles François, Gilles Demarteau and Louis Bonnet, and, as its name
would suggest, intended to imitate the appearance of chalk drawings, to which end
they made use of roulettes and punches. Demarteau and Bonnet copied many draw-
ings by Watteau and Boucher, and Bonnet increased the verisimilitude of his copies
by printing in colours from several plates, a method that never flourished in England.

The crayon manner was introduced to England by William Wynne Ryland
(1732–83) and Gabriel Smith (1724–83), who had both learned the technique while
studying in Paris.[25] Smith engraved some stylish plates from drawings by Watteau
and Boucher for *The school of art: or most compleat drawing book extant* (1765), and
Ryland made his English debut with a number of plates for Charles Rogers' *Collection
of Prints in Imitation of Drawings* (1762–78), including one from Boucher's *Bathsheba*
(1764). Ryland, who also engraved in line, soon made the easy transition from the
limited aim of the crayon manner to the more pictorial effects of stipple, and his
main effort was devoted to copying the insipid neo-classical pictures of Angelica
Kauffmann. From its beginnings stipple engraving was thus associated with art that
has superficial charm and prettiness as its main object, its softness of effect being
further emphasized by the frequent printing of impressions in red or brown ink.

The technique is synonomous with the name of Francesco Bartolozzi (1727–1815)

who came to England in 1764.[26] He had trained in Venice under Joseph Wagner, and had engraved a number of plates in a free open style after Italian old masters, and he continued to etch and engrave in line throughout his career. His first employment in England was in etching copies from drawings by Guercino in the Royal Collection, but he was quick to see the advantages of stippling, and had an advantage over English engravers in his superior training as a draughtsman. He soon struck up a partnership with his countrymen, Cipriani, and with Angelica Kauffmann, and their repertoire of bloodless mythological scenes adorned with dimpled putti, smirking and epicene, were the particular property of stipple engraving. Its soft blending of tones, 'verging on beautiful insipidity', combined with the vapid effusions of Kauffmann to satisfy the half-formed sensibility of the collector who required a print for the boudoir wall rather than the portfolio. Such prints as Ryland's *Maria* (1779) after Kauffmann (Plate 54), may be taken as typical of a large class of furniture prints, providing a tasteful incident on a wall, but not arousing any stimulating or uninvited cogitations.

Although Bartolozzi will always be associated with decorative prints, in fact he engraved a wide variety of subject matter. He was always ready to engrave a small trade-card or benefit ticket for a friend, such as the twelve he etched from designs by Cipriani for Giardini concerts, and he sometimes engraved the figures in landscape engravings by Woollett and William Byrne. Among his work in line are such fine plates as *The Holy Family amongst the Ruins* (1789) after Poussin, and the *Royal Academy Diploma* after Cipriani, and he often combined line and stipple as in the superb *Lord Mansfield* after Reynolds. He worked with especial care when copying Reynolds, and *Lady Smythe and her Children* (1789) shows his work at its most delicate, a light dusting of stipple being reinforced by etched line to break up the monotony of a purely dotted surface (Plate 48).

Bartolozzi had a large number of pupils and assistants, including Peltro William Tomkins (1759–1840), John Ogborne (*c.* 1725–95), Thomas Cheesman (1760–after 1834) and Luigi Schiavonetti (1765–1810), who was one of a number of Italians lured to London by Bartolozzi's success. A very high proportion of prints bearing Bartolozzi's signature are wholly or in part the work of these assistants, his signature being in the nature of a trademark. William Sharp noted that the dotting manner had the advantage over line or mezzotint engraving by the fact that 'assistants can without any knowledge of drawing, or any Natural taste perform the greatest part of the labour'.[27] Moreover, a dotted plate could print far more impressions than a mezzotint, and when it began to wear out it was then best suited to printing in colours.[28] The usual English way of taking a colour impression was to ink the plate *à la poupée*, inking its constituent parts with different colours applied with rags for each printing, and often working the impression up with hand colouring. William Hamilton's elegant designs for Thomson's *Seasons* (1797) were engraved by Bartolozzi and Tomkins, the plates in a few De Luxe copies being carefully colour-printed by this method. It should be noted that for every eighteenth-century print that was issued in colour at the time there are scores more that have been coloured since, to take their place in the print-shops accompanied by that ambiguous phrase 'original hand colouring'.[29]

William Hamilton was one of a number of painters who, in the wake of George Morland, contributed polite variations on fancy subjects to be translated into furniture prints by such stipple engravers as Thomas Gaugain (1748–c. 1810), Joseph Collyer (1748–1827), Schiavonetti and Ogborne. Print titles like 'Sunday Morning, a Cottage Family Going to Church', 'A Girl Returning from Milking', 'The Woodland Maid' and 'Sweet Poll of Plymouth', will at once suggest the decorative commodity supplied in abundance by Thomas Stothard, Richard Westall, William Redmore Bigg and Francis Wheatley. Most famous of all furniture prints are Francis Wheatley's 'Cries of London' (1793–7), engraved by Luigi Schiavonetti and others, which to this day retain their popularity in the form of cheap reproductions. The limited status which they enjoyed in the hierachy of eighteenth-century art is suggested by the patronizing announcement in a newspaper of 1795 that Schiavonetti 'is proceeding very successfully with his series of the Cries of London, which Wheatley contrives so well to convey through the medium of little *groups* that form an assemblage of interesting incidents. Schiavonetti is also engaged on a work of a higher order, viz. a set of plates to represent the custom and dresses of the University of Cambridge...'[30]

Lightweight subjects of this kind, popular throughout the late eighteenth and early nineteenth centuries, were easily composed, and a number of engravers like J. R. Smith, William Ward and Elias Martin (1739/40–1818) were able to dispense with the services of a painter and design their own confections. Amongst other mezzo-tinters attracted to the medium by its ease of execution and popularity were William Dickinson and John Jones: the latter's engraving after Romney's *Lady Hamilton* (1785) is a beautifully worked example.

It has often been remarked that stipple tends to lose its effectiveness when worked with too great a density over a large surface, and in the best work of Bartolozzi, such as *Lady Smythe*, there is a sense of tonal 'breathing', of a judicious blending of areas lightly touched, with points of interest closely modelled. An attractive combination of stipple and the crayon manner, where the face or the head and shoulders are taken to a high degree of finish, and the remainder of the design is drawn lightly with the roulette, is a feature of engravings after the foppish drawings of Richard Cosway by John Condé (active c. 1785–93) and Anthony Cardon (1772–1813), their decorative effect being increased by printing the face in colour.

Engravers in both stipple and line had an inexhaustible source of employment in the thousands of large and small portraits required for separate sale, or for periodicals and books. A great stimulus to portrait collecting was the habit of Grangerizing, which reached epidemic proportions towards the end of the eighteenth century. It takes its name from the Rev. James Granger's *Biographical History of England . . . adapted to a Mehodical Catalogue of Engraved British Heads* (1769–74), and consists of the extra-illustration of Granger, or such books as Clarendon's *History of the Rebellion* with portraits or historical engravings. This led to a great interest in the work of engravers like Faithorne, or Elstrack, and the desire of many collectors to be im-mortalized themselves by portrait engravings. The anonymous author of the scur-rilous long poem *Chalcographimania* (1814) instances in a note: 'a grocer who hangs out the sugar-loaf in Dean Street, and has actually caused three plates of himself to be engraved; One an Whole Length, from which he has only struck off half a dozen

impressions, and then destroyed the plates, in order to confer the title of *extra rare* upon these delineations of his sugar-plumb countenance.—*Credite posteri*!!!'[31]

The engravings of George Stubbs (1724–1806) elude any rigid classification of their technique, combining as they do elements of stipple, mezzotint, and line engraving and etching.[32] The results are of an unsurpassed beauty and refinement of tone, and, although long neglected, they represent one of the great achievements of English printmaking.

His first plates were illustrations to John Burton's *An Essay towards a Complete New System of Midwifery* (1751), in which he can have had no great pride, though the work familiarized him with the rudiments of etching and engraving. In 1760 he brought to London his drawings for the *Anatomy of the Horse* (1766), and, finding no engraver willing to undertake such an exacting task, he stoically took up the etching needle and burin to produce plates that combine scientific exactitude with a harmonious beauty of placing and balance.

Thereafter Stubbs abandoned printmaking for a few years, although a number of eminent engravers copied his pictures. Woollett, for instance, engraved four large plates from the *Shooting* series (1769–71), and John Dixon and Richard Houston scraped powerful mezzotints from, respectively, *A Tigress* (1773) and *Lion and Lioness* (1733). His engravers also included Edward Fisher, Richard Earlom (under the pseudonym Henry Birche), Thomas Burke, and his own son George Townley Stubbs (c. 1756–1815). Stubbs would certainly have visited their studios, corrected progress proofs, and taken a keen interest in the problems of translating a picture into the black and white tones of an engraving or a mezzotint. It was this aspect of printmaking that concerned Stubbs, and his own prints are either based on known paintings, or on paintings that can be presumed to have existed.

His own first attempt at translating one of his paintings into engraving is *A Horse Frightened by a Lion* (1777), which shows the influence of Woollett in its rather bitty mixture of etching and engraving, and in the use of worm-lines on the background rocks. A similar method is employed in its companion print *Leopards at Play* (1780), again a memorable image, but with the same rather harsh and restless surface. His choice of line techniques may simply reflect a desire to obtain more impressions from the plate than would have been possible with mezzotint, but Stubbs was his own publisher, not Boydell, and such attempts to combine the creative and commercial roles were notoriously prone to failure.

His next appearance as a printmaker was announced in an advertisement in 1788, opening the subscription for two large engravings, *The Haymakers* and *The Reapers*, and giving a list of prints that could be obtained at his house. This includes most of his known prints, on which he must have been engaged for some years. The publication date of 1 May 1788 to be found on these is also inscribed on two excellent mezzotints by his son, *Horses Fighting* and *Bulls Fighting*, and he was obviously making a long-planned assault on the lucrative print market.

The purpose of his prints is, on the face of it, to reproduce existing paintings, or details from them, but they are reproductive only in the sense of a great composer rescoring a composition for a different ensemble of instruments. *A Sleeping Cheetah* (1788) is in pure mezzotint, as is his last print, *Freeman, keeper to the Earl of Clarendon,*

with a hound and a wounded doe (1804), but the rest of his work is in a mixture of techniques, where he has taken up the various tools of the mezzotint or stipple engraver, and applied them to a contemplative exploration of the copper. His extreme refinement in the use of these instruments to create a fine grit of marks, mixed in parts with a meandering etched line, is evident in the 1788 version of *A Horse Frightened by a Lion* (Plate 56). Even less revealing of the means used are the *Two Foxhounds in a Landscape* (1788), and three tiny prints of foxhounds, selected from a pack of dogs in a painting more than twenty-five years old, and isolated in their small squares of copper (Plate 57). The miraculous timbre of their grey tones, and their feeling of sentient life, is put in relief by a comparison with the more mechanical technique of George Townley Stubbs in his large stipple engraving of 1793 from *Sir John Evelyn* (Plate 58).

Stubbs' nineteen prints extend in category from the 'high art' of the horse and lion theme, equine equivalents to pictures of King Lear, or The Bard, in their mood of outrage and fear, to his abortive attempt to enter that most lucrative of markets, rustic genre, with *Haymakers* (Plate 61) and *Reapers*, both published in 1791. Rustic subjects they may be, and engraved from his paintings with delicate tones of stippled and scraped greys, but the impassive faces of the labourers cut no ice with a public in search of furniture prints with a sentimental depiction of country life. A comparison of J. R. Smith's mezzotint from Lawrenson's *A Lady at Haymaking* (1780), perfumed and simpering (Plate 62), with the unsmiling girl at the centre of Stubbs' version will make the point clear. The artist of the *Anatomy of the Horse* was temperamentally incapable of introducing the smirking faces and languid poses that would have sold the prints but degraded truth.

Paul Sandby wrote to John Clerk of Eldin (8 September 1775) that: 'I perceive you have been trying at Le Prince's Secret. know my good Friend I got a key to it and am perfect master of it . . . I have already done 24 Views in Wales and 4 Large Warwicks which I will send you as soon as they are published. I own no hobby horse woud suit me eaqual to this, indeed I have rid so closely these 4 month past I have scarcely done anything else, the work is so delightful and easy to me now in the execution I do it with the same ease but with more pleasure than on paper . . .'[33]

Le Prince's 'Secret' and Sandby's 'hobby horse' was aquatint, a tonal method adapted to the imitation of wash drawings, first methodically developed and applied in 1768/9 by the French artist J. B. Le Prince (1734–81).[34] The tone is produced by depositing rosin dust on the plate; when heated, and fused to the copper, the rosin acts as a resist to the acid, which will only bite the tiny areas left exposed between the grains of rosin. Stopping out varnish is brushed on wherever a portion is to be preserved from the acid, and different tones are the result of successive immersions in the acid, varying from a minute or so, to longer periods if a deeper grey is desired. Many variations have been played on this fundamental principle, which have as their common aim the imitation of ink or watercolour washes, although the fine granular texture of aquatint can often exceed any hand-made marks in delicacy of nuance.

Although Sandby's aquatint landscapes effectively launched the technique in England, it was first used by a Liverpool artist, Peter Perez Burdett (died 1793), a

close friend of Joseph Wright—who portrayed him as the man taking notes in *The Orrery*—and a prime specimen of a failed virtuoso.[35] At the Society of Arts Exhibition of 1772 he showed '*An Etching in imitation of a Wash Drawing*' and '*An Etching from a design of Mr. Mortimer*', and in 1773 he exhibited a plate with 'The effect of a stained drawing attempted by printing from a plate wrought chemically, without the use of any instrument of sculpture'. His known prints, which may be hypothetically identified with these exhibits, include the signed and dated *Banditti Terrifying Fishermen* (1771) after Mortimer, a recently discovered aquatint of a *Skeleton on a Rocky Shore*, also after Mortimer, and the candlelit scene of *Two boys blowing a Bladder* after Joseph Wright. An impression of the latter in Liverpool Public Library bears the old inscription, 'First Speciman of aquatinta invented in Liverpool by P. P. Burdett, 1774, assisted by Mr. S. Chubbard', but this date is almost certainly too late. They are all very competent prints, with a notably smooth grounding of aquatint, and copied from most interesting subjects.

Burdett made some fruitless experiments with Wedgwood in the application of aquatint to printing on pottery, and in 1773, head over heels in debt, was considering taking his skills as an aquatint engraver—and as a designer of canals—to America. He was dissuaded by Benjamin Franklin, who noted in a letter to Burdett of 21 August 1773, that 'I should be glad to be inform'd where I can see some example of the new Art you mention of printing in Imitation of Paintings. It must be a most valuable Discovery: but more likely to meet with adequate Encouragement on this Side the water than on ours.'[36]

Paul Sandby certainly learned the rudiments of aquatint from the Hon. Charles Greville, but whether Greville had purchased the secret from Burdett or from Le Prince himself in Italy, is uncertain. However, 'it had been so imperfectly communicated to Mr. Greville, that much research and investigation remained for Mr. Sandby's industry, and it was in the endeavour to complete a plate in Le Prince's method (by sifting the rosin over the surface, etc) that he discovered a readier and more beautiful effect might be obtained by bringing the rosin into solution, and floating it on copper . . .'[37] By this means, and by the use of a lift-ground technique allowing him to use brushwork positively, he was able to recreate all the freedom and dash of his body-colour landscapes in the aquatints executed in 1774 and 1775 and mentioned in his letter to Clerk of Eldin. The *XII Views in Aquatinta from drawings taken on the spot in South Wales* and *XII Views in North Wales* were published in 1776, and were followed by a third set of *XII Views in Wales* in the following year. These small plates are of seminal importance, for not only did they establish aquatint as the handmaiden of the landscape watercolourist, but they also introduced a wide public to the rugged and austere beauty of Wales and Welsh antiquities. They have sometimes been described as topographical views, but Sandby's concern with intense effects of light and space is closer to Turner than to any Hollaresque tradition, and their rough, painterly execution is the very antithesis of the subsequent tradition of aquatint landscape, where a succession of cool, evenly grounded layers of tone echo the conventions of the orthodox tinted drawing. In a plate such as *Pont y Pair over the River Conway* (Plate 59) Sandby revelled in textured surfaces and irregular contours, contrasting them with a most delicately grained sky.[38] The paler tones

quickly wore out, and most of his Welsh subjects go through a number of states as
he renewed and altered fading areas, playing delightful variations on themes of
atmosphere and light.

Over the next few years Sandby was very productive: his work on a larger scale
included the *Five Views of Windsor Castle and Eton* (1776-7) and the luminous *Four
Views of Encampments* (1780-83). He did not neglect his penchant for satire, and used
aquatint for *Les Caprices de la Goute* (1783) and *An English Balloon* (1784). In line
etching he confined himself to a number of plates in pure outline, such as the two
sets of *The Encampments in Hyde Park* (1780), and *Twelve Views of Windsor Castle and
its Environs* (1780), which were intended as drawing guides for his pupils and have
frequently been tinted in colour.

Sandby was the friendliest of men and he soon confided his secret to deserving
friends including Francis Jukes (1747-1812), and possibly Gainsborough. He did not,
however, include the importunate Rev. William Gilpin among his confidantes.
Gilpin's descriptions of his Picturesque Tours circulated in manuscript in the 1770s,
and as soon as he had seen some early specimens of aquatint he realized that it would
enable him to illustrate his descriptions, and make their publication possible. William
Mason, on 2 February 1775, suggested that he should 'call on Paul Sandby . . . as
his new method of Etching . . . would suit your sketches admirably', but Sandby
was not forthcoming, and despite Gilpin applying himself to Lord Warwick,
Greville's brother, he did not learn the secret until 1781.[39] In 1782 appeared the first
of his illustrated books, the *Observations on the River Wye and Several Parts of South
Wales*, and thereafter followed numerous publications with his interminable pro-
nouncements on the picturesque qualities of everything from a mountainside to a
donkey's tail, illustrated with small aquatints by such artists as Jukes, Samuel Alken
and John Warwick Smith. Although these small prints, often lightly tinted, are very
monotonous in their relentless subordination of the facts of nature to the good
Rector's requirements, they represent one of the most important early uses of
aquatint.

Another pleasant diversion from the ubiquitous landscape aquatint is the 1788
edition of Ramsay's *Gentle Shepherd* with aquatints of rustic genre by the Scottish
artist David Allan (1744-96),[40] done with roughly applied but agreeably fresh tints.
Allan was a gifted line etcher whose plates of Italian scenes and figures include a
splendid representation of a Neapolitan hack artist painting yet another view of Mount
Vesuvius. Allan seems actually to have pre-dated Sandby in the use of some rudi-
mentary form of aquatint, since there is a small and clumsy plate of a *Maid of the
Island of Procita*, inscribed *D. Allan ad viv del. 1769 et tinta fecit*, executed while he
was in Italy. Sandby admired Allan's drawings and bought a set of Roman Carnival
scenes, engraving four large aquatints from them in 1781. Allan noted in the Dedica-
tion of the *Gentle Shepherd* that aquatint 'has been brought to much perfection by
Mr. Paul Sandby' and that 'I am not a master in the mechanical part of this art; but
my chief intention was not to offer expensive and smooth engravings, but expressive
and characteristic designs . . .'

Another English artist who experimented with aquatint in Italy was Henry
Tresham (1751-1814), who in 1784 published eighteen illustrations to *Le Avventure di*

Saffo, most delicately printed in green and grey, with figures of fetching neo-classical grace.

Richard Cooper (*c.* 1740–1814) studied engraving in Edinburgh under his father Richard Cooper, the teacher of Strange, and, like Strange, he attended the studio of Le Bas. He was in Italy in the 1770s, but was back in London by 1778 when he published a fine large aquatint of *Ponte Nomentano*, followed in 1779 by a *View of the Interior of the Colosseum*. Cooper should also be mentioned for his vigorously drawn landscapes in soft-ground etching, of which he published a set of twelve in 1799/1800.

Not until the early nineteenth century did the great flood of aquatint views and illustrations reach full spate, but the character of the English aquatint was established by such publications as William Hodges' (1744–97) *Select Views in India* in 1786, Thomas Malton's (1748–1804) *Picturesque Tour through the Cities of London and West-minster* in 1792, and Joseph Farington's *A History of the River Thames*, which J. C. Stadler (active 1780–1812) aquatinted between 1794 and 1796. In all these examples, a placid tenor and modest but precise intentions serve as an accompaniment, not to the great heights of the English watercolour tradition, but to the uniformly able standards of the middle range.[41]

A number of drawing-books with simple aquatint illustrations appeared in the last decade of the century, and soft-ground etching was used extensively for the same purpose, the first English examples being landscapes and copies from old master drawings by Benjamin Green (*c.* 1736–*c.* 1800), a mezzotinter, and drawing master at Christ's Hospital, which are dated from 1771. Soft-ground etching simulates the appearance of a pencil or chalk drawing by a technique where tallow is mixed with ordinary etching ground on the plate, a sheet of paper is stretched over it, and the drawing is made on this with an ordinary lead pencil. Wherever the pencil is applied the ground will adhere to the paper, leaving an exposed line on the copper which, when bitten, will exactly reproduce the texture of the drawing. The technique was much used in the early nineteenth century by Cox, Prout, Varley and others, mainly in drawing books, before being superseded by lithography.[42]

Drawing books had of course been an important sideline for draughtsmen and etchers since the seventeenth century, and Hollar, John Payne, John Dunstall and Isaac Fuller had all published such books, which served for amateurs to copy from in their acquisition of another Polite Accomplishment. In the eighteenth century, for instance, an attractive set of line etchings was produced by Bernard Lens the Younger (1680–1740) for *A New Drawing Book for y*e* Use of His Royal Highnesse y*e* Duke of Cumberland, their Royal Highness the Princess Mary and Princess Louisa* (1735). Sandby and Chatelain had etched a number of simply drawn landscapes for the purposes of instructing those 'who would draw landscapes with taste and effect' and their work is amongst the drawing books, more than two hundred in number, advertised for sale in 1775 by Sayer and Bennett.

Soft-ground etching is an ideal medium for any artist using a style of drawing in broad sweeps of soft pencil or chalk that makes the more astringent line of the etching needle unsympathetic. Its development almost simultaneously with aquatint must have delighted Gainsborough, who was perhaps initiated into their secrets by his friend Paul Sandby in 1774 or 1775.[43] Over the next ten or twelve years he used

soft-ground, aquatint, or a mellifluous combination of both, in a group of sixteen prints of landscape, cattle, trundling country carts and pensive rustic figures, that recreate much of the sparkle and freedom of his drawings.

Gainsborough had no great interest in prints as such; he desired the closest approximation possible to the appearance of a drawing in chalk or wash, and, despite his inventive handling of sugar-lift in the aquatints and bold handling of soft-ground, his prints do not enlarge his character as an artist to the same extent as those of Stubbs. However, the requirements of aquatint led him to a greater deliberation in adjusting masses of tone, so giving a certain piquancy and sharpness of definition to shadows and foliage, although he is perhaps most completely successful in three prints of about 1779/80 which were done in soft-ground etching alone. These consist of the *Landscape with Two Country Carts, Landscape with Peasant Reading a Tombstone,* and the *Landscape with Herdsman driving Cattle* (Plate 60), which are drawn with an exhilarating rain of slanting lines, the images blurred and softened by the medium, enhancing their romantic, elegiac flavour. Gainsborough intended to publish these three prints, for in their rare first state they bear a publication line of 1780, but they were not in fact published until 1797, as part of a set of twelve rather poorly printed Gainsborough prints issued by Boydell.[44]

Besides these etchings by his own hand, Gainsborough's drawings were copied in soft-ground by Rowlandson for his series of *Imitations of Modern Drawings* (c. 1784–1788), by F. Wells and J. Laporte in *A Collection of Prints illustrative of English Scenery,* and by F. L. T. Francia in his *Studies of Landscape by T. Gainsborough, J. Hoppner, and others* (1810).

Of more interest than these imitations are fourteen brisk studies by John Robert Cozens (1752–97) of *Forest Trees* (1789), dramatically positioned on steep inclines, which were later aquatinted, but of which the British Museum possesses a set of proofs touched in India ink (Plate 65). It is interesting to note that as early as 1752 his father, Alexander Cozens (c. 1717–86), who was fond of experiment, obtained an effect near to soft-ground in a *View in Italy,* etched in outline with some kind of a divided point. This produced a blurred contour, which has sometimes led to the print being described as a soft-ground etching. When in Rome, in about 1746, Alexander Cozens had referred several times to etching in his notebooks, but the only known print of this period is the dramatic *Castel Angelo* (Plate 63), broadly etched by clusters of sweeping diagonal lines. However, he is best remembered for that entertaining drawing-book, *A New Method* (c. 1786), in which his system of encouraging the imagination by working up finished landscapes from semi-random blots earned him the nickname of 'Blotmaster to the Town'.

Etching was only an occasional activity for most eighteenth-century landscape painters, one of the more sustained efforts being made by the two Smiths of Chichester; George (1714–76) and John (1717–64). Their fifty-three coarsely etched landscapes and copies from old masters were published by Boydell in 1770. However, there was a busy school of amateur etchers, male and female, who plied the needle with enthusiasm in the last part of the century, mostly spoiling a great deal of expensive copper but sometimes achieving notable results. William Austin (1721–1820), an engraver and drawing master, printed an advertisement in 1768 listing

'Names of the Nobility, Gentry, etc., Mr Austin has had the honour to attend in Drawing, Painting, Etching, and Engraving', and the list, augmented in manuscript in the British Museum copy, extends to four hundred names. The British Museum owns two large volumes of the work of Honorary Engravers, many of them essaying tremulous variations on themes of Salvator and Guercino, and the work of Princess Elizabeth, Lady Louisa Greville and the Earl of Harcourt (a pupil of Sandby) shows a high degree of skill.[45] The best amateur etchers, however, were John Clerk of Eldin (1728–1812), a Scot whose correspondence with Sandby has already been quoted, and the Fourth Earl of Aylesford (1751–1812), a collector and imitator of Rembrandt's etchings.[46]

Clerk was very active in the 1770s, etching Scottish landscapes, often on attenuated oblong plates, which have a real feeling for rhythmic line and luminous light effects (Plate 64). Much of his work, however, shows the typical amateur disbelief that the lines will really bite and a desire to make sure by drawing ten lines where one would have done.

Aylesford, like Sir George Beaumont and J. B. Skippe, studied drawing under J. B. Malchair at Oxford from 1767–71, and imbibed his lessons of drawing from nature.[47] Most of Aylesford's plates were etched in the years 1794–6, and are mostly of tumbledown cottages and barns (Plate 66) entirely in the manner of Rembrandt, but drawn from nature and etched with a very sensitive line. They are thus of more interest than the work of other Rembrandt imitators like the Rev. Richard Byron, who were content to copy existing plates.

One of the most widely admired and imitated of English romantic artists was John Hamilton Mortimer (1741–79), whose paintings are rare, but whose brilliant pen drawings were widely collected, and who etched some of the most ambitious and dramatic plates of the period. Mortimer was a whimsical character whose passion for drawing monsters, banditti, and other grisly manifestations of the Terrible in art, contrasted with his enthusiasm for the simpler pleasures of the cricket field. Most of his etchings were published in two sets: twelve large oval designs of *Shakespearian Characters* (1775–6), and fifteen smaller prints issued in 1778 and dedicated to Sir Joshua Reynolds. The second set is a medley of sea-monsters and banditry, which also includes imaginary portraits of *Salvator Rosa* and *Gerard de Lairesse*, etched in the vigorous style of his pen drawings which needed little adjustment for their translation into etched line. The grandiloquent head and shoulder studies of *Shakespearian Characters* include *King Lear* (Plate 68), eye-balls rolling and white hair billowing in the wind. This was an influential conception of a key romantic image, and was drawn with a wide repertoire of markings, from the flowing lines of the hair, through delicate stippling on the face, to a background textured with chopped and broken lines.

More numerous than Mortimer's own plates are the etchings after his drawings by a variety of artists including Samuel Ireland, Lydia Bates, R. Blyth and Rowlandson. Rowlandson and James Gillray were the real inheritors of Mortimer's graphic style, which was the starting point for their own wiry and emphatic draughtsmanship.

Alexander Runciman (1736–85), a Scottish artist who was described by Fuseli in 1771 as 'the best painter of us in Rome', etched some small plates in an impulsive

scratchy manner, of such subjects as *Sigismonda, The Landing of St. Margaret in Scot-land* and *Cormac and the Furies*, which are full of romantic intensity. His brother, John Runciman (1744–68), who is thought to have killed himself in Naples, is the probable author of an extremely spirited plate which perhaps represents *Isaac Blessing Jacob* (Plate 70), and is etched in a very similar style to Alexander's work.[48] The background is coarsely and hastily drawn, but the dynamic grouping of the figures anticipates Fuseli and is full of life.

The massive etchings of James Barry (1741–1806), in their attempt to apply the monumental scale and handling of Piranesi to heroic figure subjects, have no parallel in English printmaking. He had no patience for the polite small talk of the etcher's art, and the primitive strength of his prints did not endear them to collectors who desired more finish. They have been unjustly neglected in print literature, existing as they do in a hinterland of their own, caught between reproductive engraving and original etching.

Most of his plates were etched in two distinct periods: the end of the 1770s when he was experimenting with aquatint, and between 1791 and 1795 when he was etching large and powerful plates from his paintings of the *Progress of Human Know-ledge* in the Great Rooms of the Society of Arts (Plate 67). His earlier prints include *Job Reproved by His Friends* (1777), *The Fall of Satan* (1777) and *The Conversion of Polemon* (1778), which consist in their first states of etching mingled with heavy inspissations of aquatint printed in brown ink. Barry was an adventurous early exponent of aquatint, but he was not satisfied with the results since he later either removed it or etched heavily over its tones. A number of these early prints bear the curious pseudonym of 'Archibald MacDuff', or 'AM', but these inscriptions were scratched out in subsequent states together with the aquatint.

Barry obtained his strength of line by deep biting and by a subsequent strengthen-ing with the burin, the great sheets of copper being scored and ripped by his ill-bred hatchings and gougings, to make the printed lines stand out in relief from the page. He had his own press and took frequent trial proofs, sometimes experimenting with surface tone and often printing impressions on both sides of a sheet. Although many of his prints copy existing paintings their strength of execution is in harmony with the power of the images, and they are some of the most impressive, if least in-gratiating, plates of the period.

It is difficult to imagine a greater gulf than that between Barry and Thomas Bewick (1753–1828), whose little wood engravings of birds and animals, and vignette tailpieces, hold a unique place in popular affection for their clear-eyed observation of the life and incidents of unspoiled rural existence.[49] Bewick described his life in his *Memoir*, the most memorable passages of which deal with his upbringing in the Tyneside countryside, where he learned to relish natural objects and creatures. His career was spent in Newcastle, with a single brief period in London which he greatly disliked.

Bewick was not the first to engrave in white line, using ordinary engraving tools to incise the end-grain of boxwood, thus using the white positively, but he was the first to perfect its use, and the great popularity of his books established its regular employment in book illustration. His principal publications were *A General History*

of Quadrupeds (1790), *The History of British Birds* (*Land Birds*, 1797; *Water Birds*, 1804) and *Aesop's Fables* (1818). The birds and animals, stiffly posed in profile, would soon have their feathers ruffled by one of Barlow's turkeys or pheasants, but they are drawn and cut with great clarity and nicety of touch. It is, however, the little tailpieces, especially those to *British Birds* (Plate 69), which both assured his fame and evidently gave him the most pleasure. The little scenes of huntsmen, horses obscured by grey drizzle, farmyards, and sheltered stretches of river with fishermen knee deep in water, are perfectly observed and devoid of affectation. He shows another side to his character, however, in little images of graveyards or suicides, emblems of mortality which suggest the wagging finger of the village moralist more than the sensibility of the 'Man of Feeling'.

Visions and Caricatures

The Early Nineteenth Century

The French Revolution and the subsequent hostilities upset the thriving export trade in prints on which publishers like Boydell and Smith had relied. These events curtailed, without actually stopping, the publication of fancy subjects and large historical plates, and forced many engravers to find employment in engraving small book illustrations. However, the wars and the isolation of Britain from the Continent were a stimulus to other aspects of print production. Caricaturists were presented with an overflowing gallery of subjects, and, with James Gillray at its head, the tradition of satirical prints was at its most outspoken and vigorous. The public were turned even more to enraptured contemplation of the beauties of British landscape, and their appetite for views and Picturesque Tours was fed by an increasing army of watercolourists, whose work was multiplied by aquatints and engravings. To print publishers, republicanism was a rude interruption to commerce, but to many artists and engravers, including Barry, Smirke, Sharp and William Blake, it was—in its early manifestations at least—a cause to be celebrated.

Largely ignored in his lifetime, the shade of William Blake (1757–1827) must now observe with complacency the swarms of earnest researchers scrambling across his artistic remains, and submitting each word and mark, however hasty, to microscopic analysis and learned exegesis.[1] Blake began and ended his career as a line engraver. From 1772–79 he was apprenticed to James Basire (1730–1802), whose rather dry and old-fashioned style suited his position as engraver to the Society of Antiquaries. Blake's training thus took place against a background of antiquarianism, and there was a technical emphasis on burin work rather than the elaborate systems of preliminary etching employed by such engravers as Woollett.

The time Blake spent in Westminster Abbey making drawings for Gough's *Sepulchral Monuments in Great Britain* (1786), for which he engraved some of the plates (although all are signed by Basire) must have constituted a formative experience. From this duty he conceived a love for the flowing lines of Gothic art, an enthusiasm he shared with his friend, John Flaxman. He further trained his eye, like most artists, by building up a large collection of prints; but his choice was unorthodox, his preferred examples including Marcontonio, Dürer, Bonasone and Netherlandish mannerist prints. In lieu of life-drawing which he spoke of as 'looking more like death . . . smelling of mortality', these served as a library of forms and poses with

which he could give shape to his visionary imaginings. At the conclusion of his training, Blake earned his living as a reproductive engraver, applying the regularities of cross-hatching and dot and lozenge to numerous illustrations by Stothard, whose innocent neo-classical figures influenced some of Blake's early work. He also engraved from Fuseli, and the sensational *Head of a Damned Soul* (Plate 71) is one of Blake's more enthusiastically engraved copies. In most cases however, his confinement to copying the designs of his inferiors, when his engraving hand was quivering with the potency of his own imagination, must have been mortifying.

His opportunities to design and engrave his own work for publication were limited, and Blake did not completely fulfil himself as a line engraver until the end of his career. He did however illustrate Mary Wollestonecraft's *Original Stories from Real Life* (1791) with some playful little engravings, where the figures are modelled by sweeps of parallel lines, which have been left unelaborated as though in an etched preliminary state, and set against a background of textured worm-lines. A more ambitious undertaking was the illustration of Young's *Night Thoughts* (1797), for which he made 537 watercolours, although ultimately only a single volume, containing forty-three designs, was actually published. They are engraved in the margins around the ugly letterpress, and illuminate Young's tedious musings with plunging and posturing figures that are vigorously engraved in deeply incised curving lines which owe more to Villamena or mannerist engravers than to any contemporary English style. Perhaps the finest of his early line engravings are the two large plates of *The Complaint of Job* (1793) and *Ezekiel* of the following year (Plate 72), where the monumental figures are modelled by a system of closely packed diagonal lines, moving up from right to left and sweeping against the twisting lines that define the drapery. In the place of that systematic network of hatching and wormlines progressing from state to state like webs laid one on top of the other, Blake is asserting the rights of the burin, pushing it forward to incise lines that have their own life and value, and are not merely individual struts within a tonal system.

The 1790s, however, are the years of the great colour prints and illuminated books, in which Blake made use of the method of relief printing he had developed. The inventors of eighteenth-century print techniques were almost exclusively men whose technical ingenuity was not linked to any creative powers; they sought merely to reproduce the work of others. Blake invented, or reinvented, techniques—not from mere delight in the mechanics of experiment, but as additional means of expression for his ideas. Eternally optimistic, he also saw his printing methods as routes to prosperity, but in this, like others before him, he was disappointed. In the 1780s he had experimented with a method of relief printing, where the ink is printed from a raised flat surface by light pressure, as opposed to the intaglio method where the paper is forced into contact with the ink-bearing incisions in a plate by high pressure. His first use of this is found in *The Approach of Doom* (1787/8), based on a drawing by his younger brother Robert: this exists in a unique impression in the British Museum. Robert died in 1787, but it was his spirit, according to Blake, that informed him of a means of applying both verse and images to the copper with a substance that would resist acid, and then biting away the rest of the surface by a prolonged immersion in the acid bath. He used this method in the minute images for the tracts

There is NO Natural Religion and *All Religions are one* (1788), and employed it with more certainty in the *Songs of Innocence* (1789) and *The Book of Thel* (1789), in which pastoral and symbolic imagery is married to the verse by flowing and intertwining tendrils of line to create a harmonious unity of text and image unknown since the illuminated manuscripts of the Middle Ages. Different copies of the *Songs of Innocence* were hand coloured by Blake or by his wife, application of the colour ranging from simple, clean tints to thick, gummy deposits that restate and vary the atmosphere and meaning of the designs. *The Songs of Experience*, its companion, was not completed until 1794, and a few copies of this were printed in colour.

He applied the same method of relief printing to *The Visions of the Daughters of Albion* (1793), *America: a Prophecy* (1793), and *Europe* (1794), but he reverted to ordinary intaglio etching for the *Book of Los* (1795) and the *Book of Ahania* (1795). Six of the seven known copies of the *Book of Urizen* (1794) are colour printed, the pigments being perhaps brushed onto the plate and transferred to the paper by some kind of light pressure, producing blurred deposits of colour to suggest the dense atmosphere in which the struggling figures seek to determine their destiny (Fig. 5; page 52).[2] In 1795 he created perhaps the most familiar of all his works, the twelve large colour prints, which are really monotypes since no more than two or three impressions could be printed, and no actual engraving or etching process was used. Frederick Tatham described his method: 'Blake when he wanted to make his prints in oil . . . took a common thick millboard, and drew in some strong ink or colour his design upon it strong and thick. He then painted upon that in such oil colours and in such a state of fusion that they would blur well. He painted roughly and quickly, so that no colour would have time to dry. He then took a print of that on paper, and this impression he coloured up in watercolours, re-painting his outline on the millboard when he wanted to take another print.'[3]

The process gave a textured, mottled surface, especially effective in the great print of *Newton* where it suggests the fungoid and spongy surface on which he sits, immersed in the subterranean world of materialism, and busily deploying his compasses on the ground. Among the other designs in this series are *Nebuchadnezzar*, bearded and dismayed, gripping the ground with his taloned hands and feet, *God Creating Adam*, and *The House of Death*. During this period Blake also took some of his earlier designs, including plates from *The Book of Thel* and *The Daughters of Albion*, and printed them in bright and cheerful colours, the tints of red and blue being of great sweetness and beauty. These are found in the *Small Book of Designs* and the *Large Book of Designs* (1796), the latter including two separate plates that had not appeared in Blake's books, the *Dance of Albion* and *Joseph of Arimathea preaching to the ancient Britons*.

In 1804, Blake commenced work on his most extended and ambitious illuminated books, *Milton* and *Jerusalem*, both of which occupied him for many years. In them, he made use both of white-line engraving and broader relief processes for the designs that accompany the dense and complex verse. Much of the marginalia that decorates and assists the meaning of the text is sprightly and playful, but the larger figures are boldly drawn and massive of shape, totally lacking in comeliness. The musculature of the figures in the *Spectres of the Dead* (Plate 73), from *Jerusalem*, is defined by

Fig. 6. FRANCESCO BARTOLOZZI: *Lady Smythe and Children* [Stipple engraving after Reynolds; 1789; 375 × 293 mm (293 × 233 mm subject); see also Plate 48]
Stipple engraving utilizes both etching and engraving to create tone by means of innumerable dots and short strokes, usually augmented by etched line. A particularly soft and tender blending of tones may be achieved thus, well exemplified in the work of Bartolozzi and his school.

SHAKESPEARE - SACRIFICED; —or—*The Offering to AVARICE.*

Fig. 7. JAMES GILLRAY: *Shakespeare—Sacrificed;* —or—*The Offering to Avarice* [Coloured etching and aquatint; 20 June 1789; 466 × 369 mm]

A satire on John Boydell which suggests that his motive in starting the Shakespeare Gallery was greed rather than patriotism. Shakespeare's statue is obscured by the smoke from the burning plays, the flames being fanned by a figure of Folly adapted from West's *King Lear*. In the billowing clouds of smoke are various Shakespearian characters, adapted from paintings by Barry, Fuseli, Reynolds, and Northcote.

twisting cords of thick line, reminiscent of mannerist prints after painters like Spranger or Cornelisz van Haarlem, the coarseness of certain details being redeemed by Blake's never-failing energy of conception.

In 1805 Blake was commissioned by Robert Cromek to illustrate Robert Blair's *The Grave*, and, believing that his task was to design and engrave the plates, he made a white-line engraving of great vigour of *Death's Door*. Cromek was dismayed by this, and engaged Schiavonetti to engrave the remainder of Blake's designs, which he did in a light and pleasant style, diluting the force of Blake's conceptions by decorative flourishes of the needle. Cromek further edged himself into the 'rogue's gallery' of art history by engaging Stothard to paint the *Canterbury Pilgrims* for engraving by Schiavonetti, after he had seen Blake working on the same subject.

Blake's frustrations and anger at the long years of professional failure boiled over in the *Public Address* (1810), where, spitting venom like a harpy, he gave vent to his opinions of engraving and engravers: Woollett and Strange 'were heavy lumps of Cunning and Ignorance . . . [their] works are like those of Titian & Correggio: the Life's Labour of Ignorant Journeymen'. Blake's own style (as seen in the *Canterbury Pilgrims*) he describes as 'that of Alb. Dürer's Histories and the old Engravers, which cannot be imitated by any one who does not understand drawing, and which, according to Heath and Stothard, Flaxman, and even Romney, spoils an Engraver; for each of these Men have repeatedly asserted this Absurdity to me in condemnation of my Work . . .'[4]

Blake would probably have spent his life without the opportunity to demonstrate his full greatness as a line engraver had it not been for the intervention of John Linnell (1792–1882), who commissioned the engravings to the *Book of Job* in 1823. Linnell had received instruction when still a youth from Mulready and Varley, and his early gift was for intimate and sensitive small studies from nature, to which his drawings, and a few relaxed and unaffected etchings, bear witness (Plate 75). In his later manifestation as Samuel Palmer's father-in-law he is less sympathetic, but by this commission alone he deserves to be honoured. The Job engravings are small, their concentrated energy emphasized by the linear motives in the margins, but they express, in its most potent form, Blake's concept of the sublime (Plate 74). Dramatic light illumines a world where the interaction of the earthly and celestial is enacted by figures whose energies are suggested not merely by contour, but by the dynamic action of the burin: cutting diagonally across their draperies, lingering to pick out a torso or a face, or curling like the whorls of a thumb-mark to define a cloud. The book was not without its admirers, but to eyes accustomed to stipple engraving or the tonal systems of James Heath, Blake's lines must have seemed uncomfortably assertive and 'Gothic'. Something of Blake's admiration of the engravings of Dürer, whose *Melancholia* was a prized possession, is reflected in the crispness of the strokes, which in the broader passages of line also bear some resemblance to the early engravings of Faithorne.[5] Even bolder, and less in need of tonal embellishment, are the seven large engravings for Dante's *Divine Comedy*, which were left unfinished at his death.

Despite Fuseli's comment that 'Blake is damned good to steal from', few artists were inclined to try; and his most influential prints were some of his least typical,

being the little wood-engravings he made in 1820 for Dr. Thornton's edition of Virgil's *Eclogues* (Plate 77) which were to cast their spell over Samuel Palmer and Edward Calvert, the 'Ancients' of Shoreham, whose drawings and engravings of an idyllic earthly paradise are such a fragrant episode in English art. Palmer was introduced to Blake by Linnell in 1824, and Palmer wrote later: 'the scene recurs to me afterwards in a kind of vision; and in this most false, corrupt, and genteely stupid town my spirit sees his dwelling (the chariot of the sun), as it were an island in the midst of the sea—such a place is it for primitive gandeur, whether in the persons of Mr. and Mrs. Blake, or in the things hanging on the walls.'[6] In the Virgil wood engravings, Palmer found 'a mystic and dreamy glimmer as penetrates and kindles the inmost soul, and gives complete and unreserved delight, unlike the gaudy daylight of this world. They are like all that wonderful artist's works the drawing aside of the fleshly curtain, and the glimpse which all the most holy, studious saints and sages have enjoyed, of the rest which remaineth to the people of God.'[7]

Palmer's etchings were made years later and constitute a kind of Indian summer to his career; his only print of the Shoreham years is the tiny wood-engraving of a *Harvest under a Waning Moon* (1826). Even more than Palmer, Edward Calvert (1799–1883) is a classic example of an artist burning up his talent at an early age, and devoting the rest of his career to a desultory stirring of its embers.[8] He first met Palmer in 1826, and like him treasured a friendship with Blake, although it was the memory of Blake's intensity of spirit, and the Virgil woodcuts, rather than a real understanding of the main body of his work, that influenced Calvert's early prints. These were mostly the work of the inspired years from 1827 to 1831, but they were probably preceded by the wood engraving of a Bacchante, and two small out-line etchings; *A Woman's Head looking Upward*, and the exquisite *Back View of a Woman's Head*, deep-etched in a broad line and known only in the British Museum impression.

Calvert and his wife lived in Brixton, travelling down to Palmer's cottage in Shoreham when they could, and it was the idyllic pastoral surroundings of Shore-ham, with rounded hills and thatched cottages merging with the landscape, that Calvert took as his subject, peopling this paradise with idealized neo-classical figures. The ten small prints which form the heart of Calvert's art are in a surprising variety of techniques: line engraving for *The Bride* (1828) and *The Sheep of His Pasture* (1828), pen lithography for *The Flood* (1829) and *Ideal Pastoral Life* (1829), and wood engraving for the remainder. The earliest of the ten is *The Ploughman, or Christian Ploughing the Last Furrow of Life* (1827) (Plate 76), engraved in white line by the use of a mixture of tools, including a burin, and a round headed scorper for pecking out flecks and dashes of white. The thrilling transitions from delicate threads of white line to areas of greater light where the wood has been boldly gouged out could not be further from the regular syntax of Bewick's vignettes, and reflect Calvert's passion for Blake's wood engravings. On the left of the design a plunging angel transfixes a serpent with a rather stagey bolt of lightning, and the thrusting energy of the Plough-man is contained and thwarted, as if he were Jacob wrestling with the Angel, by the gentle counterbalancing curves of the horses, the tree, and the Shepherd pointing inward to the nymphs ecstatically making music.

Calvert's remarkable ability to master new techniques is shown in the silvery line-engraving of *The Bride*, in which a classical nude poses in a landscape overflowing with abundance. Like the *Cyder Feast*, with its rather self-conscious figures leaping and skipping in the moonlight, it shows stirrings of the paganism which eventually replaced the ardent Christian spirit of other works. His use of lithography for two tiny prints seems to reflect a simple delight in trying new techniques, for although they are beautiful images, the *Flood* being an unusually tragic subject, they show little attempt at any special lithographic qualities of tone or touch, and in parts even simulate the cutting out of whites of the wood engravings.

Calvert's last print, and the summit of his art, is the tiny, minutely worked wood-engraving of *The Chamber Idyll* (1831), a delectably sensuous vision of a rustic honeymoon (Plate 78). The lovely figures, picked out in speckled light, prepare for bed in a scene of rural bliss and fruitfulness, apples littering the floor in case passion should be succeeded by hunger. The wood-block itself, fitting easily into the palm of a hand, is an object of great beauty.[9] It was Calvert's swan-song. Having created one of the great masterpieces of wood-engraving, he never touched an engraving tool again; he had drained himself of inspiration, and devoted the remaining fifty years of his life to painting pallid images of pagan and arcadian subjects, tainted with the dead hand of suburban whimsy.

George Richmond (1809–96) became a dull and successful portrait painter, but his brief period among the Ancients resulted in two line engravings: *The Robber* (1827) and *Christ the Good Shepherd* (1827–9). The latter was left unfinished (Plate 79), Richmond exhausting his powers before he could complete the foliage and the sheep, but the sharp attenuated contours and the silvery tone are of great charm, and for a boy of eighteen it is an astonishing performance.[10]

It is an irresistible temptation to turn from the elevated musings and fluttering cloaks of the Ancients to the grosser pleasures of caricatures, gaudily coloured, and always able to attract a crowd around the print-shop window in which they were displayed. One measure of Blake's obscurity in the public eye was that he and his works never formed the object of a satirical print, although his career spans their greatest period.

The use of caricature, introduced by Pond's prints after Ghezzi and others, was first regularly applied to political subjects in the 1750s by the amateur George Townshend (1724–1807: later the fourth Viscount Townshend). Some of his designs were etched on little card-sized plates by the drawing teachers and print-sellers Matthew Darly (active *c.* 1750–78) and his wife Mary (active *c.* 1750–77), and these were among the plates included in the volumes they published from 1756 with the title of *A Political and Satyrical History*. These were significant in spreading a taste for the new art, which Mary Darly thought suitable to 'keep those that practise it out of the hipps or Vapours'.

Another influential caricaturist was Thomas Patch (1725–82) who worked in Rome, painting caricature groups of Englishmen on the Grand Tour, a genre also attempted by Reynolds in his parody of Raphael's *School of Athens* (1751). In 1768 Patch etched twenty-five full-length profiles of Englishmen in Rome, giving them exaggeratedly large lips and feet, although his distortions do not cross the barrier from playfulness into vicious travesty.

The subject that really launched the caricature, however, was that of the Macaroni; exquisites in head-dresses, wigs and costumes of fantastic excess, and the many prints of these scented and posturing marvels form a category of their own. Mostly published between 1770 and 1773, these etchings and mezzotints are often large and brightly coloured, and placed caricatures on an altogether more popular and entertaining level.

Entertaining and historically interesting though these early plates may be, they are but a tuning of instruments preceding the onslaught of the one caricaturist of real genius, James Gillray (1757–1815).[11] Gillray was born in the same year as Blake, and entered the Royal Academy Schools a year before him in 1778; it is diverting to imagine them drawing together from the antique, as perhaps they did. He was etching satires, often anonymously, from an early period, but he made a serious effort to establish himself as a reproductive engraver, and engraved several large plates from Northcote. Farington recorded as 'proper', however, a remark of Sir George Beaumont's that 'executive musicians He wd. compare to Engravers, who only execute with skill the ideas of others;'[12] and Gillray, like Blake, was too obviously capable of composing and playing his own tunes. Blake engraved one unpublished plate for Boydell's *Shakespeare Gallery*, from which Gillray obtained no work, and both were excluded from the patronage of Thomas Macklin in his *Poet's Gallery*.[13] A reputation for originality was, indeed, the worst possible recommendation for an engraver.

Gillray avenged himself on Boydell with the biting invective of *Shakespeare-Sacrificed* (Fig. 7; page 70); the brilliantly drawn figures are animated from head to toe, twitching with life, and piled up in a swirling composition where one grotesquerie generates another without rest or pause. The varied line of this and earlier prints such as *La Belle Assemblée* (1787) is much indebted to the drawings and etchings of Mortimer, and Gillray had also taken note of the crude but vigorous etchings of his rival caricaturist James Sayers (1748–1825), whose mockery of Fox in 1783/4 earned him the gift of a sinecure position from Pitt. The excitable baroque of Gillray's composition also reflects an enthusiasm for Rubens, and during the insanity of his later years he is recorded as telling the young Cruikshank that 'You are not Cruikshank, but Addison; my name is not Gillray but Rubens'.[14]

By the end of 1791 Gillray's prints were published exclusively by the print-seller Mrs. Humphrey, and his prints, brightly coloured by assistants, became the main attraction of her shop. This was depicted by Gillray in *Very Slippy Weather* (1808), showing gawpers of various rank enjoying the window display, and two clergymen perusing a caricature inside the shop. Abandoning all thought of reproductive engraving, Gillray devoted himself to an unsparing assault on the social excesses and great figures of his day: George III, relishing a boiled egg in *Temperance Enjoying a Frugal Meal* (1792), the Prince of Wales as a *Voluptuary under the Horrors of Digestion* (1792), William Pitt, sprouting from the Crown, as *An Excrescence—a Fungus; alias— a Toadstool upon a Dunghill* (1791); all served as an acid corrective to the more seemly mezzotints after Reynolds or Lawrence to be found in other shop windows. The leader of the Whigs, James Fox, portly and heavy jowled, was a caricaturist's gift, and was depicted by Gillray in a multitude of forms, from a pig or a bloody-handed

traitor to the Arch-Fiend himself, continually thwarted in his fell purpose by the trampling feet of Pitt (Plate 80). To be caricatured, however brutally, was at least to be noticed; the ambitious George Canning recorded in his Diary for 21 August 1795 that 'Mr. Gillray the caricaturist has been much solicited to publish a caricature of me and intends doing so. A great point to have a good one.' He made his début dangling from a lamp-post in *Promis'd Horrors of the French Revolution* (1796).

In 1797 Gillray was given a pension by the Tories, but for some years before that his prints had been increasingly directed against the Opposition, whose interests were identified with the gory events of the French Revolution, depicted in the savage imagery of *The Zenith of French Glory; the Pinnacle of Liberty* (1793). Some of his depictions of the menace of French republicanism, intended as grim warnings to the populace, were based on suggestions by Canning, Hookham Frere and other contributors to the *Anti-Jacobin*, and were vital instruments of propaganda. As Napoleon's star ascended, so he appears increasingly in caricatures, represented by Gillray as a diminutive and evil-minded guttersnipe, full of malicious energy and attended by gaunt Frenchmen with large wet lips and pointed teeth, with whom Fox is pictured in unholy alliance.

Gillray's energies were not entirely devoted to political satires; with equal glee he mocked the excesses of fashionable attire, the unedifying spectacle of *Germans Eating Sour-Krout* (1804), and even portrayed the miseries of *The Gout* (1799), in a horrible image of a virulent demon sinking its teeth and barbed claws into a red and swollen foot. All are drawn on the copper with the vigour that gives a ring of truth to the story that 'Sometimes he would at once etch a subject on the prepared copper plate, of which he constantly kept a stock, unable to submit to the process of drawing it on paper. When etching he worked furiously, without stopping to remove the burr thrown up by the etching needle, consequently his fingers often bled from being cut by it.'[15]

Some of Gillray's most vivid satires are parodies of well-known paintings, especially those of Fuseli, whose Three Witches he parodied in *Wierd-Sisters; Ministers of Darkness; Minions of the Moon* (1791), an attempt at the 'Caricatura-Sublime'. These spoofs of the Grand Manner are so entertaining because in his way Gillray was one of its most inventive exponents, sharing with Fuseli and Blake a natural talent for depicting hordes of figures whirling in a frenzy 'twixt the earth and the heavens. One of his most ambitious efforts was *Confederated-Coalition—or—The Giants storming Heaven* (1804), where a Homeric contest ensues for the right to Office, in which the mighty torsoes and pounding limbs of the Gods are here parodied by the flabby bellies or scrawny shanks of Addington, Pitt, Fox and their cohorts, who furiously assail each other with clods of earth, gushing syringes and blunderbusses (Plate 81).

From 1807 his activity abated, and from 1810 he became insane and incapable of work, although his prints continued to be sold for some years. Gillray's work represents the high point of the English caricature, the great interest of his themes, and the licence allowed and expected of the satirist being exploited by the artist in a whole series of famous images. However, in 1831 when the taste was for milder fare a writer in the Athenaeum could look back with distaste at Gillray as 'a caterpillar on

the green leaf of reputation'—the phrase itself immediately suggesting a marvellous subject for a Gillray print.

Thomas Rowlandson (1756–1827) was even more prolific than Gillray, but satirical prints form only a portion of his work, and not always the most interesting.[16] Gillray was first and foremost a printmaker, but Rowlandson's watercolour drawings are the most attractive aspect of his work, and the innumerable prints that he etched himself or that were etched after his designs are of secondary interest.

Rowlandson began to etch political satires regularly from 1784, and the wiry line of these earlier prints reflects the influence of Mortimer, who also anticipated Rowlandson's predilection for grotesque and hideously ugly figures. To Mortimer's vigorous penwork Rowlandson added a curvilinear and rococo style, his very name suggesting the rotundity and homely curves of his drawings. In addition to his spirited copies from Mortimer, Gainsborough and others in his *Imitations of Modern Drawings* (1784–8), Rowlandson included some of his own designs, and *Embarking from Brighthelmstone to Dieppe* (1787) is one of his best plates (Plate 82). The figures are small, but acutely characterized, the passengers in the boat preparing for their rough passage with a mixture of stoicism and dismay, and, in a typical Rowlandson detail, a fat woman's wig has blown off in the breeze, a dog yapping with excitement as it sails away.[17]

It was in social comedy of this sort that Rowlandson excelled, and he created a gallery of characters in whom the English have always delighted. Extremes of physical appearance are portrayed by gross bishops and half-starved curates, decrepit husbands and beautiful wives, and he never wearied of mocking corrupt lawyers, old maids and foreigners. Some aspects of Rowlandson anticipate the vulgar sea-side postcard: a number of prints, notably the *Exhibition Stare-Case* (*c.* 1811), explore the theme of tumbling women, skirts disarrayed to expose plump bottoms to the inexpressible delight of the elderly gentlemen who are always at hand. The cheerful bawdiness of such subjects was taken several stages further by the pornographic prints be began to etch in about 1812, which are outrageously indelicate.[18]

Many of Rowlandson's drawings were etched and aquatinted by professional engravers; Samuel Alken did some good plates, and probably the best known of all Rowlandson prints is the large *Vauxhall Gardens* (1785) engraved by Jukes and Pollard. In the latter part of his career he was much employed by Rudolph Acker-mann who published the *Tour of Dr. Syntax in Search of the Picturesque* (1812) and its sequels, and the *English Dance of Death* (1816), for which W. Combe was hired to write verses to accompany the prints. In the three volumes of the *Microcosm of London* (1810) he collaborated with Pugin, whose rather cold architectural drawings he enlivened with deftly drawn groups of figures; like many subsequent Ackermann publications this was issued in monthly parts. Rowlandson continued to etch satires throughout his career, but many of the later prints are coarsely drawn, and those published by Thomas Tegg are coloured with crudely applied and garish tints, scarcely redeemed by the interest of the imagery.

Gillray and Rowlandson are the great figures from an army of draughtsmen who helped satisfy the insatiable public demand for caricatures of every description. Until

Gillray was monopolized by Mrs. Humphrey, both were published by S. W. Fores, one of the most important print-shop proprietors, who between 1789 and 1794 exhibited a collection of caricatures, 'the whole forming an entire Caricature History, political and domestic of past and present Times'. Like other printsellers, Fores made up large volumes of caricatures for gentlemen's libraries, and portfolios of prints could even be hired out for the evening (2s. 6d. per day with one pound deposit). From 1807, Thomas Tegg sold coloured prints of a lower quality at a shilling each from his shop in Cheapside, but even at this price they were beyond the purses of most who had to be content with the free window display. An American visitor to London in 1810 found his eyes irresistibly attracted to the print-shops: '. . . not that they always exhibit those specimens of the art so justly admired all over Europe, but oftener caricatures of all sorts. My countrymen, whenever introduced in them, never fail to be represented as diminutive, starved beings, of monkey-mien, strutting about in huge hats, narrow coats, and great sabres; an overgrown Englishman crushes half a dozen of these pygmies at one squeeze. It must be owned, however, that the English do not spare themselves; their princes, their statesmen, and churchmen, are thus exhibited and hung up to ridicule, often with cleverness and humour, and a coarse sort of practical wit.'[19]

The most prolific caricaturists included the amateurs H. W. Bunbury (1756–1811), whose lumpily drawn social satires were frequently engraved in line and stipple, and John Nixon (died 1818). Of the professionals, mention should be made of George Woodward (c. 1760–1809), who specialized in drawing the shore life of sailors, the short-lived and talented Richard Newton (1777–98), Robert Dighton (c. 1752–1814), William Heath (c. 1795–1840) and Isaac Cruikshank (1765–c. 1811).

Isaac is better known as the father of George Cruikshank (1792–1878), who was brought up surrounded by the paraphernalia of the etcher's art, and began to draw and etch from an early age.[20] Gifted with great facility and boundless industry, Cruikshank's myriad satires and book illustrations make even Gillray and Rowlandson seem like sluggards. His earliest prints of note are a series of broadly drawn caricatures of the discomfiture of Napoleon and his armies as they retreated from Moscow, a typical example being *Boney Hatching a Bulletin or Snug Winter Quarters* (1812). Cruikshank finished a number of Gillray's plates after his death, and inherited the latter's detestation of the French, his working table, and much of his ability to fill a plate to overflowing with animated figures.

His brother, Isaac Robert Cruikshank (1789–1856), was also a caricaturist, and both responded joyfully to the excesses of Regency taste and fashions. The Dandies, with their pinched waists, high stock and preposterous affectations, were as much an object of ridicule as the Macaroni had been in their day, and Robert Cruikshank's *A Dandy Fainting or—An Exquisite in Fits* (1818) is an amusing example (Plate 83). Thrown into raptures by 'the last air of Signeur Noriballenas', his tiny feet and hands twitching with ecstasy, a Dandy is attended by his friends; one of them squeaks 'I am so frighten'd I can hardly stand', while another enjoins him to 'mind you don't soil the Dears linnen'. In the same year George Cruikshank etched the *Inconveniences of a Crowded Drawing Room*, which shows something of Gillray's influence, but is lightened by a greater sense of fun and a witty pertness of drawing.

The open, flowing handling of his early style is evident in another brilliant satire of fashion, *Monstrosities of* 1825 (Plate 84).

By the time Victoria came to the throne in 1837, the tradition of the outspoken and brightly coloured caricature was played out. The foundation of *Punch* in 1841, with its staid and harmless humour, marks the final demise. Cruikshank adapted himself to changes in taste, etching thousands of small plates for his *Comic Almanacks* and *Scraps and Sketches*, and for many novels and magazines. He illustrated *Sketches by Boz* (1836) and *Oliver Twist* (1838), and his appetite for the grotesque and his eye for detail made him an ideal illustrator of Dickens. In 1847 his designs for *The Bottle*, warning of the dreadful consequences of drunkenness, were reproduced by glyptography and became a huge best seller. Thence forwards the satirist of the Regency—who in 1820 had actually been bribed with £100 'in consideration of a pledge not to caricature His Majesty in any immoral situation'—became a Victorian moralist, railing against alcohol with increasing vehemence. His etched illustrations are so numerous that, with certain unforgettable examples such as *Fagin in the Condemned Cell*, the memory of one soon blurs with another into an impression of innumerable tiny figures scurrying hither and thither with the frenetic energy that is the hallmark of all his work.

It is scarcely possible to pay more than lip service to the many volumes of aquatint views published in the early nineteenth century, the production of which was only halted by the increasing popularity of lithography in the 1830s. An event of great significance, in that it both consolidated the importance of aquatint, and set a standard of precise execution on the copper and in the subsequent hand colouring, was the publication between 1795–1808 of the large plates of *Oriental Scenery* by Thomas Daniell (1749–1840) and his nephew William Daniell (1769–1837).[21] They travelled extensively in India between 1786 and 1793, making drawings which they then translated into aquatint on returning to England (Fig. 8; page 87). William Daniell told Farington that 'the great facility which he had acquired in executing in Aquatinta was obtained by the most severe application for Seven years together after He arrived in England from India. He said He had worked from 6 in the morning till 12 at night.'[22]

The series was issued in six separate parts, each containing twenty-four plates, recording the landscape and antiquities of India in precise but uncluttered lines and washes of tone, the aquatint having been applied with remarkable control and finish. The impression given of India is of a placid landscape, picturesque but hospitable, and amply provided with temples and monuments around which cluster amenable natives in attitudes of classical repose or gentle motion. The colouring is in cool moist tints of green, blue and brown, applied with unselective regularity to each subject and suggesting a climate rather like the Lake District in early autumn. The plates began to appear at a time when India was becoming of increasing importance in the Empire, and any traveller whose experience of the country was confined to the Daniell plates must have had a rude shock when he first experienced the realities of the Indian climate.

The publication was of an unprecedented ambition and scope; its success, and that of many subsequent books of aquatint views, is explained by Samuel Prout's comment

in 1813 that 'we can sit and securely traverse the extensive regions of the East, without quitting the elbow chair, and contemplate with delight the magnificence of art in the Hindoo temples, as united with the stupendous grandeur of nature.'[23]

William Daniell is also notable for his *Twelve Views of Windsor, Eton and Virginia Water* (1820), a *Series of Views of London and the Docks* (1812), and the smaller plates to a *Voyage round Great Britain* (1814–25). He also practised soft-ground etching with considerable skill, copying a series of George Dance's profile portraits between 1808 and 1814.

The 'secure traversions' and the comforts of the elbow chair mentioned by Prout suggest the essential gentility and restrained traditions of the aquatint book. The well-bred lady or gentleman, wearied by Hindoo temples, could peruse their book-shelves and choose from a large collection of expensive illustrated volumes, usually with a discursive and anecdotal text; these might be expected to include numerous tours around many parts of the globe, the costumes of their inhabitants, their sports and recreations, great buildings and monuments, and perhaps their flora and fauna. For the amateur watercolourist, books of instruction were supplied by Varley, Prout, Nicholson, Cox and others. In some of these the modes of operation were simply displayed by the progressive states of the aquatint, a method of instruction found as early as 1794 in *Process of Tinted Drawing* by Julius Caesar Ibbetson (1759–1817), and subsequently employed in 1814 by David Cox, after preliminary plates in soft-ground etching, in a *Treatise on Landscape Painting and Effect in Water Colours* (Plate 85), and later in *The Young Artist's Companion* (1825). Cox, in the preface to his *Light and Shadow, in Imitation of Indian Ink* (1812), noted of the increased prestige of the watercolour: 'with feelings of national exultation, that we can ascribe, in a great degree this improvement in so elegant a department of the fine arts to our lovely countrywomen. It is to the cultivation of the study of drawing in watercolours, by the enlightened ladies of our time, that the best artists have owed their encourage-ment . . .'

In few cases would the occupant of the elbow chair be troubled by the higher flights of art, or by anything that was not both decorative and informative. Most aquatints were intended to be coloured, publishers like Ackermann employing a battery of lowly paid colourists, often youths or French emigrés, whose application of smooth, even layers of colour was often very skilful. De Loutherbourg's *Romantic and Picturesque Scenery of England and Wales* (1805), engraved by W. Pickett, even gives the name of the colourist as J. Clark, but this is unusual.

A few examples will have to suffice within the various categories of aquatint book. Costume plates were the speciality of William Alexander (1767–1816) and J. A. Atkinson (1775–after 1831) and the latter's *Picturesque Representations of the Manners, Customs, and Amusements of the Russians* (1812) is executed with a pleasant freedom of touch. He also met the demand created by the wars for plates of military costume in a *Picturesque Representation of the Naval, Military and Miscellaneous Costumes of Great Britain* (1807), containing a hundred coloured plates. W. H. Pyne (1769–1843) contributed the *Costume of Great Britain* (1804), showing the sense of pic-turesque detail that is evident in the books he later wrote under the pseudonym of Ephraim Hardcastle, including the informative *Wine and Walnuts* (1823).

Sporting prints have always been one of the most popular commodities of English print-shops, and two of the best known sporting artists are Samuel Howitt (*c.* 1765–1822) and Henry Alken (1785–1851), both of whom provided many designs for aquatint books as well as etching their own plates.[24] Howitt illustrated Williamson's *Oriental Field Sports* (1807) and Orme's *Collection of British Field Sports* (1807), and Alken's books include the *National Sports of Great Britain* (1821) and 'Nimrod's' *The Life of a Sportsman* (1842), and *Memoirs of John Mytton* (1835).

The end of the wars in 1815 opened up the Continent to the traveller once again, and increased the already abundant supply of volumes of picturesque tours and foreign travel. William Westall (1781–1850), William Havell (1782–1857), John Hassell (died 1825), and T. H. A. Fielding (1781–1851) all produced books of aquatint views, characterized by limpid tones and careful distribution of masses of light. Havell's *Series of Picturesque Views of the River Thames* (1812) display these modest aims to pleasant effect, and were engraved by his relatives Daniel and Robert Havell. The various members of the Havell family supplied aquatints for a large number of books, best known being the plates by Robert Havell, senr (active 1800–40) after Audubon's drawings of *The Birds of America* (1827–38). Of the engravers who worked mainly from the designs of others, the most productive were J. Bluck, J. C. Stadler, R. Reeve, T. Sutherland and F. C. Lewis. Lewis (1779–1856) was a capable engraver who also worked in stipple and mezzotint, having an equal command of each process. He did most of the work in adding the aquatint to Girtin's beautiful soft-ground etchings of *A Selection of Twenty of the Most Picturesque Views in Paris* (1803), published after the artist's death in 1802. Lewis also engraved his own designs, such as the *Picturesque Scenery of the River Dart* (1821), and used aquatint for his *Imitations of Drawings by Claude in the British Museum* (1837).

Many of these artists were employed at some stage by Rudolph Ackermann (1764–1834), who commenced business as a printseller in 1796 and whose Repository of Arts in the Strand overflowed with prints and illustrated books of every kind. In elegant surroundings, the gentleman in town for the day could purchase drawing books for his family, illustrated volumes to advise in the improvement of furnishings and garden, fashion books for his wife, and, in benevolent mood he might even purchase *Hints for Improving the Condition of the Peasantry* (1816). Having fulfilled this duty he could then repair with an easy conscience to Mrs. Humphrey's shop in St. James's Street. Ackermann's first publication to be issued in parts was the *Microcosm of London* (1808–10), and this was a method he adopted increasingly. One of his most successful ventures was *The Repository of Arts, Literature, Fashions, etc.* (1809–28), a monthly magazine containing articles and illustrations on every topic, which outlived the *Poetical Magazine* (1809–11) notable only for Rowlandson's three tours of Dr. Syntax, and the *English Dance of Death*. William Combe, who had written the verse to these, and W. H. Pyne, were extensively employed by Ackermann to write lively texts to volumes of plates, performing this office in the ambitious series of views from drawings by Pugin, Westall and others, of the *University of Oxford* (1814), the *University of Cambridge* (1815), and the *Public Schools* (1816).

Ackermann publications were not confined to aquatint books; from his native

Germany he introduced the fashion for small, illustrated annuals, undemanding volumes with tit-bits of sentimental verse and highly finished steel engravings. Although he never published any very important lithographs, Ackermann travelled to Germany in 1818 to meet Senefelder, the inventor of the technique, and then published an English edition of the inventor's treatise on lithography in 1819, later persuading the Society of Arts to award him a Gold Medal.

Despite the popular appeal of aquatint, its prestige was not as high as mezzotint or line engraving. Farington referred to it as a 'low branch of the art', and Prout, in the preface to his drawing book, *Rudiments of Landscape* (1813), already quoted elsewhere, complained peevishly that: 'Amongst the many existing prejudices against modern art must be included that which so commonly leads the connoisseur to condemn almost without exception, such works as are ornamented with aquatinta prints; there are those who carry this prejudice so far, as to admit no book with prints in this style of engraving into their collection.'

This was perhaps one reason why Turner, after some initial thoughts of aquatint, turned to the more prestigious and dramatic medium of mezzotint for the plates to his *Liber Studiorum*; and the use that both he and Constable made of this technique for reproducing their landscapes is by far the most interesting aspect of its history in the nineteenth century.

The high quality of eighteenth-century mezzotints is the result of close harmony between the style of painters like Reynolds and Wright, and the technical breadth of engravers who mostly abjured glossy and excessive finish, or the complications of mixed techniques. As the age of Reynolds was succeeded by that of Lawrence, Beechey and their imitators, so the engravers had to adapt their style to glossy surfaces and glittering highlights which are entrancing in paint, but did not always translate successfully into mezzotint. Some of the most accomplished mezzotinters of the nineteenth century were S. W. Reynolds (1773–1835), his pupil Samuel Cousins (1801–87) notable for the very high finish of his work, Charles Turner (1774–1857), William Say (1768–1834) and Thomas Lupton (1791–1873).

Reynolds scraped an epic series of 357 mezzotints after pictures by his namesake, Sir Joshua, and in 1826 he went to Paris where he had considerable success; the prints of his French period include one from Géricault's *Raft of the Medusa*, a work well suited to mezzotint.[25] Lupton received a medal in 1822 from the Society of Arts for introducing the use of steel plates, the harder surface of which revolutionized nineteenth-century engraving because of the greater detail they made possible, through the closer placing of lines, and the vast editions that could be printed. Although many of these engravers produced work of spectacular virtuosity, often making extensive use of etched line, the simpler and grander effects of the earlier period are to be preferred. They all worked after Lawrence; and that bran-tub of useful information, Joseph Farington, in a diary entry of 25 April 1810, noted that William Say 'has now completed a very fine print of Mrs. Siddons for which He is to have only abt. 80 guineas, while Orme, the publisher, will get Hundreds by it. . . . This Plate was made what it is by Lawrence's superintendance, who wd. while He was at work upon it, pass whole days with Him, giving directions how to proceed . . .'[26]

This passage touches on two of the preoccupations of Joseph Mallord William

Turner (1775–1851) in his own relationship with engravers; a determination to bend their skills to his own use, and the desire for more profit than a painter normally received from engravings after his work.[27] His numerous engraved works include the *Liber Studiorum* (1807–19), engraved in etching and mezzotint with the occasional use of aquatint, the mezzotints of *River Scenery or Rivers of England* (1823–30), and, among the many prints in both etching and engraving, are those of the *Southern Coast* (1814–26), *Picturesque Tours of Italy* (1820), *Rivers of France* (1837) and the *Picturesque Views in England and Wales* (1826–38). In addition to these there are the vignette illustrations to Samuel Rogers' *Poems* (1834) and *Italy* (1830) and the beautiful mezzotints from Turner's own hand of the *Little Liber* (c. 1825).

The seventy-one plates of the *Liber Studiorum*, which were issued in parts, owe something of their inception to the example of Earlom's well-known copies from Claude's drawings in the *Liber Veritatis*, and Turner settled on a similar technique of etching and mezzotint printed in sepia.[28] Claude's book, however, had been a means of recording paintings, and had been started as a protection against forgeries; whereas at thirty-two years of age, Turner aimed to demonstrate his mastery over the various categories of landscape: 'Historical, Mountainous, Pastoral, Marine and Architectural'. A single plate was executed in aquatint by F. C. Lewis, but they quarrelled, and Turner decided on mezzotint as the more appropriate medium for the project. He first engaged the services of Charles Turner, who had engraved his *Shipwreck* in 1805 in a mixture of aquatint and mezzotint, and it was he who engraved the first four parts of the *Liber* before arguments about money severed the partnership. Engravers subsequently employed on the work included Say, Clint, Reynolds, Dawe and Lupton, and Turner himself engraved a number of the plates.

In each print, Turner etched the main outlines of the design, and the engraver completed the plate working from Turner's careful sepia drawings. The most impressive subjects are often the most dramatic, such as *Ben Arthur* or the unpublished *Swiss Bridge, Mont. St. Gothard*, and he is less successful in the rather self-conscious rustic genre scenes. The *Liber* is not the most lovable of Turner's works, but as a demonstration of intellectual power in its unfolding visual commentary on the different categories of landscape, from terrifying scenes of mountain and precipice to quiet riverside scenes, it is a formidable achievement. Ruskin thought that the subjects in the *Liber* all suggested decay and human transience, and Turner hinted at some wider philosophic purpose in a conversation with the engraver John Pye: 'When I told him I desired to have a copy of the Liber, for that I liked it, he said, "What is there in it that you like?" "The variety of effects" was my reply. "There's nothing else. I want something more than that", said he.'[29]

Sometime in the 1820s, Turner himself engraved the unpublished mezzotints of the *Little Liber*, their dramatic subjects of storms or evening light perfectly suggested by the gradual working up of the plates from dark to light. In the grandeur and solemnity of their themes, and the great skill of the engraving, they are perhaps the greatest masterpieces of the mezzotint (Plate 88).

Blake's assertion in the *Public Address* that 'Painting is drawing on Canvas, and Engraving is drawing on Copper and Nothing Else' may be instructively compared with Turner's statement of about the same time (c. 1810) in a draft for his second

lecture on colour, that 'Engrav[ing] is or ought to be a translation of a Picture, for the nature of each art varies so much in the means of expressing the same objects, that lines become the language of colours (which is the great object of the engraver's study . . .'[30] Turner was much exercised by the problem of translating the light and colour of his watercolours into etched and engraved line, and his assiduity in supervising his engravers, correcting proofs and writing detailed letters of instruction and rebuke, is legendary.

His engravers faced a daunting task; entrusted with landscapes emerging from the most atmospheric and translucent washes of colour ever committed to paper, they had to spend weeks of eye-straining work translating these marvels into black and white by thousands of delicately etched lines. Their privilege was to become part of the creative armoury of a great artist, and engravers like W. Miller, J. Pye, E. Goodall, E. Finden, W. B. Cooke and J. T. Willmore were the skilled executants, whose mechanical skill was used by Turner almost as an extension of his own hand.

Perhaps the greatest series of prints are those of the *Picturesque Views in England and Wales*, of which ninety-six plates were completed before the publication foundered on the same lack of public interest that had met the *Liber*. They were commissioned by Charles Heath (1785–1848), an engraver who had trained a large school in the production of minutely finished steel-plate etchings for illustrated annuals like the *Keepsake*, the *Bijou*, or *Friendship's Offering*. These began to appear in the 1820s and Turner sometimes provided designs for them. Heath lost heavily in the venture, however, and was forced to sell the entire stock of plates and prints in 1838; Turner then stepped into the auction-room at the last moment and bought them at the reserve price of £3,000—a sum that suggests the value he placed on his work. The plates were produced almost entirely by etching, extensive use being made of the worm-lines found in the etched parts of Woollett's engravings, which Turner admired. Inevitably they are humble fare compared to the original watercolours, but their silvery crusts of combed lines, going through subtle gradations of tone and rehearsing the vortices and swirling veils of colour in the watercolours, are sometimes of great beauty (Plate 86).[31]

Copper plates were used for the *England and Wales* set, and the plates showed signs of wear quite quickly; steel was used for the vignettes to Rogers' *Italy* and *Poems*, however, and this permitted the printing of very large editions of these popular books, to which Thomas Stothard also contributed designs. Steel plates allowed etched strokes of hair-line delicacy to be laid very closely to each other, suggesting the most delicate mists of tone, the lightest parts of the designs blending harmoniously with the white of the page. The verse of the banker-poet Samuel Rogers, which plods solemnly from page to page, is of minor interest, but the illustrations make the books some of the loveliest of the nineteenth century.

While Turner had established and trained a whole school of engravers, John Constable (1776–1837) was mainly associated with a single man, the mezzotint engraver David Lucas (1802–81), who had been a pupil of S. W. Reynolds.[32] They formed a partnership in 1829, when Lucas began to engrave the first of the twenty-two mezzotints from Constable's paintings for the *Various Subjects of Landscape*,

issued in parts between 1830 and 1833, and attracting as little contemporary praise as the rest of Constable's work.

Mezzotint was the only medium that could represent the dramatic light effects of Constable's work, and the introduction of steel plates made its use possible in the publication of ambitious large editions. Constable supervised Lucas, corresponded with him, and continually touched up proofs; some of his brief notes of instruction are suggestive of verse, in their pithy listing of objects. In 1831/2 he scribbled to Lucas:

> Dark near the Cows and dell
> Shadow a little near the plow
> put down the spot of light on the share
> make the butterfly.[33]

The range of tone that Lucas achieved, from sonorous blacks to fresh and airy lights, were obtained by mezzotint with the frequent addition of drypoint. The technique was applied effectively to the classic Constable themes of great shafts of light piercing the clouds to illuminate the ground beneath, and is well exemplified in *Weymouth Bay* (1830) and in the sombre romanticism of *Old Sarum* of the following year (Plate 89). Constable explained his intentions in the introduction to the fifth number of *Various Subjects* (1833): '. . . an attempt has been made to arrest the more abrupt and transient appearances of the CHIA'OSCURO IN NATURE; to show its effect in the most striking manner, to give "to one brief moment caught from fleeting time", a lasting and sober existence, and to render permanent many of those splendid but evanescent Exhibitions, which are ever occurring in the endless varieties of Nature, in her external changes.'

Lucas scraped a number of larger separate plates, including *The Cornfield* (1834) and *Salisbury Cathedral* (1837) and continued to engrave Constable's pictures after the latter's death, although in many cases the subjects had been discussed with the artist in earlier years. In 1845 he published a *New Series of Engravings of English Landscape*, which was another commercial failure, and the rest of his career was spent in obscurity: he died amid the gloomy surroundings in Fulham Workhouse. He is the classic example of an engraver developing a technique that was perfectly adapted to the interpretation of a particular painter, and a perusal of his prints gives a remarkably clear idea of the essential character of Constable's work, particularly of its sombre and tragic aspects.

Compared to Turner and Constable, John Martin's scenes of apocalyptic woe and destruction are merely sensational, but he scraped a large number of mezzotints which are the more effective for the absence of the crude vulgarity of his colouring.[34] Indeed, when his paintings were first exhibited in France, admirers of the mezzotints were dismayed by the garish originals. Martin was attracted to mezzotint by the introduction of the steel plate, and between 1825 and 1827 Septimus Prowett published his illustrations to *Paradise Lost* in both large and small versions (Plate 90). Martin's scraping out of whites to suggest the unearthly light from the flames of hell, or the irradiance from Heaven illuminating vast spaces, is impressively melodramatic, and the success of the publication led him to the regular production of

large mezzotints from 1826 until 1838. They depict such themes as *Belshazzar's Feast* (1826), *The Fall of Nineveh* (1829), or *Pandemonium* (1832), in which ill-drawn figures, dwarfed by vast buildings, scatter in alarm before spectacular convulsions of nature. Mezzotint was ideally adapted to Martin's purpose, and although his work is of limited value it represents the most sustained effort by a painter in scraping his own designs.

In the latter part of 1800 Aloys Senefelder, the Bavarian inventor of lithography, arrived in London to take out a patent for his discovery, which he had perfected in 1798.[35] He had originally developed this means of 'chemical printing' as a way of printing his plays, its fundamental principle being the fact that the marks made upon limestone with greasy chalk will accept printing ink, while the rest of the surface, which has been washed first with nitric acid and then with gum arabic, will repel it.

The great achievements of nineteenth-century lithography were mostly the work of French artists, but it was in England that the first lithographs by important artists were drawn and published.[36] Senefelder had been persuaded to visit England by the music publisher Johann Anton André, whose brother Philip set up and managed the first 'polyautographic' printing establishment in England. While they were waiting for the patent to be granted, Senefelder, by his own account in *A Complete Course of Lithography* (1819), was kept 'in perfect seclusion from society, for fear of losing the secret', which was guarded as jealously as mezzotint and aquatint had been in their time. He occupied some of his time by instructing the Swiss artist, Conrad Gessner (1764–1826), in the use of the lithographic crayon, and Gessner's prints of 1801 are the earliest examples of its use.

In 1801 Senefelder sold his patent to Phillip André and returned to Germany. André strove to advertise the advantages of the new method by contacting many of the leading English artists and persuading them to make a drawing on the stone. Benjamin West was the first to respond, and his *Angel of the Resurrection* (1801), crisply drawn in pen and tusche with the regular cross hatching of line engraving, is the first lithograph of real artistic excellence. In 1803, André published some of the results he had obtained in two sets of six prints each, entitled 'Specimens of Poly-autography': all had been drawn on the stone with the pen technique used by West. Some of the prints are of very high quality, particularly James Barry's *King Lear* (1803) and Thomas Stothard's *The Lost Apple* (1803), but the finest is Henry Fuseli's *Woman Waiting by a Window* (1802), a typically erotic and obsessive image (Plate 94). Despite the high quality of the prints, however, the publication was a complete failure, and in 1805 André returned to Germany, having handed over the London office to G. J. Vollweiler.

In 1806/7 Vollweiler reissued the twelve lithographs of André's set with the addition of twenty-four prints by other artists, including John Downman, Robert Hills, William Havell, Thomas Barker of Bath, and Charles Heath. Fuseli again contributed the best print, and his *Ganymede* is a vigorous early specimen of the chalk manner. Vollweiler had also commissioned a number of prints which were not published, casting his net wide enough to include William Blake—who made a spirited design of *Enoch*—and James Gillray who drew a *Musical Family* (1804). Yet

again the publication was a failure and by 1807 Vollweiler, too, had returned to Germany with no profit to show for his pains.

One reason for this early failure with lithography was the excessive zeal with which the Germans hugged the secret to their chests; Paul Sandby, whose exclusion from those invited to make a drawing on the stone is a measure of his faded reputation, wrote in December 1806 to James Gandon, who was eager to hear about the invention, 'concerning the manner of printing from stone . . . brought by a German from his country about two years since, which is the secret of drawing upon stone, and therefrom taking many impressions. Mr. West produced me two of his doing and one by his son Ralph [Raphael Lamar]. I was delighted beyond measure at the sight of them . . . the German keeps the art a profound secret, and will not divulge the mystery to anyone; he takes impressions off himself, and will only give a few to such artists as give him the drawings.'[37] Sandby examined his large collection of Dürer woodcuts and came to the eccentric opinion that they too were lithographs.

The development of many print techniques has been hastened and diversified by the activity of artists who, having garnered some basic information about a new process, have experimented in their own workshops and perhaps developed some interesting variant on the original idea. In the case of lithography, which was a chemical and not a mechanical process, the artist who had gained some inkling of its principle by drawing on a stone to be printed by André or Vollweiler, did not possess the basic materials to pursue his experiments. Those possessed of only a mild curiosity must have found the secrecy of the procedure, after the novelty of a first attempt, sufficient discouragement.

A number of amateurs tried their hand on the stone under Vollweiler's supervision, and he had an eye on this potentially large market, stressing in his advertisements that no chalcographic skill was required, that lithography was simply a means of reproducing a drawing with the minimum alteration of its character.[38] Despite his efforts, this early introduction of lithography to England was still-born, the technique even failed to supersede soft-ground etching, which was to lead a useful life in drawing books for some years to come.

From 1807, lithography almost ceased in England for a decade, although some interesting attempts were made by Thomas Barker of Bath (1769–1847) in two sets of pen lithographs: the *Forty Lithographic Impressions from Drawings . . . of Rustic Figures* (1813) and *Thirty-Two Lithographic Impressions from Pen Drawings of Landscape Scenery* (1814). The second set, published in a small edition of fifty, contains vigorous studies of rugged Welsh scenery drawn in a stringy tangle of loops and flourishes, which, as Barker pointed out in the advertisement for them in *Rustic Figures*, were 'drawn with the pen in the manner of free Etchings' (Plate 87). Both sets were published in Bath, as was the first English treatise on lithography, H. Bankes' *Lithography; or, the art of making drawings on stone* (1813), addressed to amateurs, and including landscape illustrations, which are unsigned but in Barker's style.

The firm establishment of lithography in England, and most of its technical developments, stem from the efforts of the great printer Charles Joseph Hullmandel (1789–1850), who set up a lithographic press in 1817/18 following his dissatisfaction

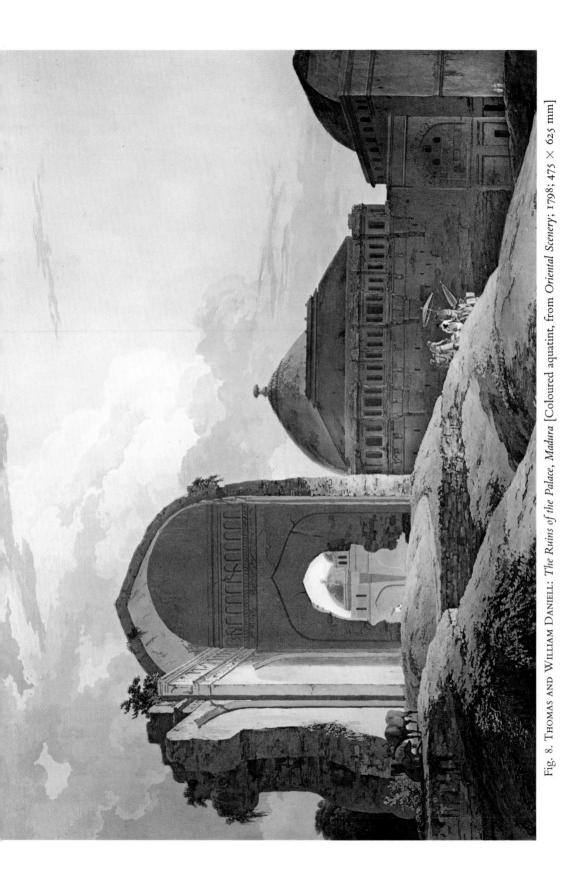

Fig. 8. THOMAS AND WILLIAM DANIELL: *The Ruins of the Palace, Madura* [Coloured aquatint, from *Oriental Scenery*; 1798; 475 × 625 mm]

Fig. 9. WILLIAM SHARP: Detail from *King Lear, Act III, Scene IV* [Engraving after Benjamin West; 1789; 492 × 630 mm; see also Plate 43]
West considered this to be one of the few successful engravings from the Shakespeare Gallery, and this detail shows the complex and systematic structure of lines that Sharp had developed for the purposes of reproductive engraving. He has laid in the main contours and some of the tones by etched line, before superimposing a network of engraved lines and marks, using parallel lines and different degrees of cross-hatching.

Fig. 10. WILLIAM HENRY SIMMONS: Detail from *The Proscribed Royalist* [Engraving after Millais; 1858; 762 × 543 mm]

Victorian engraving was characterized by great technical sophistication and a high degree of finish. Simmons here combines delicately etched lines, which were sometimes strengthened by the burin, with rather mechanically applied stipple engraving. The use of stipple allowed a plate to be finished much quicker than one executed purely in line.

Fig. 11. THOMAS SHOTTER BOYS: *The Pavillon de Flore, Paris* [Chromolithograph; 1839; 343 × 292 mm; Plate XXI from *Picturesque Architecture in Paris, Ghent, Antwerp, Rouen, etc.*]

with the printing of his own chalk lithographs of *Twenty-Four views of Italy* (1818). He printed the twenty-four lithographs included in Belzoni's *Plates Illustrative of the researches and operation in Egypt and Nubia* (1820–22), an ambitious publication which did much to draw attention to the process, and in 1824 he published his important technical treatise: *The art of drawing on stone*. His main ambition was to develop lithography as a tonal method which could rival and eventually replace the use of aquatint in the reproduction of topographical watercolours. The greatest lithographs he ever printed, however, were of a quite different and far more serious character, being Theodore Géricault's *Various Subjects drawn from life on stone* (1821). These were a set of twelve prints, known as the *English Set*, in which Géricault used short strokes of the soft chalk to orchestrate a full range of tones from light grey to deep and sombre blacks, depicting the seamier side of London life in such moving subjects as *Pity the sorrows of a poor old man*, a grim corrective to the playful English prints of *London Cries*. Hullmandel also printed fourteen lithographs of *Celebrated Horses* (1824) by James Ward, who had long abandoned mezzotint engraving, but who was tempted back to printmaking by the tonal range and free handling he had seen in the lithographs of Géricault.

English lithography, as it bent itself to the requirements of the topographical watercolour, is of limited interest.[39] The names of Francis Nicholson (1753–1844), Samuel Prout (1783–1853), William Westall and J. D. Harding (1797–1863), and their gentle views of English and foreign scenery, are unlikely to arouse more than a polite murmur of appreciation. The technical refinements of Hullmandel and the artists with whom he worked included: the addition of a tint-stone to print a neutral buff tone from which highlights could then be reserved by scraping or etching down the stone's surface; the lithotint, by which washes of lithographic ink were applied to the stone with a brush; and the soft effect of the dabbing style, where ink is applied gently by a circular wooden dabber covered by kid-skin. All these inventions were adapted to the imitation of the tinted drawing and watercolour. Most lithographs were issued in book form, plain or hand-coloured, and the market they catered for, and the level of their achievement, is identical to that of the aquatints which they were gradually to supersede, the process being virtually complete by the 1830s.

Nicholson was the first watercolourist to devote himself whole-heartedly to lithography, and from 1820 he drew hundreds of landscapes, which are uniformly innocuous in character. He made frequent use of the dabbing style to obtain soft-grained tones, employing the vignette form to repeat the blurred and woolly shapes of his soothing, picturesque views (Plate 92). Samuel Prout antedated both Nicholson and Hullmandel as a lithographer, contributing a print to Ackermann's *Repository* in 1817, and he used lithography's soft touch to reproduce his drawings of foreign architecture and ruins, which, like his many watercolours on the same themes, were greatly admired by Ruskin. His *Illustrations of the Rhine* (1822–26) show his pleasant touch in drawing the crumbly outlines of old buildings, but the underlying regularity of his draughtsmanship betrays the innate conservatism of a drawing master.

J. D. Harding was one of the most experimental of English lithographers, and in collaboration with Hullmandel he developed the use of the tint-stone from 1835, and of the lithotint from 1841. He used lithotint to recreate the fluid washes of

watercolour in the twenty-six plates of *The park and the forest* (1841), as well as in many subsequent prints. He also worked in a reproductive capacity, drawing a series of *Subjects from the works of the late R. P. Bonington* (1829–30); many lithographers worked both from their own designs and from those of others. Harding contributed the best prints to the most ambitious early book of topographical lithographs, *Britannia Delineata* (1822/3) in which Prout, Westall and Hullmandel were also represented.

John Frederick Lewis (1805–76) is best known for his highly finished watercolours of Egyptian scenes, but in his early career he etched some fine plates of animals. In the 1830s he became known as 'Spanish' Lewis for his glamourized depictions of Spanish life and scenery, to which he devoted two sets of tinted lithographs, drawn with a silky and luxurious touch. The first of these, *The Sketches and Drawings of the Alhambra* (1835), contains only eight designs drawn onto the stone by Lewis himself (Plate 91), but the *Sketches of Spain and Spanish Character* (1836) is entirely from his hand. To these may be added the *Illustrations of Constantinople* (1838), 'Arranged and Drawn on Stone from the original Sketches of Coke Smyth' by Lewis, which was a highly stylish production.

Less glamorous, but now of greater historical interest, are the lithographs by J. C. Bourne (1814–96) in *Drawings of the London and Birmingham Railway* (1839) and *History and Description of the Great Western Railway* (1846). The first set contains one particularly arresting image of a *Working-Shaft—Kilsby Tunnel* (Plate 93); a pillar of light falls on the toiling navvies, whose forms have been deftly reserved from the tint-stone.[40] This must serve as a single example from the deluge of lithographs depicting themes from the national life, its trains, its ships, its fashions and many other subjects, that began to pour from the presses at this time. Many of these are full of decorative or documentary value, but seldom of great artistic interest.

The most ambitious English publication of lithographic plates was *The Holy Land* (1842–9), containing 248 tinted lithographs by Louis Haghe (1806–85) from the watercolours of David Roberts, but even this worthy effort was dwarfed by the mammoth French publication: Baron Taylor's *Voyages Pittoresques et Romantiques dans l'Ancienne France* (1820–78), the nineteen volumes of which appeared at intervals over more than fifty years. More than two hundred lithographs were commissioned from English artists, mostly from Haghe and Harding, but the most notable con-tributions were those of Thomas Shotter Boys (1803–74) and Richard Parkes Bonington (1801–28).

Bonington was born in England, but moved to France in 1817 and most of his short career was spent there. Although the sparkling freshness and direct vision of his watercolours stem from an English tradition, his lithographs were all made in France from 1824 and can scarcely be claimed for a history of British prints. Unlike English lithography, which was tied to the apron strings of the watercolour tradition, the French style—as exemplified by Isabey, or more nobly by Bonington's friend Delacroix—aimed more to recreate the fuller tones of oil painting. This rich harmony of tone, characteristic of French romantic lithography, distinguishes two of Boning-ton's finest lithographs, the *Rue du Gros Horloge, Rouen* (1824) and *Tour du Gros Horloge à Eureux* (1824), published in the Normandie volume of the *Voyages*

Pittoresques, which are among the masterpieces of nineteenth-century lithography.

The friendship of Bonington and the influence of his watercolours was a vital factor in the work of Thomas Shotter Boys, whose two great sets of lithographs, the *Picturesque Architecture in Paris, Ghent, Antwerp, Rouen, etc.* (1839), and *Original Views of London as it is* (1842) are the high watermark of the English topographical print, and, in the case of the *Picturesque Architecture*, represent a beautiful episode in the history of colour printing.[41]

Boys studied engraving under George Cooke, and, like a number of English engravers, was attracted to Paris by the professional opportunities available there. Soon after his arrival in about 1823, he became very friendly with Bonington and began to work increasingly in watercolour, besides executing a number of soft-ground etchings of buildings, which reflect the influence of Girtin's Paris views. He contributed twenty-four lithographs to the *Voyages Pittoresques* between 1833 and 1845, but returned to England in 1837, bringing with him the watercolour drawings that formed the basis of the chromolithographs in the *Picturesque Architecture*, which he had been planning for some years. These were printed by Hullmandel and published to great acclaim in 1839. Although they were not the first attempts at colour lithography, they established a completely new standard by creating near facsimiles of the full chromatic range of a watercolour. Boys obtained this effect by printing colours from four or five separate stones, blending them with the carefully registered superimposition of successive printings. They were skilfully printed by Hullmandel who tried to claim much of the credit, and Boys wrote to *The Probe* (10 January 1840) pointing out that he was 'entirely the originator and inventor of my work as set before the public; within myself the idea originated, of producing a wash by lithography printed in colour, using the primitive colours for the first tints, and producing variety of tints by their successive super or juxtapositions.'[42]

The beauty of the prints resides in the harnessing of complex means to clean and simple effects of light and space; the buildings and figures exist in an airy atmosphere that has been perfectly translated from the original watercolours. Boys created a variety of atmospheric effects, from the night scene of *St. Etienne Du Mont*, or the golden sunset of *The Institute*, to the clear skies above the *Pavillon de Flore* (Fig. 11; page 90). The high points of colour are usually provided by some brightly coloured garment; a cherry-red scarf or a yellow waistcoat worn by the crisply drawn figures, who dispose themselves neatly across the street to provide interesting incidents.

The *Picturesque Views* represent the culmination of decades of effort in attempting to translate the effects of watercolour to a print medium with no loss of its spontaneity, and Boys is a rare instance, in the history of colour printing, of a man who combined technical ingenuity with high achievement as an artist and topographer. However, it should be remembered that, in the same year of 1839, Fox Talbot announced his negative-positive process of photography, which was eventually to sound the death-knell of the topographical artist, thus placing Boys at the end of a tradition and not at its beginning.

Despite the success of the publication, the execution and financing of such complex printing was daunting, and Boys did not repeat the attempt. *Original Views of London As It Is* (1842), containing twenty-seven lithographs, was no doubt intended as a

sequel to *Picturesque Views*, and it is of equally high quality, but Boys relied on a tint-stone and the use of hand-colouring in a few sets. His combination of the two stones is extremely sophisticated, in that he manages to marry a stone with the outlines only to a second stone carrying broadly washed tones, and the value of these prints—in that they record the busy life of the London streets—is incomparable.

In a period dominated by the topographical aquatint and lithograph, the art of landscape etching flourished most effectively in the quiet city of Norwich, secluded from the dictates of Ackermann and the busy machinery of the London print market. The members of the Norwich school, both professional and amateur, constitute the first group of English painter-etchers. Applying themselves mainly to unpretentious and intimate studies of landscape, they used etching for its own sake and not merely as a means of reproducing a drawing.[43]

The central figure in the history and foundation of the Norwich school is John Crome, but the most prolific etcher and the only one whose work formed an extended professional activity was John Sell Cotman (1782–1842), who etched more than 370 plates of landscape and architectural subjects.[44] Many of these are dull, antiquarian subjects undertaken for the Yarmouth banker and amateur antiquary Dawson Turner, who was Cotman's chief patron. But there is a central core of plates, ranging from soft-ground studies of tumbledown cottages to epic depictions of Norman castles, that is of very high quality. Cotman's primary genius was for watercolours, constructed by the harmonious disposition of blocks of cool tone, washed on smoothly in flat areas to create beautiful patterns of interlocking shapes. If he had followed his career in London instead of Norwich these may have found their way into aquatint; as it was, the etching needle released another aspect of his draughtsmanship, where the tones of wash drawings were translated into a restless surface of wiry, scratched lines, delighting in varied details of texture.

Cotman's first set of etchings was published in 1811, and consisted of twenty-six plates of Yorkshire and Norfolk scenery and picturesque ruins. In these, his lines are at their liveliest and most expressive, twisting themselves into wiry masses in the foliage, and relaxing into cursive loops and scratches in lighter areas. Most of the plates are of architectural subjects, showing the incisive curves of Gothic arches resisting the softer contours of encroaching nature, but one of the finest is the pure landscape of *Duncombe Park, Yorkshire* (Plate 95) for which Cotman worked from a drawing from the period of 1805–6, when he was painting his great watercolours of Duncombe Park, the Greta and its environs. It was this print that his subscribers particularly disliked according to his Yorkshire patron Francis Cholmeley, who wrote that many of them 'did not like the view in Duncombe Park, because it migh have been *anywhere*. Two-thirds of mankind you know, mind more *what* is represented than *how* it is done.'[45]

Cotman settled permanently in Norwich at the end of 1806, and in 1811 he issued proposals for subscriptions to a series of etchings of *Architectural Antiquities of Norfolk*, the sixty plates being issued in parts and published in their entirety in 1818. Subjects such as *South Gate, Yarmouth* (1812) or *The North West Tower, Yarmouth* (1812) show Cotman's love for broken surfaces, for massive piles of masonry crumbling by degrees (Fig. 3; page 34). He told Dawson Turner in 1812 that 'I decidedly follow

Piranesi, however far I may be behind him in every requisite', but his vision is placid and reassuring compared to the Italian's dramatic etchings of shattered Roman ruins, and he eschewed the latter's stormy skies and gesticulating figures. Piranesi was to have a more obvious imitator in George Cuitt (1779–1854), who published his first etchings of Chester in 1810, and published a collection of them in 1848 with the title of *Wanderings and Pencillings amongst Ruins of Olden Times*; the title suggests the foolish theatricality of the contents.

From 1812, when he moved to Yarmouth, Cotman was increasingly in thrall to Dawson Turner, who commissioned him to draw such dull subjects as the *Sepulchral Brasses of Norfolk* (1819). Turner was, however, responsible for the inception of the *Architectural Antiquities of Normandy* (1822), which contains one hundred etchings of Gothic architecture of a kind little studied at the time. Some of the plates are rather dry renderings of themes selected by Dawson Turner, who contributed a dull text to the two volumes, but in subjects like *Chateau Gaillard* or the *Castle of Falaise*, Cotman achieves a bleak grandeur of effect, contrasting the massive bulk of Norman buildings with the broken contours and sweeping lines of the surrounding landscape. It is this interest in the formal organization of the design, the carefully chosen viewpoint, and the disposition of shadows to emphasize the forms, that elevates the prints beyond the archaeological purpose of his mentor. However, their austere vision and execution did little to commend them to a public who preferred the romanticized products of more wistful rambling and 'pencilling' amongst mossy ruins, and the publication was a failure.

Cotman's enthusiasm for etching sometimes flagged, and his lines can be harsh and mechanically applied in an engraver's manner. In 1838, however, Henry Bohn published the forty-eight plates of the *Liber Studiorum*, containing thirty-nine soft-ground etchings which Cotman had probably made between about 1810 and 1817; Bohn noted in his introduction that 'Mr. Cotman entertained some reluctance to the publication of these early efforts'. The title was taken from Turner's great work, to which Cotman had been an early subscriber, and his freely drawn soft-ground landscapes show a variety of themes including peaceful Norfolk river scenes like *Postwick Grove*, wild Welsh scenery (Plate 96) and even an attempt at classical land-scape in the *Judgement of Midas*. He used the medium with particular effect in drawing great masses of foliage, and its tender touch and soft tones had seldom been exploited with such success, so that the *Liber* contains some of his most attractive plates.

His eldest son, Miles Edmund Cotman (1810–58), etched twenty-four small plates, a set of eleven being published in 1846, although most were probably executed in the late 1830s. The best of these are views of shipping on the Medway, with cleanly etched hulks and hay-barges nicely positioned on the page. They show some influence from the work of his boyhood friend E. W. Cooke (1811–80), whose *Fifty Plates of Shipping and Craft* (1829) are notable for the precision and clarity of their line. Cotman etched plates from a number of his father's designs, including the famous *Greta Bridge*, and in 1842 published a fine set of *Twelve Lithographs of Norfolk Scenery* from the lyrical chalk drawings of his father's last months.

John Crome (1768–1821) was the founder of the Norwich Society and the dominating figure of the Norwich school; he presented a formidable obstacle to the

professional advancement of Cotman.[46] He etched thirty-three landscapes between 1809 and 1813, but although he issued a prospectus in 1812 for a proposed publication of etchings, they were not published until after his death. His earliest plate is the soft-ground etching of *Colney*, which is dated 1809, preceding and probably inspiring a number of soft-ground etchings by Norwich artists in the next few years. These include some feeble studies of *Picturesque Norfolk Scenery* (1812) by Robert Dixon (1780–1815), most of which were etched in 1810, and some more accomplished studies of cattle and dogs by Thomas Harvey of Catton, an amateur who was a close friend of Crome. Crome etched nine landscapes in soft-ground, in which he traced his drawings onto the copper with no diminution of freshness and beauty of tone, and they are the only prints which preserve most of their value in the later reissues of his plates.

His drawings needed no special adaptation for soft-ground etching, but when handling the etching needle he had to rethink his compositions in terms of a thin, wiry line, with which he followed the intricate contours of tree-trunks and curving boughs in a series of etchings that reflect his love of such Dutch artists as Ruisdael, Hobbema and Waterloo. Dawson Turner noted in a letter of 1813 that 'He has been at my house just three weeks, intent all the time on his new employment of etching, and more than once sitting up with me till two in the morning, without knowing or caring to know, how time went.' This enthusiasm resulted in some of the finest of all landscape etchings, the most dramatic being *Mousehold Heath*, its stormy sky and undulating rhythms of landscape having a stressful atmosphere not often found in Norwich prints. He more usually employed the etching needle to depict quiet woodland, the dense modelling of foliage or dead trees set off by patches of light on banks of chalky earth. Two of the finest plates are *Composition: a Sandy Road*, and *Road Scene, Trowse Hall* (1813) with its lingering drawing of the gentle curves of fencing and boughs moving slowly across the design, typifying the contemplative mood of Crome's etchings (Plate 97).

The story of the plates Crome left at his death is melancholy. Thirty-one were published in 1834 by his widow with the title of *Norfolk Picturesque Scenery*, and in this edition the plates were printed largely as Crome had left them, although *Road Scene, Trowse Hall* was spoiled by the amputation of two inches from the right of the plate. The set had few subscribers, and the meddling Dawson Turner—who had ominously been disturbed by 'the want of finish observable in these performances'— persuaded John Berney Crome to suggest alterations to the plates, and these were implemented by Henry Ninham and W. C. Edwards. Most notorious of these 'improvements' was the removal of the sky from *Mousehold Heath* and the substitution of one mechanically ruled in with the diamond point by Edwards. Seldom has a great print been so mutilated, and in this state it should be purchased only with a view to its destruction.

Crome's pupils, James Stark and George Vincent, both etched a few landscapes, but they were less accomplished than Joseph Stannard (1797–1830), a pupil of Robert Ladbrooke. Some of Stannard's twelve etchings show an interest in figures that is unusual for the Norwich school. *On the Beach at Mundesley* (1827) is a fine example of his descriptive but open line, and his feeling for contrasts of light and texture

(Plate 98). The fisherman employed in untangling his nets is no mere picturesque incident, nor is there the danger that, like so many of his Victorian successors, he will eagerly abandon his work to tell a yarn or dandle a baby. It is this natural and unsentimental vision that gives the work of the Norwich school its special value.

Stannard is reputed to have taught etching to the gifted amateur, the Rev. E. T. Daniell (1804–42), a pupil of Crome at Norwich Grammar School. From 1835 Daniell was a curate in London, where he became friendly with some of the leading artists of the day, including Turner. Perhaps inspired by the travels of his friend David Roberts, he journeyed to the Near East, but it was while there that he died. His etchings and drypoints show a freedom and breadth of handling that is closer to the ideals of Seymour Haden than to those of the Norwich school, but he has a tendency to dispose objects across the plate in a rather clumsy way.

Two further members of the Norwich school are worthy of discussion. Thomas Lound (1802–61) was another amateur of great ability who engraved a number of small drypoints in the early 1830s, and his river scenes with barges defined by almost solid masses of burr are of a freshness and spontaneity that the artists of the 'Etching Revival' aspired to but seldom attained. The last distinguished member of the school was the short-lived John Middleton (1827–56), whose nine small landscape etchings trace the complexities of tree trunks and foliage with a most delicate use of line, at its best in *Ivy Bridge—South Devon* (c. 1854).

Landscape etching was not entirely confined to Norwich in these years, and one of its most energetic practitioners was the Salisbury artist D. C. Read (1790–1851), who, for a while, was a rather tiresome protégé of John Constable. Constable only etched four plates, and found the medium unsympathetic, but Read produced many energetic plates in etching or drypoint, taking Rembrandt as his example, and believing firmly in his own genius—a conviction that his contemporaries did not share. Read was an unconvincing draughtsman, but his prints have a feeling for the atmosphere of the open air that is sometimes well expressed. He published a catalogue of his prints in 1832, printing in the introduction two letters from Goethe which praise his work, and which Read had presumably solicited with a gift of prints. One of the letters, written to Read in 1829, states kindly that '. . . at a period when the English 'Forget me not' and other similar Annuals make us acquainted with the microscopic skill of the Copper Plates of that country, it was an appearance in the highest degree agreeable to me to see a collection of Plates from an artist so well acquainted with delicate keeping; and who knows to feel with Rembrandt the reflection even of an already far-departed light; and with Ruisdael the cheerful and prosperously growing fruits of the field, so nicely arranged in sheaves.'

These letters were the highlight of a life where ambition outstripped achievement, and Read quoted the approbation of Goethe in the two large volumes of his prints that he presented to the British Museum, noting miserably that they 'had been produced in obscurity and distress'.[47]

The drypoint needle was handled with more conviction by the Scottish artist Andrew Geddes (1783–1844), who shared Read's admiration for Rembrandt's etchings, and had a large collection. His landscapes, such as *Halliford* or *Peckham Rye*, are of remarkable immediacy of vision and execution, but the majority of his plates

are variations on his portrait paintings. His usual method was to begin with a brilliant first assault on the plate, the head being drawn in with a forceful use of the drypoint, which prints with a rich burr; he then gradually worked the portrait up, taking frequent progress proofs and sometimes proceeding rather timidly lest he should spoil his first statement. Most Rembrandtesque of his prints is the drypoint portrait of his mother, where he used a mezzotint rocker to gain additional richness of black. Other fine examples of his portraiture are those of *Francis Jeffrey, Nathaniel Plimer,* and *Alexander Nasmyth* (Plate 116). In the midst of a great sea of portrait mezzotints and engravings, these thoughtful translations by a painter from his own work have a special value and charm.[48]

The Etching Revival

The Late Nineteenth Century

Few middle-class Victorian homes would have been without their quota of massively framed steel-engravings, reproducing—in highly finished detail—popular Academy pictures of events sacred, colonial, sentimental and sporting. John Ruskin deplored this tendency of the Briton to spend his money on reproductive engravings rather than original watercolours, telling an Edinburgh audience that 'when you spend a guinea upon an engraving, what have you done? You have paid a man for a certain number of hours to sit at a dirty table in a dirty room, inhaling the fumes of nitric acid, stooping over a steel plate, on which, by the help of a magnifying glass, he is, one by one laboriously cutting out certain notches and scratches of which the effect is to be the copy of another man's work. You cannot suppose you have done a very charitable thing in this!'[1]

However, most of these guineas chinked in the pockets of artists and print dealers, and the large payments made to painters by dealers like Gambart, Colnaghi or Graves for the engraving rights to their pictures were to become a feature of the nineteenth century. In 1822, Sir Thomas Lawrence had entered into an agreement with the print publishers, Robinson and Hurst, to grant them the exclusive right to issue engravings from his portraits for £3,000 per annum, but the painter who really initiated the custom was David Wilkie. Wilkie etched a few genre plates, but he was more interested in the lucrative engravings from his popular pictures of anecdotal genre; his friend Benjamin Robert Haydon observing, with typical high-mindedness, that when they both visited Paris in 1814 'Wilkie's principal object was to open a connection for the sale of his prints, and mine to see France and the Louvre'. For his painting of *Reading the Gazette of Waterloo*, Wilkie received £1,200 from the Duke of Wellington, and the same sum from the publishers Moon, Boys and Graves for the copyright to an engraving from the picture.

Wilkie was succeeded as the best-seller of the print-shops by Sir Edwin Landseer, whose animal subjects became some of the most familiar of all Victorian pictures through the medium of large engravings. His father was the engraver John Landseer (1769–1852), well known for his opposition to the Academy and for his attack on the memory of John Boydell in his *Lectures on the Art of Engraving* (1807). His brother Thomas was an engraver, copying the *Monarch of the Glen* in 1852, so Landseer was familiar with all the intricacies of the print trade. Landseer in his turn was rivalled

by William Powell Frith, Millais and Holman Hunt, and the great dealer Ernest Gambert purchased the copyright of Frith's *Derby Day* in 1857 before Frith had actually started work on the picture. For Holman Hunt's *Christ in the Temple* Gambert paid the prodigious sum of 5,500 guineas for the picture, the copyright and the exhibition rights—and made a profit on the exhibition entrance fee alone. In a memorandum of 1860, he noted that from the engraving 'I propose to Print from 1,000 to 2,000 artist's proofs at 15 Gs, 1,000 Before letters Proofs at 12 Gs, 1,000 Proofs at 8 Gs, & I hope 10,000 Prints at 5 Gs.'[2]

It was the steel plate, and an increasing audience for art, that made such ambitious operations possible, and the publication of prints had been placed on a more regular basis by the formation of the Printseller's Association in 1847; this body recorded the publication of prints and how many proofs were issued, and thus eliminated the malpractice in their issue that had long been notorious.

Engravers like Raimbach, trained in an old school, bewailed the fact that the fashion for the highly finished engravings in the various Annuals had degraded the craft of engraving. In the small plates used in these books, grey tones were produced by means of ruling machines that could place lines close together with mechanical regularity, superseding the richer harmonies and more open stroke-work of engravers like Woollett and Sharp.[3] A few engravers, like G. T. Doo (1800–86), continued to work with a system of cross-hatched line and dot and lozenge, but the trend was increasingly towards mixed methods that would produce a smoother and glossier effect. Increased use was made of stippling, which was more expeditious than line-work, and it was employed with great skill by W. H. Simmons (1811–82) in large plates such as *The Proscribed Royalist* (1858) after Millais, where it is combined with etched line (Fig. 10; page 89).

The standardized Victorian engraving, then, was from a picture that told some sentimental or moralistic story, and was engraved by an artisan whose personality was entirely excluded by the mechanics of his trade. A remarkable exception, however, is an engraving by James Sharples (1825–92) from his picture of *The Forge* (1859). Sharples was self-taught, earning his living in a steel-foundry of the type depicted in *The Forge* (plate 99), which he engraved between 1847 and 1858 in his leisure hours. Much of the plate is engraved by short clusters of parallel line, with some dot-work in the faces, and it has little in common with nineteenth-century engraving techniques, being executed even without the aid of a preliminary etching. It was very well received on its publication: the Athenaeum critic wrote that 'It has been wisely published at the earnest desire of the artist's brother-workmen, who look upon it as gratifying evidence of social progress—of the spread of Art amongst our labouring population. For a first work, it is indeed a marvel . . . In fact, to our eyes, it has a freshness of manner as much superior to the dull artificial linyness of the common hard steel engraving, as home made cloth is better than the sleek devil's dust of cheap tailorism.'[4] The solemn atmosphere of *The Forge*, and its combination of verisimilitude to details with an impressively structured composition, give it the status of a minor masterpiece.[5]

In addition to the expensive engravings for their walls, the Victorian public was regaled by an innumerable variety of wood-engraved illustrations in books and

periodicals. For the first forty years of the century, illustrators usually adopted the small vignette form popularized by Bewick, and by pupils of his such as Luke Clennell, Charlton Nesbit and William Harvey who all came to work in London. Its blending with the white of the page gave such vignettes a harmony with the text, and an airy quality that was enhanced by the light, free touch of many of the best wood-engravers of this period. Clennell's engravings from Stothard's illustrations to Rogers' *Poems* (1812), or William Harvey's illustrations to Henderson's *History of Ancient and Modern Wines* (1824), are examples of the development of wood engraving from Bewick's more regular approach to a more draughtsman-like quality of line. In many books of this period, drawings were made specifically with the requirements of the wood engraver in mind, particularly by John Thurston who trained as an engraver before devoting himself wholly to designing.

A very different attitude characterized the work of the 'Illustrators of the 'Sixties'.[6] This period was signalized by Moxon's edition of *The Poems of Tennyson* (1857) for which Millais, Holman Hunt and Rossetti all made drawings which were mostly engraved by the Dalziel brothers. For these illustrations, and for the many that followed in the next decade, the artist made a pen and ink drawing onto the wood, often of great elaboration, and expected the engraver to follow it as exactly as possible. The effect was usually pictorial, little attempt being made to integrate the rectangle of the block with the letterpress. Despite the ugliness of page that often resulted, the designs by artists such as Arthur Hughes, Arthur Boyd Houghton, Frederick Sandys and George Pinwell are frequently some of the most compelling imaginative designs to appear in Victorian books. *The Arabian Nights* (1865) with engravings by the Dalziels after a number of artists, particularly Houghton, is a notable example of a badly designed book that contains many beautiful prints.

The Dalziel workshop undertook every kind of commission; their progress books in the British Museum constitute a record of all their work, pasted into the book as it was completed, and these books contain illustrations for whalebone corsetry jostling for space with the most elevated subjects.[7] Some of the finest wood engravings of the whole period were the blocks engraved by the Dalziels from the illustrations for the *Parables of Our Lord* (1863) by Millais. Millais took most of his book illustration very seriously, and devoted himself with particular intensity to these designs, covering the wood with a dense mesh of lines which has been engraved with great fidelity. The design of the *Foolish Virgins*, caught in the rainy night without their lamps and fallen in despairing attitudes that are almost amorous in their intensity, shows the tradition of the 'sixties at its finest (Plate 100).

Besides these illustrations by some of the leading painters of the day, there were also many wood engravings done for periodicals such as *The Illustrated London News* or *The Graphic*, whose purpose was frequently documentary, but they were often full of vitality and interest. Many large engravings were the result of joint production; a drawing of some newsworthy event would be transferred to wood by several engravers working on individual blocks, each copying a portion of the drawing, each block correlating with the others when they were screwed together. They would engrave anything that was set before them; thus the January number of the *Illustrated London News* in 1863, contained on facing pages an engraving from a free pen drawing

of the *Royal Meet of the West Norfolk Hunt at Snettisham*, and a gallant attempt by
J. Harral to engrave with the use of six blocks Turner's *Snowstorm—Steamboat off a
Harbour's Mouth Making Signals*, as unpromising a subject for wood engraving as can
be imagined. This exemplifies the ability of the Victorian wood engraver to digest
a drawing, painting, or a photograph of whatever kind, and after a period of earnest
labour disgorge an engraving from it.

In 1862 Charles Baudelaire, after discussing the revival of etching in France, wrote
'... let us not hope that it win as great a popularity as it did in London, in the heigh-
day of the Etching Club, when even fair "ladies" prided themselves on their ability
to run an inexperienced needle over the varnished plate. A typically British craze,
a passing mania, which would bode ill for us.'[8]

At least one of the 'ladies' was Queen Victoria, who, with Prince Albert, etched a
few plates of dogs, highlanders and such subjects. The Etching Club, thus dismissed
by withering Gallic contempt, was founded in 1838, making its debut with the
publication in 1841 of seventy-nine etchings illustrating Goldsmith's *Deserted Village*.
The contributors included Thomas Creswick (1811–69), Richard Redgrave (1804–
1888) Charles West Cope (1811–90) and Frederick Taylor (1804–89), their work
showing the neat finish and illustrative purpose that was characteristic of this and
many other Etching Club publications. It was the belief of the Club's members that
their etchings should be priced in accordance with the amount of manual labour
that they have displayed, a doctrine that completely discredited them in the eyes
of a later generation who were to be influenced by Whistler and Seymour Haden
and burned many candles at the altar of 'spontaneity'.

Many of the etchings by the Club's most regular contributors such as Creswick,
who etched many neat landscapes, or Redgrave, are of minor interest, but the Club's
publications had their moments of glory, albeit rarely. In 1857, thirty *Etchings for the
Art-Union of London by the Etching Club* were published, which included an especially
romantic plate by C. W. Cope of *Milton's Dream of his Deceased Wife* (Plate 102),
two by William Holman Hunt (1827–1910), including *The Desolation of Egypt*
(Plate 103), and an etching that by itself would have justified the Club's existence:
Samuel Palmer's elegiac *Sleeping Shepherd; Early Morning* (Plate 104).

In 1872 Palmer wrote, with typically boyish ebullience: 'O! the joy—colours and
brushes pitched out of the window; plates the Liber Studiorum size got out of the
dear, little etching-cupboard where they have long reposed; great needles sharpened
three-corner-wise like bayonets; opodeldoc rubbed into the forehead to wake the
brain up; and a Great Gorge of old poetry to get up the dreaming; for, after all,
that's "the seasoning as does it".'[9] It was only in etching and in his love of all its
attendant labours, the endless rebiting and stopping out, the very burnishing away
of faults, that Palmer recaptured something of the rapturous spirit of his visionary
years in Shoreham, and the thirteen highly wrought plates he had completed by his
death are the most vital aspect of his later career.

It was possibly the friendship of Cope that led Palmer to etch his first plate, the
rather clumsy *Willow* of 1850. He etched three more small plates in the same year:
The Skylark (published in the 1857 Etching Club series), *The Herdsman's Cottage* and
Christmas, or Folding the Last Sheep, which are a return in spirit to his evening rambles

along the paths and lanes of Shoreham. In these he is already squeezing effects of evening light from the paper, working the black lines into dense structures that release 'those thousand little luminous eyes which peer through a finished linear etching'.

There was a pause before his next etching, the *Sleeping Shepherd*, the last of his prints in a small upright format, a shape repeated in the wooden framework which encloses, like a picture, the distant view of a ploughman on a hillside. Thenceforwards, Palmer adopted larger plates for the pastorals of *The Rising Moon* (1857), *The Weary Ploughman* (1858) and *The Early Ploughman* (c. 1861) which combine memories of Shoreham with those of his sojourn in Italy, and where his passion for Blake's Virgil woodcuts has been united with a close study of Claude and the etchings of Rembrandt, who, like Palmer, believed that the copper could be etched again and again, the glimmers of white paper acquiring more value each time. The theme of these plates is the slow movement into the centre of the design of the returning rustic figures, this inward movement being counterbalanced by the contours of distant hills. Palmer tried to combine minute detail in the landscape with solemn rhythms of composition, speaking of the necessity of establishing 'the great, leading, pathetic lines, having first obtained the same in the figures. Work from the great leading lines and to them recur. Make friends of the white paper.'[10]

His etching reaches its greatest heights in *The Bellman* (Plate 112) and *The Lonely Tower* (both 1879), the first being rebitten thirteen times and the second fourteen, as Palmer laboured to obtain the precise depth of black and gradation of light that he desired and captured with their aid, a last glowing ember of romanticism. He spent his last months working on four plates to illustrate his translation of Virgil's *Eclogues*, and these plates were completed by his son, whose other filial duties included the burning of nearly all Palmer's Shoreham sketchbooks.

The intensity of Palmer's work is in marked contrast with the triviality of many Etching Club plates, and some of the twelve etchings by James Smetham (1821–1889), a painter on the fringe of the pre-Raphaelite movement, similarly profit from the comparison. The twelve small etchings appear in his published *Studies from a Sketchbook* (1861), and some of these, such as *The Days of Noah* and *The Last Sleep* (Plate 105), have a quality that is restrained but haunting. Although he was a close friend of Rossetti, Smetham worked outside normal artistic circles and was a dedicated Methodist teacher, devoting much of his time to this duty.

His plates are etched with a thin but persistent line, which he sometimes supplemented with machine ruling, though this is not always successful. Ruskin, who had admired Smetham's work from the first sight of his remarkable sketchbooks, told him that 'These etchings of yours are very wonderful and beautiful; I admire both exceedingly. But pray, on account of fatigue, don't work so finely, and don't draw so much on your imagination.' With a sensitivity to madness in other people, Ruskin had warned Smetham in 1857 that 'it is unsafe for you, with your peculiar temperament, to set yourself subjects of this pathetic and exciting kind for some time to come ... devote yourself to drawing and painting pretty and pleasant faces and things, involving little thought or pathos, until, your skill being perfectly developed, you find yourself able to touch the higher chords without effort.' Ruskin's acute

forebodings were borne out, and Smetham's last years were shrouded by insane melancholia.[11]

The products of the Etching Club and the high finish of Victorian etching were exposed to criticism of an almost evangelical fervour in P. G. Hamerton's influential book *Etching and Etchers* (1868), where he noted that 'the misfortune of the English school has been that it has endeavoured to please an uneducated public, and to do this has aimed at making etching pretty'. Some of Hamerton's phrases express the attitudes that were to characterize the belief of the artists and critics of the so-called 'Etching Revival' that there was 'true' etching and 'false' etching; 'true' etching was distinguished by bold, open use of line, and 'false' etching attempted to imitate the appearance of a painting by excessive finish. Although Hamerton admired Palmer's work it was thus 'false' etching by this definition, and Hamerton had only contempt for Thomas Creswick, noting that the foliage in *The Deserted Village* 'is very graceful and light, but it is not masculine work', indeed, he felt that it 'may easily pass into effeminacy'. By contrast, he noted that Cope's etching of the *Life School of the Royal Academy* was 'true etching, and one of the manliest pieces of work ever executed in England', and he further praised its 'frank' and 'fearless use of the pure etched line'. His choice of words suggest some homily delivered in ringing tones from the pulpit of a Victorian public school, and they indicate the purist and even moralistic standards that were to be applied to the criticism of etching over the next fifty years.

Hamerton's book was dedicated to Sir Francis Seymour Haden (1818–1910), and it was the etchings of Haden and of his brother-in-law, James McNeill Whistler (1834–1903), that were most widely imitated and admired in the second half of the century. Hamerton's greatest admiration was reserved for Haden, but it was Whistler who was to be the dominating figure of the period, so much so that his work was to acquire, by the end of the century, a status second only to that of Rembrandt.[12]

Whistler's first print was a lithograph made when he was a rather unlikely cadet at West Point Military Academy, and he learned the rudiments of etching while working reluctantly for the United States Coast Survey in 1854 and 1855. He departed for Paris in the latter year, where, besides delighting in the vagaries of Bohemian life, he learned from the etched work of Millet, Charles Jacque and Meryon who had brought new vigour to French etching, Whistler's *Douze eaux-fortes d'après nature* (1858), known as the *French Set*, are mostly studies of figures or of tumbledown buildings owing something to the realism of Jacque's etchings. They are etched with vigorous line that makes no attempt to give a neat and impartial attention to each part of the plate, but instead moves rapidly to define one portion with a few lines and stops in others to define a face or a textured wall with highly wrought drawing. *La Vielle Aux Loques*, showing an old woman in her kitchen seen through an open door, illustrates this early realistic phase and interest in strong contrasts of light and texture, as well as anticipating a frequent theme of his etchings of street life.

In 1858 Whistler travelled to London, finally settling there in 1859. He frequented the well-appointed house of Seymour Haden, who had married his half-sister, and it was to Haden that he dedicated the *French Set*. Between 1859 and 1861 he etched the sixteen plates of the *Thames Set* (published as a set in 1871) which became the most widely imitated of all his prints, and are the finest examples of his realist work.

At this period he showed little interest in the effects of light and mist on the river, a subject which was later to preoccupy him, and none at all in the sluggish flow of the river itself, water being indicated with a few cursory strokes. His attention was focused on riverside life: the peeling façades of wharfside buildings, masts and rigging, and the men who work amongst them (Plate 106), and his drawing goes through changes of pace, showing the selective concentration that he was later to refine.

At the same period Whistler was making many portraits in etching or drypoint, taking as subjects young English girls and a series of French writers and artists. He handled the drypoint with a great sensitivity for its sensuous bloom of black, revelling in the deposits of burr that define the great expanse of black dress in *Finette* (1859), and again using it on a large scale in the portrait of *Annie Haden* (1860). He used it more languorously in the swirling lines of *Weary* (1863), and although Hamerton asserted peevishly that Whistler was 'self-concentrated and repellant of the softer emotions', his many portraits of young women and adolescent girls are drawn with tenderness, and even with romantic ardour (Plate 108).

In 1879, following his bankruptcy, Whistler was commissioned by the Fine Art Society to make a set of etchings of Venice. He later explained to his disciples, Mortimer Menpes and Sickert, how, while drawing a bridge in Venice, he had discovered the secret of drawing: 'I began first of all by seizing upon the chief point of interest. Perhaps it might have been the extreme distance,—the little palaces and the shipping beneath the bridge. If so, I would begin drawing that distance in elaborately, and then would expand from it until I came to the bridge, which I would draw in one broad sweep. If by chance I did not see the whole of the bridge, I would not put it in. In this way the picture must necessarily be a perfect thing from start to finish. Even if one were to be arrested in the middle of it, it would still be a fine and complete picture.'[13]

The principles of this method had been applied by Whistler before the *Venice Set*, for instance in the drypoint of *Speke Hall* (1870), but in the Venice etchings it is carried to a new pitch of refinement. He often focuses on a door or window, with figures grouped in its shadows, and models it with a dense mass of lines, arranging figures or objects around this central block in a fragmentary and suggestive way like marginalia that can be adjusted at will (Plate 107). The figures are drawn with a spidery line, and Whistler's drawing became ever more precious and refined. This refinement was even carried to details like the positioning of the signature; Whistler would trim away most of the margin, leaving a small tab for his butterfly signature, and its positioning was a matter for the nicest deliberations.

On his return to England at the end of 1880, Whistler increasingly adopted the habit of leaving surface tone on the paper, and the hand-wiping of the plate when these films of ink were adjusted occupied him as much as the etching of the lines, so that the printing of each impression became a unique operation. He abhorred the mechanical printing of professionals, and Menpes recalled Whistler looking through a batch of proofs and finding a drypoint that interested him: ' "Ha, ha!" he would say. "Now, here is a proof that could only have been printed by one man—myself." ' The dandyism and delight in performance that was such an entertaining aspect of

Whistler's career, was carried through to his art. He arranged lines on the paper with the same deliberation that he devoted to the combing of his hair; the plates go through many changes of state, not so much in determined pursuit of an elusive goal, but in a series of posturings with different arrangements of line. The results are often entrancing without providing the nourishment of the greatest art.

Whistler etched a whole series of little plates of Chelsea street scenes, suggesting a shopfront with children clustered around it with a minimum of short, silvery lines. This reduction is even more evident in the set of twelve plates of the *Jubilee Naval Review* of 1887. In 1889 he visited Amsterdam and etched some of his finest plates, returning to the themes of the *Venice Set*; houses glimpsed from a canal or the road, windows and doors with figures peeping out; but instead of elaborating one area at the expense of another, his needle now flickers across the whole surface, describing cobblestones or brickwork in all corners of the plate.

In 1878, Whistler was introduced to lithography by the printer Thomas Way, and he used lithotint for two views of the Thames: *Nocturne: The River at Battersea* (1878) and *Early Morning* (1879). Both of these prints evoke the mists of the river and they are the most atmospheric of all his plates. He did not return to the medium, which was held in very low esteem by most English artists, until 1887, and most of his lithographs were completed between 1889 and 1896. The use of transfer paper, whereby he could draw on the spot and have the design transferred to the stone by Way, allowed him to make a whole series of London and Paris street scenes with the same light scattering of carefully chosen lines that is found in his etchings. He also drew a number of lightly draped female models in playful variations on classical themes, but perhaps the finest of his lithographs, and those which best use the soft touch of the crayon, are the portrait and figure studies. These are drawn crisply in diagonal lines, shifting direction or tone to suggest different planes. Portraits, such as those of *Mallarmé* (drawn as a frontispiece to his *Vers et Prose* of 1894), *Sickert* of 1895 or *La Belle Dame Endormie* of 1894 (Plate 109), are perfect demonstrations of Whistler's claim that great art should appear to be made without effort, even though it may have been the result of prolonged contemplation and repeated efforts.

Sir Francis Seymour Haden (1818–1910) was by profession a surgeon, but, despite his amateur status, his many landscape etchings and dictatorial pronouncements on the art had an influence second only to Whistler's.[14] He had learned how to etch in his youth, but it was Whistler who had encouraged him to return to its practice, and to work directly from nature onto a ready grounded plate. On some occasions they worked side by side from the same motif; Whistler's *Greenwich Pensioner* (1859), for instance, is a close-up of a figure who is merely used as an incident in Haden's landscape *Sub Tegmine* (1859). Haden always admired Whistler's etchings, and valued them equally with his collection of Rembrandt prints, on which he was an expert, but the two men became more and more incompatible. A. M. Hind recorded, with an Edwardian nicety of phrase, that Whistler's behaviour 'seems not infrequently to have overlooked the claims and conditions of society and friendship', and in Paris in 1867 Whistler pushed Haden through a plate-glass door, this violent defenestration not unnaturally terminating their friendship.

One of Haden's earliest plates, the drypoint *Thames Fisherman*, was exhibited at the

Fig. 12. EDUARDO PAOLOZZI: *Futurism at Lenabo* [Screenprint from *As is When*; 1965; 965 ×
654 mm]

Fig. 13. JOHN KEYSE SHERWIN: *William Woollett* [Engraving; 1784; 305 × 254 mm] Woollett is shown working with a burin on a large copper plate, which rests on a leather pad so that it can be turned easily. The screen of oiled paper above him is to diffuse the light and prevent glare from the copper.

According to Walpole, Woollett 'died as he had lived, at peace with all the world, in which he never had an enemy', but William Blake 'knew him to be one of the most ignorant fellows that I ever knew' who 'did not know how to Grind his Graver'.

Fig. 14. SIR FRANCIS SEYMOUR HADEN: *Self-portrait* [Etching and drypoint; 1862; 270 × 197 mm]
A rare attempt at portraiture by Seymour Haden, who has depicted himself working on the plate with containers of acid at his side.

Fig. 16. DAVID HOCKNEY: *The Print Collector* [Lithograph, unfinished progress proof; 1970/1971; 670 × 530 mm]
From *Europaeische Graphik VII*. A portrait of the well-known photographer, and historian of lithography, Felix Man.

Fig. 15. CHARLES HAZELWOOD SHANNON: *The Wood Engraver* [Lithograph; 1896; 170 × 175 mm; a portrait of Charles Ricketts]

Paris Salon of 1859. In 1865 Delâtre printed the thirty plates of the *Etudes à l'Eau-forte* which were very well received in Paris. They contain some of his finest work: *Mytton Hall* (1859) shows a power in handling drypoint that is excelled only by Whistler, and *Egham* (1859) demonstrate his skill in setting off the principal incidents of a landscape by large areas of luminous white (Plate 115). Haden believed that etching should be the result of spontaneous drawing onto the plate from nature, and that any work that smacked of reproduction from a painting was to be deplored. His pronouncements were delivered with all the certainty of a man who epitomized the Eminent Victorian; the signatures on his nomination sheet for the Athenaeum included those of Arnold, Browning, Trollope, Poynter, Huxley, the Lord Chief Justice and the Archbishop of Canterbury, and give some idea of his station in society, which lent considerable weight to his views.

Haden's etchings and drypoints are mainly of landscape, but he etched a number of plates of Thames-side scenes, such as *Old Chelsea Church* (1865), which show the influence of Whistler's 'Thames Set'. A real sensitivity to light and space is well exemplified in such prints as the *Water Meadow* (1859) and *Shere Mill Pond* (1860), and at his best his work has a plein-air quality that compares well with such French artists as his friend Daubigny. At times, however, his use of drypoint is blotchy and self-indulgent, and the wiry scrabbles of line in clouds and foliage show the self-satisfied repetitiveness of the amateur. Throughout the 1870s his work became increasingly broad in handling, and his vigorous drawing of the central portions of a design contrast with the large areas of white he preserved at the corners of the plate, filled only by an assertive signature. Partially as a consequence of weakening eye-sight, he etched little after 1880, and turned instead to mezzotint.

In 1882 he undertook a lecture tour of America, where he was widely admired, giving dogmatic utterance to his views on the merits of original etching and the worthlessness of reproductive engraving. He enjoyed his visit, and it had some influence in enlarging the American market for etchings, but Haden told his friend Frederick Keppel that: 'One thing alone would render it impossible for me ever to reside permanently in the United States, and that is the intolerable and brutal insolence of the lower classes.'

Haden's influence on etching was widespread, but he had few immediate followers. Whistler, however, had many close initiators, and was often to be seen with a train of attendant admirers, all hanging on his every word. These included his fellow Americans Mr. and Mrs. Pennell, whose *Life of James McNeill Whistler* (1908) chronicles the 'Master's' deeds and sayings with fawning sycophancy; Joseph Pennell was himself an enthusiastic but heavy-handed etcher and lithographer. Walter Greaves (1841–1930) and the Australian Mortimer Menpes (1860–1938) were both ardent disciples, and Menpes is best remembered for his drypoint portrait studies of Whistler. He later abandoned (or was expelled) from the Whistler camp, and betook himself to Japan where attached himself to the painter Kyosai, although his draughtsmanship remained as inadequate as ever.

By far the most gifted of Whistler's pupils was Walter Richard Sickert (1860–1942), who was, with Menpes, particularly close to Whistler from about 1881–3. He helped to print Whistler's etchings and worked in his style. The rare etching of

Whistler in His Studio (1882) is a good example from this phase in his career (Plate 110), before he came under the more invigorating influence of Degas and adopted an etching style deliberately opposed to everything that Whistler stood for. Although the etching has been drawn onto the plate from life, with a minimum of lines picking out the salient points, Sickert's lines have a cutting edge and strength that makes them more than mere rehearsals of Whistler's style.[15]

Entirely in Whistler's style, on the other hand, though not without a quiet charm, are the etchings and drypoints of Théodore Roussel (1847–1926), a Frenchman who lived for most of his life in London. He wandered about the streets of Fulham and Chelsea, already Whistlerian territory, etching many small street-scenes with an observant eye (Plate 111). He took his imitation to the extent of adopting Whistler's habit of putting his signature on a small tab at the foot of the plate.

Roussel departed from Whistler's example, however, in his complicated experiments in colour etching, where a small image is surrounded by a decorative mount, both printed in colour. He published a set of these in 1899, noting in his introduction to the Catalogue that '. . . the mount on which each proof is laid is itself an etching printed in colours, as is also the frame surrounding the mount. I have adopted this arrangement in order that the central proof should, at least according to my own ideas, form with this mount and frame, always specially printed for it, a complete harmony of colour, each proof presented being the result sometimes of as many as twenty-four or even a greater number of printings.' The results are decorative, but a little weak in the basic designs on which the colours rest; he took his method to even greater lengths in his large print *Dawn*, the result of fifteen to seventeen printings from nine plates.[16]

It may also have been the example of Whistler that encouraged the French artist James Tissot (1836–1902) to make a number of etchings and drypoints during his residence in London from 1871 until 1872.[17] The stylishness and panache of Tissot's draughtsmanship is wholly French, but he profited from the study of Royal Academy genre pictures, and his detailed pictures of well-shod Victorians picknicking, or enjoying a shipboard dance, exhale the spirit of the opulent class of society. He had made a few etchings in Paris in the 1860s, but did not take up the needle again for ten years, by which time he was settled in St. John's Wood and was enjoying considerable success. His work shows no trace of the spontaneous style associated with the Etching Revival, and relies on deeply incised, drypoint, parallel lines, drawn with great verve but often rather heavy in effect. Some of his prints were original designs, but many were based on his paintings, such as *Croquet*, etched in 1878 (Plate 114), or *On the Thames* (1877). The density of the blacks he obtained from the heavy workings of drypoint give some of his prints, despite the apparent charm of their subjects, a claustrophobic and melancholic mood particularly evident in the portraits of his mistress Kathleen Newton, of which *Croquet* is an example.

One of the few English artists to be admired by Whistler was Charles Keene (1823–91), whose many illustrations for *Punch* were also highly esteemed by Degas, Pissarro and Von Menzel. Keene's name was constantly on the lips of Sickert, who shared his relish for seedy models in dilapidated clothes. The great part of his work was devoted to illustrating rather feeble jokes to be wood engraved for *Punch*, but

he also etched thirty-four plates which include some of the finest English etchings of the period. They consist of figure studies, interiors and beach scenes, and their clear drawing and unforced directness of vision are a corrective to the self-conscious spontaneity of more dedicated painter-etchers. The French etcher, Bracquemond, considered that 'par la liberté, l'ampleur de leur dessin et de leur execution, ces gravures doivent être classés parmi les eaux fortes modernes du premier ordre' and such plates as the *Interior of Birket Foster's House*, *Madame Zambaco*, or *Lady with a Book* (Plate 113), show the quality of drawing that could please a critical French audience.

Keene was unimpressed; he was perfectly happy making drawings for *Punch* while etching the occasional plate in spare moments, and this unassuming attitude to art was what endeared him to Sickert. The news that Beraldi intended to catalogue his work in *Les Gravures du XIX Siècle* inspired a typical response in a letter to Mrs. Edwards: 'I am amused at the idea of putting me down as a "Graveur de XIXᵉ Siècle", I have only scratched a few studies or sketches, not more than a dozen all told, I should think—the merest experiments! Titles they have not. To save my life I couldn't tell the dates, and as to writing my life story, "God bless you, sir, I've none to tell"... try and choke the French biographer off.'[18]

An austere corrective to the influence of Whistler lay in the teaching of the French artist Alphonse Legros (1837–1911) at the Slade School, where he was professor from 1876 to 1894.[19] Legros came to London in 1863, at the suggestion of Whistler, and was resident there from 1866 until his death. His early work consists of a morbid realism, often of dolorous Spanish subjects, reflecting the influence of Courbet. He was an important figure in the French revival of etching and in fact his most powerful prints were those completed before he came to England, there being nothing in his later work to equal the forceful melodrama of the drypoints of *Les Baugneuses*, or *Paysanne se lavent les pieds*. It was not to his benefit, ultimately, that he exchanged the intellectual companionship of Degas and Baudelaire for the security of his Slade teaching post.

Legros was very productive, etching more than 700 prints, and it is difficult to think of any artist whose work is so relentlessly grim and humourless in character. He turned again and again to monastic themes, beggars, labourers in bleak landscapes, and miserable old men surprised by the Grim Reaper. The many landscapes that he produced in etching or in drypoint lacked zest or sense of observation and give the impression of being turned out by rote, as a rather glum, but compulsive habit. His strongest prints are drypoint portraits, usually in three-quarter profile, drawn with great firmness onto the copper with bold sloping lines, modelling the cheekbones with delicate shading. Some of his most illustrious contemporaries posed for him, including Cardinal Manning, Watts, Darwin and Alfred Stevens (Plate 117), and there is a gravity in his style and placing of the heads that owes something to Holbein, and was ideally suited to the demeanour of his sitters. His delicacy of modelling is even more evident in his portrait lithographs, which reflect his sound grounding as a draughtsman at the *École des Beaux Arts*.

It was in transmitting some of these standards of draughtsmanship and academic severity through the Slade that Legros' influence was at its greatest. His most attentive pupil was the Scottish etcher, William Strang (1859–1921), who inherited Legros' penchant for grim and macabre subjects, expressed in such subjects as *The End* (1889),

or the series of *Death and the Ploughman's Wife*. Strang specialized in large plates of realistic subjects, such as *The Socialists* (1891) or *The Dissection* (1887), into which he frequently introduced rather gawky and theatrical figures (Plate 118), old men with wispy beards who have stepped from some Scottish ballad and add a note of fantasy to the proceedings.

Strang invented a species of burin which was hooked at the end, allowing him to obtain the strength of an engraved line, and yet handle the burin with the ease of an etching needle. He used this to engrave some of his portrait studies directly onto the plate, although his drawing remains rather tight and constrained, without the broad shading of Legros. Strang also produced some woodcuts, including the vivid illustrations to a *Book of Giants* (1898), and the huge print of *The Plough* commissioned by the Art for Schools Association, which measures five feet by six.

A large decorative woodcut such as this was a rare phenomenon; the history of the English woodcuts of the late nineteenth century is more closely connected with the production of fine illustrated books from private presses. The ideals of the wood engravers of the 'sixties had been the simple desire to reproduce the artist's pen drawing with as little loss of its original appearance as possible. No attempt was made to fuse the design with the letterpress so as to make a decorative ensemble on the page. The ideals of William Morris were very different, however, and the Kelmscott Press *Chaucer* integrated text, illustrations and marginal decorations into a harmonious whole. Morris deplored the modern methods of book production, and looked back wistfully to the glories of early German and Italian books with woodcut illustrations. Most of his publications have no illustrations, and rely entirely on woodcut ornament, but the *Chaucer* has illustrations which were designed by Burne-Jones, and then translated by Catterson Smith into a suitable form to be engraved on wood by Hooper. The influence of Morris and Burne-Jones, avowed archaisers that they were, was widespread in reviving the use of woodcut illustrations for the finely produced private-press editions.

However, the greatest illustrator of the 1890s was Aubrey Beardsley, whose drawings were designed for reproduction by the line block. A more precious attitude to book production was taken by Charles Ricketts (1866–1931), who complained in a letter of 1915 to Gordon Bottomley that 'my book-illustration work has been swamped for ever by the success of Beardsley'.[20] Ricketts, and his life-long companion Charles Hazelwood Shannon (1863–1937), both designed illustrations for *Daphnis and Chloe* (1893) which Ricketts then drew onto the wood and Shannon engraved (Plate 119). The style of designs is steeped in the great Venetian book, the *Hypnerotomachi Poliphilli* (1499); beautifully cut outlines, accentuated by occasional flurries of sloping lines, defining the skinny little figures in the grip of exquisitely fretful passions.

Shannon later turned to lithography, but Ricketts founded the Vale Press in 1896, and the later books he designed, including *The Parables* (1903), *De Cupidinis et Psyches Amoribus* (1901) and *Danae* (1903), are rather more vigorous in conception than *Daphnis and Chloe*; in each case Ricketts designed the whole book, the ornaments and illustrations complementing each other. Ricketts stands for all that was most rarified in the aesthetic movement, and on one occasion was even moved to

call Oscar Wilde a 'Vulgar Beast', but much of his work was anaesthetized by his eclecticism, so that every line he made contained some reference to a painting or object from the past. Nevertheless, his powerful personality, and the *Dial* magazine which he founded, played an important part in spreading ideas and establishing the tradition of the private press.

Whistler's example had encouraged a number of artists to take up the neglected medium of lithography in the 1890s, including Charles Conder (1868–1909), Robert Anning Bell (1863–1933), and William Rothenstein (1872–1945), whose series of *English Portraits* (1897) includes a study of Ricketts and Shannon. Rothenstein himself was the subject of a brilliant study by John Singer Sargent (1856–1925), who made a few rare lithographs. Shannon employed lithography with a luxurious touch, and with a refined use of pale greys both in portraits, such as *Lucien Pissarro* (1895) or *Charles Ricketts* (Fig. 15; page 108) and in romanticized visions of young mothers, bathing girls and nymphs elegantly drawn but rather bloodless.[21] One of the best of his figure subjects is the *Romantic Landscape* (1893) with its group of clean-living girls, showing their shoulders coyly, drawn with a soft and grainy tone (Plate 101). Shannon's career ended horribly: he struck his head while hanging a heavy frame, damaged his brain, and spent the rest of his life as an imbecile.

Lucien Pissarro (1863–1944) settled in England in 1893 and was told by his father Camille, in a letter of 1898, that '. . .you would have to disregard friend Ricketts, who is of course, a charming man, but who from the point of view of *art* seems to stray from the true direction, which is the return to *nature*.' Lucien founded the Eragny Press and illustrated a number of books with woodcuts printed in clean, bright colours, and drawn with a kind of artful clumsiness of contour. He worked both from his own and from his father's designs, frequently reproducing scenes of French country life.

The poet Thomas Sturge Moore (1870–1944) came under the influence of Ricketts in the 1890s, but his wood engravings are more vigorously cut, with a twisting, convoluted line and with a richer use of black. Much of his work was done between 1892 and 1902, including his three illustrations for Guérin's *The Centaur and the Bacchante*, published by the Vale Press, and the *Pan* series. He delighted in woodland scenes, peopled by centaurs, nymphs and such-like creatures, who gambol contentedly amongst its leafery. His book-plates are some of his best designs and include those for W. B. Yeats and Campbell Dodgson (Plate 120), one of the greatest Keepers of Prints and Drawings at the British Museum.

Sir William Nicholson (1872–1949), who formed a partnership with James Pryde as the Beggarstaff Brothers between 1893–95, used the bolder medium of woodcut for large poster designs, simplifying figures and objects into large flat shapes, set off by a few well-placed lines. This stemmed partly from the influence of Lautrec and the Japanese print, but Nicholson had no interest in the elaborate use of colour overprinting, and in this respect his work is closer to the black and white woodcuts of Felix Vallotton. The partnership dissolved in 1895, due to Pryde's dilatory habits, but Nicholson continued to make woodcuts, and his famous print of *Queen Victoria* (1897) persuaded Heinemann to commission a whole series of illustrated albums. These included the *Alphabet* (1898), *London Types* (1898), and the *Almanack of Sports*

(1898). The designs were cut in wood and then transferred to lithography for printing in large editions. They owe something to the simple humour of the chapbook tradition revived by Joseph Crawhall, and their influence on book design both here and abroad was widespread. *The Barmaid* from *London Types* (Plate 121) is a telling example of the cool vision and exactitude of composition that was inherited by his son Ben Nicholson.

Nicholson abandoned the woodcut in 1901, but in about 1890 he had given some instruction to Edward Gordon Craig (1872–1966), who was to become one of the most inventive and technically adroit of all English wood engravers.[22] From 1896 to 1901 Craig was 'cutting boxwood all day', and by his own account he cut 236 blocks, many of them tiny, in this period. A large number of these were published in the periodicals he had founded, *The Page* (1898) and the later *Mask* (1908), as little tail-pieces and headpieces of a charming playfulness (Fig. 1; page 1). Craig was also a great stage designer, and, as might be expected, his work often includes theatrical images: posturing figures, Italian hill towns framed by swirling clouds, like backdrops to a stage set, and the streamlined Black Figure prints of Shakespearian characters (1907–1909), some of his most original work. He used a variety of techniques, including a speckled dot-work looking back to *manière criblée* prints of the Renaissance, combings of white line against flat black areas, and the lowering of the block to obtain paler greys at the edges; but these devices are never obtrusive and always contribute to the sense of ebullience and free flow of invention that is typical of his work.

The Limited Edition

The Twentieth Century

Sickert, with characteristic wit, described how he once brought a smile to 'the some-what difficult lips of Mr. Augustus John by a description of the difference in the exclamations of the spectator when drawings or etchings were shown. To a drawing he will say "Oh!" in a tone that means "I suppose so", if not "What of it?" or as the French say, "Et puis après?" To an etching he will exclaim "O-o-o-oh!" as much as to say, "Now you're talking!" '[1]

This enthusiasm for etching, a legacy from Whistler and Haden, resulted in the multitude of etchings produced in the first three decades of the new century, catering for a collector's market that went from strength to strength until it was destroyed by reverberations from the Wall Street Crash in 1929. Dozens of etchers applied them-selves to the required subjects of architectural views, harbour scenes clearly derived from Whistler's *Thames Set*, Scottish hills and quiet, rural scenery. Etched with a spirited line and richly printed in heavy brown or black ink, which had been dragged to the surface by *retroussage* (the passing of muslin over the surface of the inked plate), many of these prints constitute a standardized Edwardian product; technically sound, full of work, but a little dull.

The more prominent etchers of the time, whose skilful tunes on what was really a nineteenth-century instrument created a great demand for their work, included Sir D. Y. Cameron (1865–1945), Sir Frank Short (1857–1945), Sir Muirhead Bone (1876–1953) and James McBey (1883–1959). They all looked back to Whistler and Haden or to Meryon, whose views of Paris inspired a whole school of British archi-tectural etching. Cameron was a Scot whose work shows a gloomy character in depicting Gothic buildings, their dark shadows owing much to Meryon, whose *La Stryge*, for instance, was the direct inspiration for Cameron's *Chimera of Amiens* (1910). He turned later to the subject of Scottish hills, suggesting their sombre shadows and declivities with copious deposits of drypoint burr in such plates as *Ben Lomond* (1923).

The drypoints of Muirhead Bone include portraits and landscapes, but his best-known subjects are building or demolition sites, with bleak shards of architecture surrounded by scaffoding. He, too, had pored over the etchings of Meryon, but added some of the monumental scale and baroque animation that he had gleaned from Piranesi. The work of Bone and Cameron is highly accomplished, but its

dramatic character is rather second hand and spurious, owing more to conscientious study of past masters than to any real originality of style.

Another Scottish etcher, James McBey, who has described his early life in a short but moving autobiography, etched in a freer style, suggesting forms and atmosphere with an energetic fuzz of lines.[2] Some of his best plates are those depicting his experiences in the desert during the First World War, when he was attached as a war artist to the Australian Camel Corps. His later etchings and drypoints of Venice, however, show the very worst aspects of Whistler's legacy in their parade of spontaneity and clumsy use of surface tone.

Sir Frank Short exerted a powerful influence on the traditionalist school of British etching, teaching etching at the Royal College of Art from 1891 to 1924, and succeeding Seymour Haden in 1910 as President of the Royal Society of Painter-Etchers. Short etched many plates of landscape in an open style, which owed something to Haden, and also scraped a number of mezzotints from Turner drawings for the *Liber* that had never been engraved. Also in a traditional spirit, and executed with competence, are the portraits and architectural etchings of Francis Dodd (1874–1949), and the architectural plates of Henry Rushbury (1889–1968), whose work shows the influence of Bone.

Perhaps the finest English painter and etcher of the first part of the century, however, was Sickert. In both his etchings and his writings on the subject he reacted increasingly against the fashionable mores of the British etching school: their predilection for masses of 'velvety' burr, their brow-furrowed attempts at spirited touches, and their sterile refinements of nineteenth-century innovations. Even in the period of his apprenticeship to Whistler, when his stylish abbreviations of drawing reflected the latter's influence, he was reacting against a precious approach to etching and printing by treating his own prints in an offhand manner, taking only a few impressions, and those often on grubby bits of paper. Much of Sickert's later work, in its deliberately inelegant handling, can be seen an attempt to exorcize the lingering spirit of Whistler, although some of Sickert's own affectations of a functional or casual style constitute a form of artistic dandyism in their own right.

Sickert's friendship with Degas, which dated from 1883, helped direct him to a more observant and realistic approach, and this was expressed in the series of music-hall subjects he painted between about 1885 and 1895. He based a number of later etchings on these pictures, and, in such plates as *Noctes Ambrosianae* (1906), *The Old Middlesex* (c. 1910), and *The Old Bedford* (c. 1908), he used the medium to concentrate on the effects of lighting on the intent faces peering down from the balcony, delighting in the contrast between the bowler-hatted figures and the caryatids and ornate decoration of the theatres.[3]

From 1899 to 1905 Sickert was living in Dieppe, and one of his most interesting plates is the *Quai Duquesne, Dieppe* (Plates 123 and 124). This may have been etched during this period and combines elements from his early and his later style. The delicate and tremulous drawing of the street in the background shows the influence of Whistler, and is in contrast to the rain of vertical lines in the foreground, and the net of cross-hatching on the silhouetted figure of the woman. This idiosyncratic variation on an engraver's syntax of lines is in contradiction to the 'butterfly' touch

of the 'Master', and marks Sickert's rejection of the values established by the Etching Revival. In later states of this print he made a number of changes, breaking up the cut-out shape of the woman by a large patch of light, and giving more substance to her form by little patches of modelling. The drypoint additions to the street opening in the background give greater depth to the composition, which has been made far more airy and open.

On his return to London in 1905, Sickert began to etch regularly, frequently reworking the themes of his paintings in two or three etchings of different size executed over widely separated periods. At this time, too, the Camden Town Group was developing under Sickert's leadership, and many of his paintings and the subsequent prints explore the theme of figures in seedy Camden Town interiors: frowsty bedrooms, and kitchens that seem heavy with the odour of cabbage-water. Some of his most important subjects of this period are *The Camden Town Murder*, *Jack Ashore* and *Ennui*, each subject being repeated in a number of etchings with a variety of treatments. Sickert was not merely copying his pictures, he was playing linear variations on them; areas of regularly shaded tone were set off by emphatically scored lines that define the edge of a table, or a crumpled sheet against a flabby thigh. In many cases, particularly in the illustration of such themes as *A Weak Defence* (c. 1912) or *An Awkward Customer*, the etchings bring out a witty character that is not always apparent in the paintings. The clarity of etched line led Sickert to the sharp definition of contours that are often obscured and blurred by broad strokes of the brush.

Sickert was continually preoccupied by the problem of depicting light. He evolved a method of creating shadows with rows of thread-like descending lines, their regularity broken by occasional kinks, and these are crossed by horizontal lines in the darker areas to create a muslin-like texture. This linear system is used in *The Rasher*, etched in about 1910 (Plate 122), and in a number of the etchings published by the Carfax Gallery in 1915 and 1916; in these the clarity and careful spacing of the lines left nothing to the skills of the printer. Sickert's entertaining article in 1912 in the *New Review* entitled 'The Old Ladies of Etching Needle Street', which has already been quoted, was an attack on all the ritual of printing tricks, proof impressions and rare states that had grown around the activity of etching. Sickert maintained that all the work should be on the plate, which could be printed with as little fuss as a visiting card, and that etching was just a convenient way of multiplying a drawing and should not cater to the collector's desire for rarities and signed impressions. He quoted as his ideal the clean drawing and straightforward execution of Karel Dujardin, the Dutch seventeenth-century etcher, and stated that 'The truth about Whistler and about the whole "revival" in England is that it was an interesting and sincere amateur revival', although he excepted Samuel Palmer from this charge.

Sickert's writings about etching have sometimes worked against his reputation as an etcher; the assumption is often made that his work merely represents multiplied drawings with no special qualities appropriate to the medium. His biographer, Robert Emmons, noted fatuously that Sickert attached no importance to his etchings, despite the large corpus of etched work that bears witness to the contrary.[4] In soft-ground etchings, such as *The Passing Funeral* (1910), Sickert was indeed primarily

concerned with duplicating a pencil drawing, but in his more frequent drawing with the needle Sickert had developed a style that was concerned with the special qualities of the bitten line. His delicate use of this style, the subtle play of light in his interiors, and the variations he played on themes, gave his etched work a special value.

Sickert had a number of followers, and the most talented etcher of his school was Sylvia Gosse (1881–1965), daughter of Sir Edmund Gosse. Her plates are of Sickertian subjects but they are drawn with a more inflexible contour. A particularly good example of her work is *The Toilet* (1909), which shows something of Sickert's gift for relating two figures in an interior, making us curious to hear what they are saying despite the probability that it will be humdrum gossip (Plate 126). Gosse later cut off the right-hand portion of the plate to eliminate the standing woman, but in so doing she took much of the interest from the design.

The flamboyant draughtsmanship of Augustus John (1878–1961) was given an astringency and concentration by the etched line, and his small portrait etchings, mostly the work of 1901–1910, are amongst his best works.[5] He was influenced by the delicate lines of Rembrandt's etchings, particularly the animated movement of his early portrait plates, such as the small self-portraits, where the head pivots sharply on the shoulders. John's portraits were usually drawn directly onto the plate, and this first incisive statement often exhausted his powers so that progressive states show a diminution of his energy. Among his best portraits are those of *Percy Wyndham Lewis* (1903), the five portraits of W. B. Yeats, and the gentle etching of his sister *Gwendolen* (1902), a painter whose restrained and sober style was the reverse of her brother's (Plate 125). In this plate he eschewed the violent motions and twisting heads of his other portraits, and, by taking the plate through several states, carefully built up a restrained composition in which he chronicles her oval face and platter-like hat with amused affection.

Apart from the work of Sickert and John, few prints of great interest were made in the decade before the Great War. The horrors of the war provided themes of undreamed of strangeness, and compelling reasons to record them; Nash, Wadsworth and Nevinson all made paintings and prints of war subjects that must be put among their most powerful work. Paul Nash (1889–1946) served in France in the early part of 1917, and expressed his awful fascination with the battered and sterile landscape that had resulted from years of warfare in seven lithographs of uncompromising realism.[6] Grey and austere in technique, prints like *Hill 60* (1917), *Void* (1918) and *Rain, Lake Zillebeke* (1918) are unsentimental records of the churned mud and rain-filled craters of the Western Front.

C. R. W. Nevinson (1889–1946) had been one of the talented generation of students at the Slade between 1908–12 that included Wadsworth, Bomberg, Gertler and Nash, and he became, with Wyndham Lewis, the most aggressive spirit among the Vorticist artists, who trumpeted their enthusiasm for the violence and speed of modern life.[7] When the war started, Nevinson went to France with the Red Cross and was attached to the French Army. Some of his most effective paintings show French soldiers on the march to the front in long tramping columns, and he repeated these compositions in drypoints such as *Returning to the Trenches* (1916) and *Column on the March* (1916). The paintings and prints he made during this period are among

the strongest images to come out of Vorticism; the energetic rhythms and jagged planes, originally moulded to celebrate the dynamism of modern life, and here applied to themes of high tragedy. He used drypoint with vehemence and crude force, not attempting to obtain velvety blacks or rich burr, but using it for the greatest emphasis of line and density of tone. This is evident in the brutal subject matter of *The Dressing Room* (1916) and in *Boesinghe Farm* (1916), a small plate recording the effects of shellfire, in which a building has been pounded into a ready-made Vorticist structure (Plate 127).

Nevinson and Nash were both appointed official war artists in 1917, and Nevinson was commissioned to make a series of lithographs for the series of prints: *Britain's Efforts and Ideals in the Great War*. It includes six large prints which record the progress of an aircraft from its construction to its use in the air, and includes some effective aerial views, Nevinson claiming to be the first artist to have made drawings from an aeroplane. He was to return to this theme in the lithograph of *From a Paris Plane* (1927/8) an unusually fine print for this phase of his career (Plate 128).

After the war he found equally stimulating subjects in New York, where he was invited to have an exhibition of his prints in 1919. He enthused over the skyscrapers and the pace and excitement of New York life, and the series of drypoints he made of such subjects as *Looking through Brooklyn Bridge*, or *Looking down into Wall Street*, communicate his excitement at this vision of Futurism made real. He was one of the few artists to use mezzotint at this period, scraping out effectively to depict the glow from office windows in *43rd Street at Night*. Thereafter his decline as an artist was catastrophic, and the inventive energy he had sustained for the past few years was seldom revived.

The woodcuts that Edward Wadsworth (1889–1949) made in his Vorticist period, between 1913 and 1920, constitute perhaps the most original use of the medium in England.[8] He contributed a small abstract print, *Newcastle* (1913), to the Vorticist exhibition of 1915, and in the next four years cut a series of small but immensely energetic designs, where angular forms, such as girders, recede into space at break-neck speed, or thrust violently to the edge of the design, threatening to burst its limits before they are broken back at right-angles. Some of these are abstract, others are of towns or villages, such as *Mytholmroyd* (c. 1914), *Yorkshire Village* (c. 1914) and *Bradford: View of a Town* (c. 1914); in these prints, simplified blocks of form, with strongly lit, flat surfaces, stand in for the angle of a roof, or a street receding into the distance. Wadsworth printed only a few impressions, usually in varying colour schemes of grey or blues, with the occasional use of orange or purple. From 1914 to 1917 he served as a naval intelligence officer on the Mediterranean island of Mudros, where he developed his earlier themes in such woodcuts as *Riponelli: A Village in Lemnos* (Plate 130), executed in 1917.

On his return to England he worked in Liverpool dockyards, supervising the dazzle camouflage of shipping. The strange spectacle of these great shapes broken up by broad stripes of paint provided subjects for some of his most striking woodcuts. In *Liverpool Shipping* (1918) or *Drydocked for Scaling and Painting* (1918) he used woodcut like a blunt instrument, reducing the design to its simplest components of black and white with no intermediate tones (Plate 129). Both prints were later

adapted to use as posters. Nothing could be further from the world of Ricketts and the Vale Press, with woodcuts nestling comfortably in thickets of arcane text set in beautiful typography; instead the work of Wadsworth has a place in the more vital tradition of the twentieth-century woodcut, where the medium has been used aggressively for its broader and simpler effects.

These possibilities attracted a number of English painters to the medium in the years following the war. Paul Nash's lithograph of *The Void of War* (1918), designed as a poster for his exhibition of that title at the Leicester Galleries, was conceived in the simplified shapes and contrasts appropriate to woodcut, and in the following year, too, he cut a few roughly executed blocks. Over the next ten years, in fact, he made eighty-nine woodcuts, including romantic landscapes, the folksy illustrations to *Cotswold Characters* (1921), and the mystical designs for *Genesis* (1924). Although the woodland depicted in such landscapes as *Winter Wood* (1922) or *Black Poplar Pond* (Plate 131) of the same year is idyllic, the cutting out of the whites is excitable and violent. The staccato movements of light in *Black Poplar Pond*, however, are softened by the curved left edge of the block.

Paul's younger brother, John Nash (1893–1977), had a more prosaic and modest talent, but the woodcuts he made during the 1920s have an uncomplicated directness of execution, exemplified by *Woodland Study, Suffolk* (c. 1924), where the lights are boldly cut from the wood with the crispness of slices from an apple (Plate 132). He turned to white-line engraving for his illustrations of *Poisonous Plants* (1927) and *Flowers and Faces* (1935), and the gentle depiction of flowers and Suffolk landscape remained a life-long preoccupation.

Another painter who turned successfully to the woodcut was Charles Ginner (1878–1952), co-founder, with Sickert, of the Camden Town Group. His prints are mostly studies of Cornish buildings, in which a broad line moves from building to building, picking out details of brickwork, and creating surface pattern and light. In the *Thames Embankment* (c. 1923) he used white line, every notch in the wood contributing to his inventory of surface incident (Plate 133).

An international interest in the woodcut was concurrent with the prosperous market for etchings in the 1920s, and one sign of this newfound importance was the foundation of the Society of Wood-engravers in 1920 by Noel Rooke and Robert Gibbings.[11] Various *Studio* publications such as *The Woodcut of To-Day at Home and Abroad* (1927), give a good cross-section of some of its international manifestations. The German expressionists, however, were notable for their absence, and Michael Salaman noted sarcastically in *The New Woodcut* (1930) that 'Herr Max Beckmann, Herr E. L. Kirchmer [*sic*], Herr Erich Heckel, Herr Emil Nolde, Herr Max Pechstein and Herr Christian Rohlfs . . . take themselves very seriously.'

The English style of wood engraving was characterized by a high standard of technical competence, and a fondness for landscape, often rather whimsical in appeal. One of the most influential early members of the Society, however, was Eric Gill (1882–1940), a sculptor and scribe, who was a lay member of the Order of St. Dominic and many of whose prints are of sacred subjects.[9] Gill engraved blocks in both white and black outline, but some of his most satisfactory work was in prints like *Leda Loved* (1929), where the forms are defined by a mass of little peckings of

white. Gill had some feeling for a simple, flowing line, but his mannered Byzantine figures, skinny and elongated, and coy affectation of sexual frankness in such prints as *Woman asleep* (1936) are sometimes an obstacle to any enjoyment of his work.

The development of English wood engraving remained closely connected with the private press, and the foundation of the Golden Cockerel Press in 1920, taken over by Robert Gibbings in 1924, was quickly followed by the Gregynog and Nonesuch presses. Gill illustrated and designed several ambitious books for the Golden Cockerel Press, including *Troilus and Criseyde* (1927) and *Canterbury Tales* (1929). David Jones (1895–1975), too, who was a follower of Gill at his community in Ditchling, designed some dramatic illustrations for *The Deluge* (1927), in which intense light is released from the wood to illuminate his frenetic compositions. But Jones' gift for line of an almost uncontrollable energy is best seen in his line engravings for *The Rime of the Ancient Mariner* (1929), especially in the plate of *Going into Church* (Plate 138), where the wedding guests are twisted and turned in violent motion by their wiry contours, buttocks and elbows awry, as they seek to propel themselves in the right direction.

Perhaps the greatest pitch of technical virtuosity in wood engraving was attained by Blair Hughes-Stanton and Gertrude Hermes, pupils of Leon Underwood, himself a printmaker of great virtuosity: all three contributed wood engravings to the Cresset Press *Apocrypha* (1929). Hermes and Hughes-Stanton were unrivalled in their use of white-line engraving in bold attempts at epic figure compositions. They used the burin and the *vélo*, a multiple graver, to model light effects with fine cross-hatchings of white line, achieving greater intensity of light by broader pointings of gouged-out white. Hughes-Stanton, in particular, applied himself to monumental figure subjects, such as the cycles of prints for *Pilgrim's Progress* (1928), *Revelations* (1932/3), *Lamentations* (1933) and in more recent years *Genesis* (1970). In these ambitious engravings, where the medium is stretched almost to bursting point, massive figures with broad shoulders and tapering waists grapple with destiny in compositions that combine memories of Blake with the jagged and fragmented surfaces of provincial cubism. As in other English art of the period, however, a 'modernist' approach is expressed more in a distortion of figurative types than in any new approach to formal structure, and this uneasy alliance is often mannered and eclectic. Nevertheless, in such wood engravings as *The Model* (1926/7) or *The Turkish Bath* (1929), there is an engaging exuberance in the incision of white hair-lines defining the contour of a black-hued nude, flicks of white picking out the texture of a carpet, or the bold juxtaposition of jet black areas with scooped out masses of white (Plate 140).

Gertrude Hermes could use white line with equal vigour, and made an attempt at monumental figuration in *Fish Haulers* (1926). But she was more at home in flower studies such as *Tiger Lilies* (1927), where the corners of the block have been cleared away to fold the forms in an enclosing blanket of black, a device she frequently used. Since the war she has used the rougher effects of plank-grain wood, combining it with lino-cut in such designs as *The Ram* (1956), an animal subject of characteristic liveliness.

Few wood engravers were as ambitious as Hughes-Stanton and Hermes, however,

and such artists as Gwendolen Raverat, Douglas Percy Bliss or Noel Rooke worked in a more refined manner, the very engraving of the boxwood seeming to conjure up silvan thoughts and imagery. Bliss's *Two Lovers in a Storm* (1926) are shown huddling together wide-eyed, the rain dripping off the man's hat; it is a good example of the homely charm, expressed in precise lines, that typifies one aspect of English wood engraving.

Bliss was one of a gifted generation of students at the Royal College of Art that included Edward Bawden and Eric Ravilious (1903–41). Ravilious engraved illustrations and decorations for the Golden Cockerel and the Curwen Press, depicting sharp-nosed little figures disporting in leafy gardens in the little series of the *Twelve Months* (1927), and expressing his delight for scenes of rural whimsy in *A Boy Birds-nesting* (1927), in which he deployed a simple repertoire of freshly minted lines and scorper work with great charm (Plate 134).[10] Charm is the keynote of his work, whether it be in small, decorative tailpieces, or in the more ambitious figure compositions for the Golden Cockerel *Twelfth Night* (1932) or *The Tragedy of the Jew of Malta* (1933) Ravilious turned more to watercolour paintings and lithography in the later stages of his career, which ended tragically during World War II, when he was killed while serving as a war artist with the R.A.F. in Iceland. His crisp designs for Wisden's Cricketer's Almanack (1938) and for London Transport's Green Route booklets are still in use, and their clear lighting and broad strokes still catch the eye.

The lino-cut is essentially a member of the woodcut family; the same principle of relief cutting is applied to the softer material of linoleum, yielding notable results in the hands of Matisse and Picasso. Under the leadership of Claude Flight (1881–1955), a busy school of lino-cut artists flourished in England between the wars, printing bright colours from several blocks, and using jagged forms and simplified shapes to depict what they saw as the vital dynamism of modern life.[11] Flight took up the lino-cut on his demobilization in 1918 and applied this rather belated form of Futurism to such subjects as London trams in *Speed* (1926), or racing cars in *Brooklands*. His pupils at the Grosvenor School of Modern Art included Edith Lawrence, Cyril Power, Eileen Mayo and Lill Tschudi, who all applied themselves with enthusiasm to similar subjects. Flight's work is always cheerful, but no amount of hectic cutting could disguise his limitations as a draughtsman. He was a member of the '7 & 5' group which included Paul Nash, Barbara Hepworth and Ben Nicholson, but he was eventually voted out: his ideas must have seemed outdated and naive to the younger members.

While Flight gazed awe-struck at trams rattling down the Strand, Frederick Landseer Griggs (1876–1938) and a group of young etchers including Graham Sutherland and Paul Drury, looked back with nostalgia at the romantic landscape etchings of Samuel Palmer, following his example in dense working of the plate and the use of etching as a slow and contemplative process.

Griggs spent the first years of his career travelling around England making drawings for the *Highways and Byways* series of books published by Macmillan.[12] He turned seriously to etching in 1912, and real or imagined architecture formed the subject of most of his work. His love of Palmer's etchings is reflected in plates such as *Maur's Farm* (1913), where the determined lines of a Gothic building are contrasted

with the rounded contours of trees and thatched barns, seen in glowing evening light. Like Palmer, Griggs believed that the copper should be lovingly reworked and rebitten until the last drop of meaning and emotional intensity had been wrung from it.

In 1912 Griggs was received into the Catholic church, and his etchings become imbued with nostalgia for pre-Reformation England and its great ecclesiastical buildings. In some cases he recorded existing chapels or abbeys, but from 1915 he began to etch imaginative reconstructions of churches and towns, seen as they might have appeared at the moment before the Reformation, with hooded figures peering over bridges or battlements. In highly worked plates like *The Quay* (1916), *The Cresset* (1915), *The Barbican* (1920) and *Anglia Perdita* (1921) he depicted imaginary Gothic structures, seen from angles that emphasized their towering height, the shadows densely textured by a mesh of finely etched lines and the whole building drawn with a minute attention to every detail of brickwork. They are hallucinatory and dream-like in mood, but his intensity of vision never allows his work to degenerate into mere antiquarian whimsy.

One of Griggs' most highly wrought and haunting etchings is of *Owlpen Manor* (1930), the Gloucestershire house restored and occupied by his friend Norman Jewison, its shape half-obscured by an avenue of clipped yew trees (Plate 135). Its atmosphere of intense but inaccessible reality recalls not only Palmer, but also the ghost stories of M. R. James, for which it might almost serve as an illustration.

Graham Sutherland began his career as an etcher of small pastorals, inspired by Samuel Palmer and the wood engravings of Virgil by Blake.[13] He shared his enthusiasm for these with Paul Drury, a fellow student at Goldsmith's College of Art in the 1920s. Sutherland has written that 'It seemed to me wonderful that a strong emotion, such as was Palmer's, could change and transform the appearance of things. I know that this obsession was a young man's passion, an adolescent flame, which was bound to end in one's "first death". Nevertheless the idea of the way in which emotion can change appearances has never left me.'[14] His idyllic prints of this period include *Pecken Wood* of 1925, and *St. Mary Hatch* (Plate 136) and *Lammas*, both of 1926; they are intense visions of unsullied village life glimpsed at eventide, the inhabitants wandering slowly by thatched cottages, the shadows deep-bitten and worked upon until the light gleams through in tiny pinpricks. Drury's etchings include *After Work* (1925) and *September* (1928) which are lighter and less heavily textured, but are of similarly blissful rural scenes.

Sutherland later began to develop the more personal themes expressed in the twisted shapes of dead trees in *Pastoral* (1930) and in the greater abstraction of *The Garden* (1931). The collapse of the etching market helped impel him towards a career as a painter, and in this medium he has portrayed hostile and spiky vegetation and contorted shapes—a concept of landscape quite at odds with his 'Shoreham' period. Since the war he has made many lithographs on these themes, and on animal subjects, notably in the series of twenty-five colour lithographs for *The Bestiary* (1968), executed with painterly freedom.

Line engraving of a traditional kind was revived in the 1920s by Robert Austin (1895–1973), who engraved wonderfully crisp and sharp lines to create images with

a clarity that has a 'super-real' quality. One of his most frequent themes was that of a figure on a staircase casting intense shadows on the wall behind, of which *The Curtain* (1939) is a good example.

But the practice of line-engraving was given an entirely new direction by the British-born printmaker Stanley William Hayter, whose influence on twentieth-century printmaking has been immense.[15] Hayter was born in London in 1901, but his career has been spent in France and America, and he can hardly be claimed for the British school. He has had a great influence on British printmaking, however, both through his books, *New Ways of Gravure* and *About Prints*, and through the many English artists who have worked at his Paris studio, Atelier 17, and have been influenced by his experimental approach to printmaking.

Hayter went to Paris in 1926, and became acquainted with surrealist artists such as Arp and Miro. He was greatly influenced by the surrealist practice of automatic drawing, but the main stimulus to his technical development as an engraver came from Joseph Hecht, whose decorative plates of animals were engraved with a free, linear use of the burin. Hayter developed this technique in line engravings of tortured surrealist shapes, engraved by lines twisting and bending back on themselves at great speed. For Hayter 'the burin is a kind of plough which goes ahead of the manipulator in an exploratory and inventive way and not behind him.'

In 1927 he founded a studio for printmaking and for research into new methods, which acquired its famous name of Atelier 17 through a change of address in 1933. Since then many artists, including Picasso and Miro, and students of every nationality, have worked at the studio and have learned within its experimental atmosphere. One of the English artists of Hayter's own generation who worked there was Julian Trevelyan, who developed a method of impressing textured materials into soft-ground subsequently used by Hayter in a number of plates in the late 1930s (Plate 139). At this time Trevelyan himself was etching playful surrealist compositions in the manner of Klee, and he has since etched many decorative colour plates.

In 1940 Hayter moved to America, and it was there that he began to experiment with the printing of several colours from a single plate, using different rollers and viscosities of ink to deposit colours in lines of varying depths. It is in this development of colour printing from a single plate that Hayter's influence has been most pervasive, and what is perhaps the most vital aspect of his art, the brilliant creative use of the burin, has had fewer followers. In America he re-established Atelier 17, and his influence is reflected in some of the dynamic etchings made there by Jackson Pollock, energetically deploying the methods of automatism.

Hayter's technical brilliance and the exhilarating vigour of his best plates is beyond dispute, but his influence on weaker artists has not always been happy. In some respects *New Ways of Gravure* has been the twentieth-century equivalent of Hamerton's *Etching and Etchers*, replacing the cult of spontaneity with that of restless experimentation. His methods of colour printing have spawned some good prints, but also a great many where after countless bitings and inkings the result is a technically ingenious image, densely textured and brightly coloured, but deadened as though struck by the metallic glare of the copper.

Another English artist, Anthony Gross, also settled in France in 1926, and, like

Hayter, was influenced by Hecht's playful use of the burin; but there the similarity ends.[16] Gross has mostly abjured the use of colour and tonal techniques, and has instead explored the infinite possibilities of etched and engraved line in prints of a consistently cheerful and sprightly character. His subjects have been figures crowded together on busy streets or beaches; wriggling with animation; he can seldom resist the urge to include yet one more figure scampering across a street, or to pick out with a spindly line every item displayed in a shop window. In landscapes his needle joyfully describes the most tangled bushes and undergrowth, lingering over the detailed examination of spiders, grasshoppers or centipedes, as they busy themselves among the leaves. Some of his best early plates are in the series of the *Sortie d'Usine* (1930/1), showing the after-work activities of workers from a power station (Plate 137). The figures are in perpetual motion; a few broad lines rapidly define the contour of one, and then produce a flurry of marks on another, bringing a girl's form briefly into focus. The jumps in scale are mischievous and ebullient; Amazonian females tower above chirpy squiggles on the ground, which on closer examination turn out to be figures of children or dogs, and this refusal to allow the eye a moment's repose is both the charm, and at times the drawback, of Gross's work.

Gross returned to London at the beginning of the war and travelled widely in his capacity as a war artist. He had little time for etching, although his work of this period includes the amusing *11 o'clock Parade, Guards Depot, Caterham* (1940). His gift for depicting hordes of figures is akin to Ensor's, but without any of the Belgian artist's satirical edge; Gross is always an affectionate observer. From 1955, when he began to teach at the Slade, Gross began to etch with an increasingly profligate use of texture, using such tools as a multiple needle and a roulette made from a cigarette lighter wheel to score and stipple a plate from top to bottom, thus finding some graphic equivalent for every twig and rut of earth in the landscape he is celebrating. Sometimes this restless inclusiveness, a persistent *allegro vivace*, is too lacking in concentration, but the cheerfulness of his work, his inventiveness within the limits of technique he has imposed on himself, give him a unique place in the history of modern British etching.

With the collapse of the etching market in the 1930s and the subsequent war, there occurs a hiatus in the development of the English print. One interesting project of the period, however, was the Contemporary Lithographs scheme, started by John Piper and Robert Wellington, in which a number of artists including Wadsworth, Sutherland (who drew an uncharacteristic print of a *Sick Duck*) and Edward Bawden, were invited to make a colour lithograph, to be printed in large editions and sold cheaply to schools. These were printed at the Curwen Press, who for some years had been associated with some of the best illustrations and press work done in England, and who were to develop into printers of artists' lithographs after the war.[17] In the immediate post-war years the market for prints was negligible, especially for those in a modern spirit. Some notable prints were made, however, even without the backing of an established market and the apparatus of the print publisher. Ben Nicholson had made a handful of lino-cuts between 1926 and 1937, not with any view to publication, but from the impulse to incise a white line in another material. The drypoints he began to execute from 1948 were similarly limited in the number

of impressions taken.[18] *Halse Town* (1948) shows all his capacity for lines alternating at a rapid pace from the descriptive to the discursive (Plate 142). Nicholson recorded that 'The bite of the steel point into the metal is a terrific experience when all goes right and the necessity I am finding to reduce the idea to a series of lines is interesting. There is a point also where I can cut into the metal in a line as straight as any ruler but with this difference, that the ruler will always rule straight whereas my hand may at any moment decide to develop a curve . . .'[19] In 1966, the Marlborough Gallery issued the ten etchings of the *Architectural Suite*, and since then he has made a number of etchings, sometimes on an irregularly shaped plate, of abstract themes and of architectural and still-life subjects.

Merlyn Evans began engraving in the late 1930s, his rather severe improvisations on linear themes owing something to Hayter and Surrealism.[20] After the war he combined etching with aquatint in the powerful subjects of *The Execution* (1946/8) and *The Chess Players* (1949/51), but employed harsh lines and deep biting for the large *Tragic Group* (1949/50), in which the figures seem to have been hacked out of rusting sheet metal (Plate 141). A rhetorical assertiveness, here applied to the grim reflections inspired by the war, is also characteristic of his later work, such as the gestural shapes of the *Vertical Suite in Black* (1958). He turned to mezzotint in 1958, using it on a massive scale in the *Pentaptych* series (1961) where densely black shapes rise from a base, and in the *Venture Triptych* series (1969–70), where they float free in space. In his predilection for monumental cut-out shapes and in the heavily constructed figures of his earlier prints, Evans relates more closely to the sculpture of the period than to any print tradition.

His *Vertical Suite in Black* was published by Robert Erskine at the St. George's Gallery, which Erskine had founded in 1955, and although some years were to pass before the extraordinary boom in printmaking really began, this event laid some of its foundations. Erskine's aim was to persuade the British public to buy prints, a habit they had long-since lost, and to educate them in the special qualities of the printed image. He has pointed out that he made a deliberate attempt to revive the Vollard concept of the suite of prints, and—besides the Evans set—he commissioned *Le Boulvé Suite* from Anthony Gross (1956) and the *Hammerklavier Suite* (1959) by Ceri Richards.[21] Since then, the suite of prints, where some central theme or idea is explored from a number of different angles, has become a particular feature of British printmaking.

Erskine was also responsible for encouraging Stanley Jones to study the art of lithographic printing in Paris, and Jones subsequently brought to England a skill and dedication in printing that had always survived in Paris, but had not existed in England since the days of Thomas Way. His skill is such that eminent painters, blissfully unaware of what is or is not possible in lithography, have been able to draw upon lithographic plates in the sure knowledge that, whenever they transgress its rules, the indefatigable Jones will rescue their work from disaster. He was employed as a printer by the Curwen Press when they set up a studio for printing editions of artists' lithographs in 1958, its first important undertaking being the printing of Ceri Richards' *Hammerklavier Suite*. In these prints, Richards' romantic lyricism is expressed in overprintings of rich colour, and dynamic movement. The

suitability of lithography for this painterly freedom of execution is even more evident in his *Twelve Lithographs for Six Poems by Dylan Thomas* (1965), and it was unfortunate that Richards turned increasingly to screenprinting with its more impersonal surface. Many of the best post-war lithographers have worked with the Curwen Press, including Reg Butler and John Piper. Piper's series of prints in *A Retrospect of Churches* (1964) took advantage of Jones' skills in an attempt to 'make the prints look frightfully casual . . .' A playful variety of techniques, including photo-lithography, were employed for instance in *Llangloffan, Pembrokeshire, the Baptist Chapel*, where the austere outlines of a Methodist chapel appear behind a dense mass of foliage.

Jones has been strongly associated with Henry Moore, who since 1963 has been an increasingly prolific printmaker, both in etching and lithography.[22] Before this period, Moore had, in his own words, 'spasms of printmaking', which were essentially a diversion from his main activity as a sculptor. He had contributed a number of lithographs to the ambitious Schools Prints project of 1949, whereby a number of eminent artists including Picasso were persuaded by Brenda Rawnsley to make a colour lithograph to be printed in a large edition for cheap sale to schools. Moore's *Sculptural Objects* (1949), crisply drawn and printed in bright reds and blues, anticipates the purpose of many of his later lithographs, which is to reflect on his sculptural themes in a number of objects drawn side by side. Moore has always viewed printmaking as another means of making a drawing, and with a draughtsman of such stature this has resulted in fine prints; but many of his lithographs, frequently printed in cheerful colours, present the appearance of skilfully reproduced sketch-book leaves that do not materially extend the artist's range. Since 1973, Moore has made extensive use of a process in which a drawing on transparent paper can be transferred, by the action of ultra-violet light, to a diazo plate, preserving all the freedom of the artist's lines and washes of colour.

Moore has said that: '. . . of the two mediums I prefer etching. Technically and physically I like using the fine point of an etching needle on metal rather more than soft-chalk on stone.' Moore was introduced to intaglio processes by Merlyn Evans after the war, and one result of this association was the small drypoint, with roughly grained aquatint, of the perennial theme of a *Reclining Figure* (Plate 143), which he began in 1951 and reworked in 1966. The long, curved body culminates in a playfully drawn profile, but there is also a suggestion of another head turned away from the spectator; the figure thus presents itself physically but seems to withdraw its personality, in diminishing echoes, into the depths of the background. Moore loves the etchings of Rembrandt, and some memory of the reclining figure of the *Naked Negress* is perhaps to be found in this plate. Its mysterious light, and burnished and aquatinted texture are the result of a contemplative working of the medium. The same may be said of the great series of etchings of the *Elephant Skull* (1969–70), which were drawn directly onto the plate with the finest of lines and express Moore's enthralled exploration of the subject's 'intricate and mysterious interior structure, with perspectives and depths like caves and columns and tunnels.'

From the early 1960s the publication of prints of every description increased from a steady flow to a flood. Print publishers sprang up overnight, galleries that had

hitherto ignored and even scorned prints hastily purchased racks and folders, and announced the opening of a 'graphics' department. Painters musing quietly in their studios were persuaded by the seductive entreaties of their dealers to bestir themselves, and make a screenprint, lithograph or etching. Print prices began to rocket; the collector with his signed and numbered print from a limited edition of fifty or seventy-five could, if he had purchased wisely or luckily, find himself with one of the most lucrative investments of the decade.

A central feature of this buoyant print market was the great vogue for the screen-print, hitherto largely confined to commercial printing. It was singularly suitable to the requirements of pop artists or hard edge abstractionists, since it could accept the photographic imagery used by the former and exactly reproduce the clean edges, flat, dense colour and rather impersonal surface qualities required by the latter. A central feature of the development of the screenprint was the skilled printing of Chris Prater. He established himself as a printer of posters in 1957, and in 1961 he made his first artist's print for Gordon House. Eduardo Paolozzi had made a limited use of screenprinting before this date, but it was not until he was introduced to Prater by House that he began fully to explore its possibilities. In his turn, Richard Hamilton was persuaded to make a screenprint, and it was he who then chose the artists to be commissioned by the Institute of Contemporary Arts to make a print in the medium, their numbers including Victor Pasmore, R. B. Kitaj and Joe Tilson.

In a contravention of the accepted definition of what constituted an original print, both Hamilton and Paolozzi believed that an artist should utilize all the modern technical developments available to him, harnessing to his purpose the craftsmen who could best implement them. Hamilton found that screenprinting 'has a certain appeal also because it is less autographic than etching or litho—it hasn't their dependence on the hand of the artist: in that sense it is a modern print-maker's medium.'[23]

Paolozzi's first major screenprint was *Metalization of a Dream* (1962/3). For this print he developed his procedure of making a collage which was then photographed so that stencils for the individual colours could then be prepared by Prater or other skilled craftsmen.[24] In the series of twelve screenprints of *As is When* (1965), based on the life and writings of Wittgenstein, Paolozzi deployed a jangling profusion of visual material to mirror the verbal paradoxes and conundrums posed by the philosopher (Fig. 12; page 107). Stridently coloured geometric patterns and shapes jostle with printed words, with cut-out photographic imagery and with engineering diagrams representing the intestines of automated figures, in a game of cybernetic snakes and ladders. A further blow was aimed at the accepted concept of an artist's original print, by the printing of each set in different colour schemes. In their energetic juggling with the possibilities of a new print medium through the extension of the repertoire of visual language which it can carry, the *As is When* prints represent one of the most vital new departures in post-war printmaking.

From his student days, Paolozzi had a consuming interest not only in traditional manifestations of fine art, but in photographs from glossy magazines, comics, toy robots, the garishly packaged consumer products of America; all of these he saw as legitimate material for the artist's attention. In his series of screenprints such as

Moonstrips Empire News (1967), *Universal Electronic Vacuum* (1967) and *General Dynamic F.U.N.* (1968), he used the print as a receptacle for the most varied imagery in which Donald Duck has as much right to a place as a photograph of a Michelangelo sculpture or the purely abstract configurations of shape suggestive of computers and high technology.

Paolozzi's eager utilization of available printmaking techniques has not been confined to screenprinting; in 1970 he turned to photogravure etching to produce minute definition within the small prints of the *Conditional Probability Machine*, in which photographs of scientific experiments, or of the dummies used in simulated car crashes, suggest human situations and problems. In more recent prints, the content has become less strident, less interested in an aggressive modernity of subject and technique, and he has applied himself to a more restrained and formal abstraction in the set of etchings of the *Ravel Suite* (1974) and the screenprints of *Calcium Light Night* (1975–6). These are visual interpretations of the music of Ravel and Charles Ives respectively. In a complete volte-face from his earlier immersion in highly complex print techniques, he has returned to the oldest and simplest process, the woodcut, in the suite of six prints *For Charles Rennie Mackintosh* (1975–6), in which the curving pipes and grid forms common to many of his prints deploy themselves in gentler harmony, and shed themselves of bright colour.

Richard Hamilton, like Paolozzi, anticipated Pop Art in his appropriation of imagery and techniques from commercial advertising into a fine art context. Hamilton had etched and engraved a good many plates before coming to the screenprint in 1963, when he took his painting *Adonis in Y fronts* as the basis for a print, combining grainy photographic imagery with clean-cut, stencilled shapes. A photograph of a collage served as the basis for *Interior* (1964–65), in which the minutiae of a well-furnished household, complete with doll-like housewife, are overlaid or clipped into place by broad slats of tone (Plate 144). Hamilton has used prints to rework and reconsider the imagery of his paintings in progress, and to debate the permutations that may be played between the hand-made and the photographic; each work represents his ruminations over a problem posed by the nature of a technique or subject. Thus a detail from a transparency of German holidaymakers splashing in a Greek bay served, in the screenprint *Bathers* (1967), as the basis for a series of experiments in photographic printing procedures, the identity of the figures being progressively whittled away by each technical evolution. Similarly in *People* (1968), a small-edition print incorporating collage and hand-made marks, Hamilton took a detail from a postcard of a crowded beach scene, blowing it up to a large scale and searching for the piquant moment when the figures in the image blur into mere surface marks. Hamilton has played a number of variations on the more recognizable subject of Bing Crosby; he is seen in negative in *I'm dreaming of a white Christmas* (1967), and is turned back to positive tones in *I'm dreaming of a black Christmas* (1971). Hamilton's reappraisal of subjects over a period of years seems to tread a narrow line between perfectionism and narcissism.

R. B. Kitaj, an American who has followed his career in London, has made extensive and demanding use of the screenprint as a vehicle for fragmented compositions, containing an abundance of esoteric subjects and allusions. Like Paolozzi,

he has relied on the skills of Chris Prater at the Kelpra studios to find ways of print-
ing multiple layers of colour, photographic imagery and painted areas, that together
make up the serial imagery of his work. *Die gute alte Zeit* (Plate 146) from the series
of seven prints, *Struggle in the West—The Bombing of London* (1967-9), involved not
only forty-three printings but the addition of collaged fragments, no less than eighty-
one operations being involved in the making of the print. The structure itself,
regardless of any layers of literary meaning, is of great beauty: oblongs and squares
are hinged together, some torn at the edges to provide openings in the design;
elaborate wall-papers evocative of the period are set against photographs on which
the eye fixes to extract immediately identifiable nuggets of information. His major
series of prints include *Mahler Becomes Politics, Beisbol* (1967), *First Series—Some Poets*
(1966-69), in which dryly painted portrait heads have been transferred to the screen
and then inset amongst a montage of shapes and photographs, and the portfolio *In
Our Time* (1970), which solemnly records the covers of books from Kitaj's library.

The impersonal surface of the screenprint, and the clarity of a precisely cut,
stencilled edge are also ideally suited to translating the simplified shapes, and the
flat, even colour, of Patrick Caulfield's paintings. The packages of information in a
Kitaj or a Paolozzi are a world away from Caulfield's imagery. This normally con-
sists of images of a judiciously selected banality; the artist chooses such subjects as a
pipe and a box of matches, the pine furnishings of a suburban Trattoria, or a bowl of
flowers in the corner of a room (Plate 145), in which the perspectival lines irradiate
from the vase and intersect the surrounding frame in coy salutation to Mondrian.

Some of the finest English prints of the last two decades have been published by
Editions Alecto, and one of their earliest successes was the set of etchings of *The
Rake's Progress* (1961-3) by David Hockney.[25] In these witty variations on Hogarth's
themes, Hockney chronicled his adventures amongst the dangers and delights of
America: with his neck sticking nervously from his collar he sells some of his prints
in *Receiving the Inheritance*, or is engorged by a snake in *Cast Aside*. The plates use
playful variations of line, from a scratchy profile to haystacks of shading, set off by
blocks of aquatinted tone. This basic fare of the etcher's art is deployed with equal
effectiveness, and with the same artfully naive drawing in *The Hypnotist* (1963), in
which 'an innocent helpless-looking boy' is menaced by a malevolent figure, perform-
ing the stagy evolutions of his calling (Plate 147).

Hockney has written that 'I'm not a printmaker, I'm a painter who makes a few
prints. The point about etching is that you have to know how to draw; it's basically
a linear medium.'[26] It is a comment that might have been made by Sickert, and, in
their etchings at least, the two, rather surprisingly, have points in common. Thus
Hockney's illustrations to *Fourteen Poems from C. P. Cavafy* (1966), etched in wiry
outline, explore the theme of two figures in a bedroom so often drawn by Sickert,
though the bedrooms and the figures are very different. Likewise they both show little
patience with all the technical tricks acquired by full-time printmakers, whose
horizons are limited by the acid bath and the quest for new effects of printing.

Hockney made extensive use of a regular system of cross-hatched line as a back-
ground to freely drawn lines in his inventive and entertaining illustrations to *Six
Fairy Tales from the Brothers Grimm* (1969). The wry commentary on pictorial and

graphic conventions to be found in these prints is a recurring preoccupation of
Hockney's, an earlier example being the set of colour lithographs of *A Hollywood
Collection* (1965), where six parodies of conventional art subjects include elaborately
drawn frames; these include such subjects as *Picture of a Pointless Abstraction Framed
under Glass*.

As a draughtsman from the life Hockney has few peers among living artists, and
his many lucid pen outline drawings of his friends, and the more luxuriant crayon
studies, have their counterpart in etchings and lithographs. A remarkable example of
the latter is the large portrait of *The Print Collector* (1969), drawn from life straight
onto the plate with a fine sense of placing, and with a nice attention to the scraggy
details of his model's profile (Fig. 16; page 108). Hockney's observant eye and ability
to concentrate on the significant details, often of mundane objects, is also evident in
still-lifes such as the colour etching entitled *Postcard of Richard Wagner with Glass of
Water* (1973). In 1973 Hockney worked in the print studio of Crommelynck in
Paris, and acquired a number of new print skills, including lift-ground, or sugar-lift,
which he experimented with in *Showing Maurice the Sugar Lift* (1974). Nonetheless,
his range of techniques, compared with many professional printmakers, is small.
Such is the scope and varied character of his work, however, whether in whimsical
mood or in ungarnished representation of person or place, that he already takes a
place among the finest British printmakers. It is not too fanciful to imagine that
Hogarth would have reciprocated Hockney's admiration.

Allen Jones is another painter from a generation of young English pop-artists who
emerged from the Royal College at the beginning of the 1960s and who have made
brilliantly inventive prints. In numerous lithographs he has pursued a world of
feminine glamour, or of viragos in fetishistic habiliment and propped up on stiletto
heels of awesome severity. In *Leg-Splash* (1970), the sharp contour of leg and heel
slice across the page in contrast to the bold splashes of lithographic wash, illustrating
the dynamism and aplomb of his best work (Plate 148). He combined photo-litho
with autolithography in the *Life-Class* series of 1968, the bottom half of the prints
showing the specially posed and photographed legs of a mini-skirted model, while
the upper half, and sometimes the lower, is invaded by hand drawn figuration,
reality jostling energetically with fantasy.

Printmaking has been practised with such energy and variety of purpose and
technique in recent years, that no sooner has an official body defined the precise
nature of an original artst's print in measured and portentous prose, than some
ingenious artist has pegged out a space for activity well beyond its frontiers.[27]
Michael Rothenstein, for instance, has applied boundless energy to extending the
range of the relief processes of wood and lino, sometimes combining them with
screenprint and photo-screen. In contrast to this mixture of methods are the prints
of Birgit Skiold, influenced by the refinement of Japanese art, which largely dispense
with ink and rely on the embossed effect of relief etching or intaglio printed lino-
blocks. Richard Smith has added another spatial dimension to his lithographs by
cutting and folding them into shapes after printing, and by adding attachments of
string or other materials. The use of photographic imagery in prints, pioneered by
Hamilton and Paolozzi, has been employed by many artists, notably by Colin Self

in the etchings and screenprints of his *Power and Beauty* series (1968). Peter Freeth uses a collage of ephemeral printed imagery as a basis for his aquatints, distinguished by a subtle play of soft grey tones and reticent wistfulness of mood (Plate 149). In this they are at odds with the tendency of many prints to be large and brightly coloured, the better to shout for attention from the dealer's 'print-bin'.

In addition to the many specialist printmakers, few noteworthy painters and sculptors have not made at least a few prints, although Francis Bacon is a notable exception to this general rule. Amongst the senior generation of abstract painters and constructivists, Victor Pasmore has used prints as another outlet in which to deploy his well-rehearsed repertoire of nicely poised shapes, or blocks of tone, traversed or opened up by meandering lines. For his series of prints entitled *Points of Contact* (1965–) he used screenprint or lithography, but relied on etching or aquatint in the series *Correspondences, Words and Images* (1974) from which 'When the curtain falls' is an unusually romantic example (Plate 150).

The enthusiasm with which new subjects and techniques have been exploited has not precluded the creation of fine prints on traditional themes, and Richard Beer and Valerie Thornton have both etched many interesting architectural plates. In large and atmospheric landscapes, Norman Ackroyd depicts the sweeping contours of Welsh and Scottish hills, with acid brushed onto the plate with great control (Plate 152). He has also found subjects in America, particularly of buildings and industrial installations. Although they are large plates, and usually printed in deep black, their mood is celebratory rather than sombre. A number of artists have recently turned to the long neglected medium of mezzotint, in which Norman Stevens has achieved results of particular excellence. In the large print of *Dusk* (1973), printed in colours from two plates, a strong pattern is created by the horizontal blocks of the steps which are crossed by the blurred shadows of trees (Plate 151). Emphatic, formal qualities are here united with an intensely romantic atmosphere. In this, as in other prints and paintings by the artist, of such themes as a quiet lane, a flight of steps, or a clapboard house with shuttered windows, sound and motion are excluded.

It is not unusual to conclude a book such as this with a rousing peroration, and some thoughtful reflections on what the future may hold in store. Such predictions, when the dust raised by the hectic production of the last few years has not begun to settle, would be rash indeed. A certain turning away from mere technical virtuosity, the breathless espousal of multi-media effects, is already evident and shows a realization that the dextrous manipulation of technique is not enough. No doubt the history of prints will continue to reflect, as it always has, the vigour or lassitude evident in the current school of painting. In the face of the photographic reproduction, film and television, the artist's print can never hope to regain the central place it once held in the nation's affairs; any claims for the print as the 'democratic' art are merely childish, and the limited edition aimed at a relatively small collector's market is likely to remain the norm. Yet, within these limited bounds, more original and inventive artists' prints have been made in the last two decades than at any other period in English art, and future generations, while discarding the dross, will find much that is vital and enduring.

Notes

Chapter One

1. A few separate sheets, mostly *Images of Pity*, are contemporary with Caxton's books. See C. Dodgson, English Devotional Woodcuts of the late fifteenth century, *Walpole Society*, XVII, 1928–9.
2. E. Hodnett, *English Woodcuts 1480–1535*. Reprinted with additions and corrections, Oxford, 1973. See also A. M. Hind, *An Introduction to a History of Woodcut*, 2 vols, London, 1935.
3. A. M. Hind, 'Hans Holbein and English Woodcut in the Sixteenth Century, Studies in English Engraving', II, *Connoisseur*, 1933.
4. Known to Hind only in the Edinburgh University copy.
5. For a comprehensive illustrated catalogue of English engraving up to the Civil War (but not including Hollar or Faithorne) see A. M. Hind, *Engraving in England in the Sixteenth and Seventeenth Centuries*, Part I, *The Tudor Period*, Cambridge, 1952; Part II, *The Reign of James I*, Cambridge, 1955; and M. Corbett, and M. Norton, Part III, *The Reign of Charles I*, Cambridge, 1964.
6. R. Strong, *Portraits of Queen Elizabeth*, Oxford, 1963.
7. E. Hodnett, *Marcus Gheeraerts the Elder, of Bruges, London and Antwerp*, Utrecht, 1971.
8. In the Royal Collection; it was also engraved by Crispin Van de Passe the Elder.
9. G. S. Layard, *Catalogue Raisonné of Engraved British Portraits from altered plates*, 1935.

Chapter Two

1. The standard catalogue of Hollar's etchings is G. Parthey's *Wenzel Hollar, Beschreibendes Verzeichnis seiner Kupferstiche*, Berlin, 1854; revised edition, 1856.
2. See F. C. Springell, *Connoisseur and Diplomat. The Earl of Arundel's Embassy to Germany in 1636 . . .*, London, 1963. This contains an excellent chapter on Hollar.
3. Quoted in Springell, op. cit., p. 143.
4. *The Diary of John Evelyn*, ed. E. S. De Beer, Oxford, 1959, p. 18.
5. See A. M. Hind, *Wenceslaus Hollar and his Views of London and Windsor in the seventeenth century*, London, 1922.
6. George Vertue Notebooks, Vol. I, p. 112, *Walpole Society*, XVIII, London, 1930.
7. *Brief Lives*, ed. O. C. Dick, London, 1949, pp. 162–3.
8. Vertue, I, pp. 34–5.
9. Marmion, who was made free of the Painter-Stainer's Company on 4 March 1650, the same day as Barlow, is known only by these prints.
10. Bredius numbers Br. 539A and Br. 134 respectively; Bredius, *Rembrandt*, London, 1971.
11. Strict priority may be claimed by some incompetent Italian views by John Evelyn (1645), and some little prints by Peregrine Lovell.
12. H. Jenkins, *Edward Benlowes*, London, 1952.
13. Although the plate to Canto II, *The Abnegation*, is very close to Marmion's style.
14. The 1687 edition contains thirty-one new plates designed by Barlow to illustrate Aesop's life and mostly etched by Thomas Dudley.
15. See E. Croft-Murray, and P. Hulton, *Catalogue of British Drawings*, British Museum, 1960, Vol. I.
16. F. G. Stephens, *Political and Personal Satires*, Vol. I, No. 1045, British Museum, 1870.
17. H. M. Hake, *Some Contemporary Records relating to Francis Place . . . with a Catalogue of his Engraved Work*, Vol. 10, *Walpole Society*, 1922, pp. 39–69.
18. Vertue, I, pp. 34–5.
19. H. V. S. and M. S. Ogden, *English Taste in Landscape in the Seventeenth Century*, Ann Arbor, 1955.
20. H. Honour, 'York Virtuosi', *Apollo*, 71, 1957, pp. 143–5.
21. L. Fagan, *A Descriptive Catalogue of the Engraved Works of William Faithorne*, London,

1888. A. M. Hind, Studies in English Engraving, IV, *Connoisseur*, Aug. 1933.

22. J. Charrington, *A Catalogue of the English Portraits in the Library of Samuel Pepys*, Cambridge, 1936.

23. H. M. Petter, *The Oxford Almanacks*, Oxford, 1974.

24. Vertue, III, p. 7

25. Orovida C. Pissarro, 'Prince Rupert and the Invention of Mezzotint', *Walpole Society*, XXXVI, 1956, pp. 1–9.

26. Pissarro, op. cit., p. 8.

27. D. Alexander, 'Dutch Mezzotint Engravers in Holland and England in the late Seventeenth Century', *Connoisseur*, 193, Oct. 1976, pp. 134–9.

28. J. Chaloner-Smith, *British Mezzotint Portraits*, 4 vols., London, 1878–83.

29. Browne's name appears, as publisher only, on many anonymous plates.

30. Vertue, I, p. 43.

31. R. Raines, *Marcellus Laroon*, London, 1966.

32. Hake, op. cit., pp. 65–6.

33. See E. Croft-Murray, *Decorative Painting in England*, Country Life, 1962, Vol. I, pp. 46–7.

34. Mr. Christopher Mendez kindly informs me that Robinson's *Vanitas Still Life* is a slightly altered copy from a mezzotint by Pieter Schenck.

35. Vertue, III, p. 14.

Chapter Three

1. Walpole Society, Nos. XVIII (1930), XX (1932), XXII (1934), XXIV (1938), XXIX (1947), and XXX (1955), (Vertue 1–6).

2. F. Paknadel, 'Shaftesbury's Illustrations of Characteristics', *Journal of the Warburg and Courtauld Institutes*, Vol., XXXVII.

3. R. Paulson, *Hogarth's Graphic Works*, 2 vols., Yale University Press, 1965. See also, *The Analysis of Beauty with the Rejected Passages from the Manuscript Drafts and Autobiographical Notes*, Ed. J. Burke, Oxford, 1955.

4. *Autobiographical Notes*, op. cit., p. 226.

5. Vertue, III, p. 147.

6. Dorothy George, *English Political Caricature to 1792*, Oxford, 1959. See also, H. M. Atherton, *Political Prints in the Age of Hogarth*, Oxford, 1974.

7. However, the 'Engraver's' first statement is: '. . . I am sensible we Engravers are pretty much Painter's Copyists'.

8. Burke, op. cit., p. 226.

9. H. Hammelmann, *Book Illustrators in Eighteenth Century England*, Yale University Press, 1975, pp. 96–101.

10. Quoted in Atherton, op. cit., p. 79.

11. Hammelmann, op. cit., pp. 38–46.

12. *Farington Diary*, 1 July 1806, Typescript from Windsor MSS. in the Print Room, British Museum.

13. *Gentleman's Magazine*, II, 1810, p. 499.

14. He was immediately imprisoned in the Bastille as a reprisal for French prisoners taken at Culloden.

15. J. Hayes, *Gainsborough as Printmaker*, London, 1971.

16. Hayes, op. cit., p. 41, says of the *Wooded Landscape with Gipsies*, that 'no impressions of the original etching by Gainsborough are now known', but his Plate 34 reproduces the preliminary etched state which is entirely the work of Gainsborough.

17. *An Essay on the Whole Art of Criticism*, 1773, (Collected edition), p. 234.

18. See Wilson's *Autobiographical Memoirs*, edited by The Rev. Herbert Randolph, in Vol. I of *Life of General Sir Robert Wilson*, London, 1862.

19. C. Dack, *Sketch of the Life of Thomas Worlidge*, Peterborough, 1907.

20. J. T. Smith, *A Book for a Rainy Day*, 3rd ed., 1861, p. 98.

21. One hundred of Sandby's etchings were published in 1765 by Ryland and Bryer.

22. E. Hodnett, 'Elisha Kirkall', *The Book Collector*, Summer, 1976, pp. 195–209.

23. Kirkall's colour prints for *A Catalogue of Trees, Shrubs, Plants, and Flowers . . .* (1730) are printed à la poupée. His preferred colours are green and blue.

24. Hodnett, op. cit., establishes Kirkall's authorship of these.

25. Vertue III, p. 105.

26. A. M. Hake, 'Pond and Knapton's Imitations of Drawings', *Print Collectors' Quarterly*, IX, 1922.

27. H. W. Singer, *Le Blon*, 1901.

28. Progress proofs of *Van Dyck's Self-Portrait* are in the British Museum. Le Blon sometimes had recourse to the use of black from a fourth plate.

29. J. Kainen, 'John Baptist Jackson', *Smithsonian Bulletin* 222, 1962.

30. Chiaroscuro woodcuts were used almost entirely for the reproduction of drawings.

31. I believe that Kainen, op. cit., overestimates the number of blocks used, not allowing sufficiently for the effects of overprinting.

32. Vertue III, p. 88.

Chapter Four

1. In 1769 engravers were admitted in the inferior capacity of Associates, with no say in the proceedings of the body; the first being Thomas Major. Most of the best engravers considered this status as degrading and would have nothing to do with the Academy. Apprentice engravers were admitted to the Schools to study drawing, but engraving was never taught there.

2. *Lectures on Painting*, 1820, p. 185.

3. L. Fagan, *A Catalogue Raisonné of the Engraved Works of William Woollett*, London, 1885.

4. For Boydell's account of this commission see

J. T. Smith, *Nollekens and his Times*, 2nd ed., 1829, Vol. 2, p. 186.

5. *Memoirs and Recollections of the Late Abraham Raimbach*, 1843, pp. 53–4.

6. 'Memoirs of Thomas Jones', ed. A. P. Oppé, *Walpole Society*, XXXII, 1951.

7. *Farington Diary*, July 8 1806.

8. James Dennistoun, *Memoirs of Sir Robert Strange, and of His Brother-in-Law Andrew Lumisden*, 2 vols., London, 1855.

9. W. S. Baker, *William Sharp*, Philadelphia, 1877.

10. D. J. Prown, *John Singleton Copley*, 2 vols., Harvard University Press, 1966.

11. *A Critical Guide to the Exhibition of the Royal Academy*, 1796.

12. The Balmanno collection of engravings after Stothard is in the British Museum.

13. Boydell's stock is listed in *An Alphabetical Catalogue of Plates . . .* (1803).

14. *The Present State of the Arts in England*, 1755, p. 82.

15. E. Hamilton, *A Catalogue Raisonné of the Engraved Works of Sir Joshua Reynolds*, London, 1874.

16. James Northcote, *The Life of Sir Joshua Reynolds*, 1818, Vol. I, p. 64.

17. W. G. Strickland, *A Dictionary of Irish Artists*, 2 vols., Dublin, 1913.

18. Benedict Nicolson, *Joseph Wright of Derby*, Paul Mellon Foundation, Vol. I, 1968, p. 31 and pp. 42–5.

19. J. E. Wessely, *Richard Earlom*, Hamburg, 1886.

20. *A Review of the Polite Arts in France, Compared with their Present State in England . . .*, London, 1782.

21. Raimbach, op. cit., pp. 143–4.

22. Julia Frankau, *John Raphael Smith*, London, 1902.

23. *Reminiscences of Henry Angelo*, 2 vols., London, 1830, Vol. I, p. 246.

24. Julia Frankau, *William and James Ward*, London, 1904.

25. *Authentic Memoirs of William Wynne Ryland*, 1784. Ryland is best remembered for the manner of his death; he was hanged at Tyburn for forging an East India Company bill.

26. Calabi and De Vesme, *Francesco Bartolozzi*, Milan, 1928. Much interesting information is contained in A. W. Tuer's *Bartolozzi and his Works*, 1882.

27. See Sharp's long and important letter of 1810 about the state of engraving at that time, printed in H. C. Levis's *Descriptive Bibliography of The Most Important Books in the English Language Relating to the Art and History of Engraving*, 1913, reprinted, 1974, pp. 96–9.

28. Caroline Watson (*c.* 1761–1814), noted for the high finish of her stipple engravings, wrote to William Hayley to say that her portrait of William Cowper 'with respect to the printing . . . shall run fifteen hundred good impressions' (Whitley Papers, 1642, British Museum Printroom); this would not have been an especially big printing.

29. Julia Frankau, *Eighteenth Century Colour Prints*, London, 1900.

30. Library of the Victoria and Albert Museum, Press Cuttings on Art, p. 730.

31. Possibly by W. H. Ireland. An amusing satire in verse, with many notes, on print collectors, dealers, etc. There is an especially spiteful attack on Paul Colnaghi, whose illustrious firm still flourishes. Colnaghi is accused of first earning his living in London as a rat-catcher: 'His calling then to catch our rats—but faith he soon caught better fiats— For patronage of weak John Bull,—With coin has stow'd his lockers full.'

32. Basil Taylor, *The Prints of George Stubbs*, Paul Mellon Foundation, 1969.

33. *P.C.Q.*, Vol. 20, 1938.

34. Some form of aquatint was used in about 1653 by Jan van de Velde in his portrait of Oliver Cromwell.

35. Nicolson, op. cit., pp. 117–18.

36. *The Writings of Benjamin Franklin*, ed. A. H. Smyth, Vol. VI, 697, London, 1906.

37. 'Memoir of Paul Sandby by his Son', ed. Paul Oppé, *Burlington Magazine*, LXXXVIII, pp. 143–7. Sandby's description of his aquatint technique is printed in William Sandby's *Thomas and Paul Sandby*, 1892, Chapter VI.

38. The body-colour painting on which this is based is in the Mellon Collection, and the print shows a number of interesting changes.

39. See P. Barbier, *William Gilpin*, Oxford, 1963, Chapter VI.

40. T. Crouther Gordon, *David Allan of Alloa*, 1951.

41. S. T. Prideaux, *Aquatint Engraving*, 1909. A good general introduction to the subject.

42. A. M. Hind, 'Notes on the History of Soft-Ground Etching', *P.C.Q.*, Vol. 8, 1921.

43. John Hayes, op. cit., p. 12, has plausibly suggested that Gainsborough learned aqua-tinting from Burdett, but it seems rather more likely to have been Sandby, who is known to have shared his secret with his friends; Sandby made no soft-ground etchings, but described the process in detail to Clerk of Eldin in a letter of 1775 (*P.C.Q.*, Vol. 20, 1938), and may also have done the same for Gainsborough.

44. Eleven of Gainsborough's plates survive, and were printed in a limited edition in 1971 by Philip McQueen.

45. *Etchings and Engravings by the Nobility and Gentry of England; or, by persons not exercising the Art as a Trade.* (189.b.22) Collected by Richard Bull. I am most grateful to Richard Schneiderman for informing me of these volumes.

46. A. P. Oppé, 'The Fourth Earl of Aylesford', *P.C.Q.*, Vol. XI; E. S. Lumsden, 'John Clerk of Eldin', *P.C.Q.*, Vol. XII.

47. J. B. Skippe (1742–96) should be mentioned for his rather crude chiaroscuro woodcuts from Italian drawings in his own collection, mostly executed between 1781 and 1783.

48. I am most grateful to James Holloway of the National Gallery of Scotland for suggesting both subject and attribution of this print. An impression in the British Museum bears John Runciman's name in an old inscription.

49. Austin Dobson, *Thomas Bewick and his pupils*, 1884.

Chapter Five

1. Up to date bibliographies of the vast Blake literature are published in the *Blake Quarterly*, University of New Mexico. Four of the most valuable books are G. L. Keynes and E. Wolf, *William Blake's Illuminated Books: a Census*, 1953; G. L. Keynes, *Engravings by William Blake: The Separate Plates*, 1956; David Bindman, *Blake as an artist*, Phaidon, Oxford, 1977; and David Bindman, *The Complete Graphic Works of William Blake*, London, 1978.

2. Bindman notes in *Blake as an artist*, p. 90, that 'the lack of definition in colour-printing would have made it appropriate to what Blake later argued was the indefiniteness of the material world.'

3. A. Gilchrist, *Life of William Blake*, 1863.

4. Blake, *Complete Writings*, Edited by Geoffrey Keynes, O.U.P., 1966, pp. 591–603. From a notebook of about 1810. West did not share the views of the artists mentioned by Blake, finding in the Shakespeare Gallery prints 'such a general deficiency in respect of drawing, which he observed the Engravers seemed to know little of . . . he did not wonder many subscribers had declined to continue their subscriptions' (Farington Diary, 26 May 1804).

5. In the *Public Address* Blake 'invites the admirers of old English Portraits to look at his print [the *Canterbury Pilgrims*]', an appeal to the Grangerizers.

6. *The Life and Letters of Samuel Palmer*, ed. A. H. Palmer, 1892, p. 10.

7. Ibid., pp. 15–16.

8. Raymond Lister, *Edward Calvert*, London, 1962.

9. Most of his blocks are in the British Museum.

10. C. Dodgson, 'The Engravings of George Richmond and Welby Sherman', *P.C.Q.*, Vol. 17, No. 4, 1930.

11. See Draper Hill's *Mr. Gillray the Caricaturist*, Phaidon, London, 1965, and *Fashionable Contrasts*, Phaidon, 1966.

12. *Diary*, 1 June 1807.

13. See Algernon Graves, 'Boydell and his Engravers', *The Collector*, Vol. III, 1907, (reprinted from *The Queen*). The engravings of Macklin's *Poet's Gallery* were published between 1788 and 1799.

14. R. W. Buss, *English Graphic Satire*, London, 1874, p. 128.

15. Ibid., p. 129; both stories probably rest on the authority of Cruikshank.

16. Joseph Grego, *Rowlandson the Caricaturist*, 1880. This describes many of the prints.

17. The drawing for this is in Boston Public Library (reproduced in John Hayes, *Rowlandson, Watercolours and Drawings*, Phaidon, 1972, plate 43) but the etching has been given greater dramatic effect by the addition of a stormy sky.

18. Gert Schiff, *The Amorous Illustrations of Thomas Rowlandson*, New York, 1969.

19. Louis Simond, *An American in Regency England*, Ed. Christopher Hibbert, London, 1968, p. 28. Simond was French born, and his 'countrymen' could mean Frenchmen.

20. G. W. Reid, *Descriptive Catalogue of the Works of George Cruikshank*, 3 Vols., London, 1871.

21. Thomas Sutton, *The Daniells, Artists and Travellers*, London, 1954.

22. *Diary*, 1 June 1807.

23. *Rudiments of Landscape*, 1813, p. 17.

24. F. Siltzer, *The Story of British Sporting Prints*, London, 1929.

25. Alfred Whitman, *Samuel William Reynolds*, London, 1903.

26. However, on 18 July, Cardon told Farington of 'the difficulty the engravers had in obtaining from Mr. Lawrence any attention to the works carrying on from his pictures'.

27. W. G. Rawlinson, *The Engraved Works of J. M. W. Turner R.A.*, 2 vols., 1908 and 1913.

28. A. J. Finberg, *The History of Turner's Liber Studiorum with a New Catalogue Raisonné*, 1924. There were another twenty unpublished plates.

29. J. L. Roget, *Notes and Memoranda respecting the Liber Studiorum . . .*, 1879, p. 21.

30. Quoted in John Gage, *Colour in Turner*, London, 1969, p. 196. Chapter Two of this book, *Turner and engraving*, is a valuable discussion of the subject.

31. See Andrew Wilton's exhibition catalogue, *Turner in the British Museum: Drawings and Watercolours*, 1975, pp. 20–25, for a particularly sensitive short introduction to the England and Wales watercolours.

32. A. Shirley, *The Published Mezzotints of David Lucas after John Constable*, R.A., Oxford, 1930. The mezzotints go through many states and progress proofs. A number of corrections to Shirley's catalogue have been made by Osbert Barnard.

33. Shirley, p. 149, Letter 206.

34. Thomas Balston, *John Martin . . . His Life and Works*, London, 1947; William Feaver, *The Art of John Martin*, Oxford, 1975.

35. C. Wagner, *Alois Senefelder, sein Leben und Wirken*, Leipzig, 1914, 2nd ed., 1943.

36. Felix H. Man, 'Lithography in England (1801–1810)', Essay 6, pp. 97–131, of Carl Zigrosser, *Prints*, London, 1963.

37. Sandby, op. cit.,

38. Thomas Fisher's *Album of early Lithographs* (British Museum, 190*b.1, II.,) contains a number of amateur lithographs. One reason for the failure of lithography in England was the imposition of a heavy import duty on the necessary limestone blocks.

39. Michael Twyman, *Lithography 1800–1850, The techniques of drawing on stone in England and France and their application in works of topography*, O.U.P., 1970. An exhaustively researched study of the subject.

40. For a discussion of Bourne see F. D. Klingender, *Art and the Industrial Revolution*, London, 1968 (Revised edition), pp. 153–163.

41. James Roundell, *Thomas Shotter Boys*, with an Introduction by Alistair Smart, London, 1974. See also 'The Prints of T. S. Boys', G. von Groschwitz, essay in *Prints* by C. Zigrosser, London, 1963; and R. M. Burch, *Colour Printing and Colour Printers*, London, 1910.

42. Quoted in Roundell, op. cit., pp. 46–7.

43. *Catalogue of Drawings and Etchings by Norfolk and Norwich Artists in the Collection of James Reeve*, (MSS. British Museum); also H. Bolingbroke catalogue (MSS. Norwich Castle Museum), *Norwich School Prints*, Aldeburgh Festival Exhibition Catalogue, Introduction by Angus Stirling, Paul Mellon Foundation, 1968; William Weston Gallery, Exhibition Catalogues April 1972, February 1973, Cat. No. 9, 1975.

44. A. E. Popham, 'The Etchings of John Sell Cotman', *P.C.Q.*, Vol. 9, No. 3, 1922.

45. Sydney Kitson, *The Life of John Sell Cotman*, 1937, p. 143.

46. Derek Clifford and Timothy Clifford, *John Crome*, London, 1968, pp. 163–75. This catalogue contains corrections to H. S. Theobald's *Crome's Etchings* (1906).

47. They have an MSS. catalogue by his son Raphael Read, containing 237 plates.

48. C. Dodgson 'The Etchings of Andrew Geddes', *Walpole Society*, Vol. V, 1917, pp. 19–45.

Chapter Six

1. Edinburgh Lectures II, 1853, pp. 46–7.

2. Quoted from the Gillott papers in Jeremy Maas' informative book *Gambart, Prince of the Victorian art world*, 1975, p. 131.

3. The ruling machine was invented by the engraver Wilson Lowry (1762–1824), and then improved by the use of a diamond point instead of a steel needle in 1798. He used it largely for engraving architectural subjects.

4. 24 Dec. 1859.

5. For a discussion of Sharples see F. D. Klingender, *Art and the Industrial Revolution*, Revised edition, London, 1968, 174–6.

6. Gleeson White, *English Illustrators, the Sixties*, 1897; Forrest Reid, *Illustrators of the Eighteen Sixties*, London, 1928. Geoffrey Wakeman's *Victorian Book Illustration*, London, 1973, is an excellent short introduction to the many other print techniques used in Victorian book illustration.

7. G. & E. Dalziel, *The Brothers Dalziel, 1840–1890*, 1901. A self-congratulatory volume with numerous quotations from the letters of satisfied artists.

8. *Painters and Etchers*, 1862; see *Baudelaire, Art in Paris 1845–62*, ed. Jonathan Mayne, London, 1965.

9. *The Life and Letters of Samuel Palmer*, written and edited by A. H. Palmer, London, 1892, p. 338.

10. *Life and Letters*, p. 158.

11. *Letters of James Smetham, With an Introductory Memoir by William Davies*, London, 1891.

12. E. C. Kennedy, *The Etched Work of Whistler*, Grolier Club, New York, 1910.

13. Mortimer Menpes, *Whistler as I Knew Him*, 1904, pp. 22–3. Menpes noted that Sickert 'took down every word on his cuff'.

14. H. N. Harrington, *The Engraved Works of Sir Francis Seymour Haden*, Liverpool, 1910. See also, Francis Seymour Haden, *The Relative Claims of Etching and Engraving to rank as Fine Arts and to be represented as such in the Royal Academy of Arts*, 1883.

15. Harold Wright's MSS. notes for a catalogue of Sickert's etchings are in the British Museum.

16. A large collection of Roussel's progress proofs is in the British Museum.

17. Henri Beraldi, *Les Graveurs du XIX^e siècle; guide de l'amateurs d'estampes modernes*, Paris, 1892, Vol. 12, pp. 125–134.

18. Joseph Pennell, *The Work of Charles Keene . . . with a Catalogue of his Etchings by W. H. Chesson*, London, 1897.

19. *L'Oeuvre Gravé et Lithographié de Alphonse Legros*, Preface by Gustave Soulier, Paris, 1904.

20. *Self-Portrait*. Taken from the Letters and Journals of Charles Ricketts. Collected and Compiled by T. Sturge Moore, ed. by Cecil Lewis, 1939.

21. *A Catalogue of Mr. Shannon's Lithographs*, with prefatory note by Charles Ricketts, 1909.

22. Edward Gordon Craig, *Woodcuts and Some Words*, With an Introduction by Campbell Dodgson, 1924.

Chapter Seven

1. 'The Old Ladies of Etching Needle Street', *The English Review*, Jan., 1912. Sickert's writings are collected in *A Free House*, edited by Osbert Sitwell, London, 1947.

2. *The Early Life of James McBey, 1883–1911*, Ed. Barker, Oxford, 1977.

3. The dating of Sickert's plates poses many problems; the theatre subjects are sometimes given dates in the late nineteenth century.

4. Robert Emmons, *The Life and Opinions of Walter Richard Sickert*, London, 1941.

5. Campbell Dodgson, *A Catalogue of Etchings by Augustus John, 1901–14*, London, 1920.

6. Alexander Postan, *The Complete Graphic Work of Paul Nash*, London, 1973.

7. C. R. W. Nevinson, *Paint and Prejudice*, London, 1937. An exhaustive study of the movement is Richard Cork's *Vorticism and Abstract Art in the first machine age*, 2 vols., London, 1976.

8. *Edward Wadsworth*, Colnaghi's exhibition catalogue, 1974, Introduction by Mark Glazebrook.

9. John Physick, *Catalogue of the Engraved Work of Eric Gill*, H.M.S.O., 1963.

10. *The Wood Engravings of Eric Ravilious*, Introduction by J. M. Richards, London, 1972.

11. Claude Flight, *Linocuts*, London, 1927.

12. F. A. Comstock, *A Gothic Vision: F. L. Griggs and His Work*, Boston, 1966.

13. Felix H. Man, *Graham Sutherland, The Graphic Work 1922–70*, Munich, 1970.

14. *Introduction to The English Vision*, Exhibition Catalogue, William Weston Gallery, Cat., 10, 1973.

15. Graham Reynolds, *The Engravings of S. W. Hayter*, Victoria and Albert Museum, London, 1967.

16. Graham Reynolds, *The Etchings of Anthony Cross*, Victoria and Albert Museum, London, 1968.

17. Pat Gilmour, *Artists at Curwen*, Tate Gallery, London, 1977. An extremely good history of the press, with a catalogue of its bequest of lithographs to the Tate.

18. Ben Nicholson, *The Graphic Art*, catalogue to Victoria and Albert Museum Exhibition, Introduction by Carol Hogben, 1975.

19. From a letter to Maurice de Sausmarez, 8 Feb., 1967. Quoted in 'Ben Nicholson', *Studio International Special*, edited by Maurice de Sausmarez, London, 1969.

20. *The Graphic Work of Merlyn Evans*, Victoria and Albert Museum, Introduction by Robert Erskine, Essay by Bryan Robertson, 1972.

21. *A Decade of Printmaking*, edited by Charles Spencer, London, 1973; a history of Editions Alecto, the successor to the St. Georges Gallery.

22. Gerald Cramer, Alistair Grant, David Mitchinson: *Henry Moore, Catalogue of Graphic Work 1931–72*, Geneva, 1973. Pat Gilmour, *Henry Moore: graphics in the making*, Tate Gallery, London, 1975.

23. Richard Hamilton, *Prints, multiples and drawings*, Exhibition Catalogue, Whitworth Art Gallery, Manchester, 1972, p. 13.

24. *The complete prints of Eduardo Paolozzi*, Victoria and Albert Museum Catalogue, Rosemary Miles, 1977.

25. See *A Decade of Printmaking*, op. cit.

26. *David Hockney by David Hockney*, edited by Nikos Stangos, London, 1976, p. 294.

27. A lively commentary on printmaking of the last years is to be found in the many reviews by Pat Gilmour and Rosemary Simmons in *Arts Review*.

The Plates

And at a knyght thenne I wille begynne

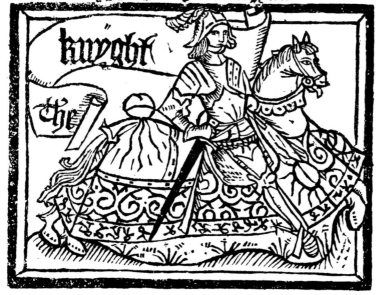

knyght there was a worthy man
a That fro the tyme that he first began

Plate 1. ANONYMOUS: *The Knight* [Woodcut from Richard Pynson's edition of the *Canterbury Tales*; c. 1490; 86 × 114 mm]

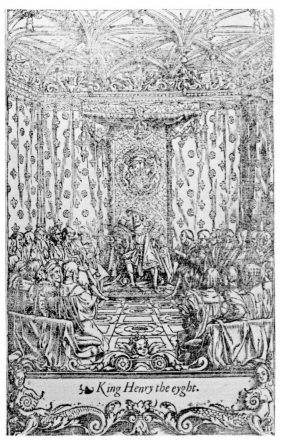

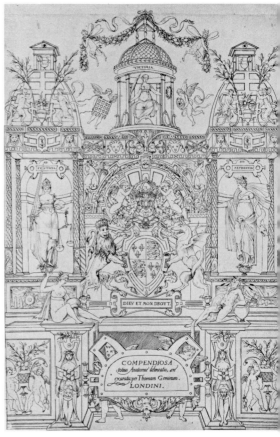

Plate 2. HANS HOLBEIN THE YOUNGER: *King Henry VIII in Council* [Woodcut by Jacob Faber after Holbein's design; Published 1548; 206 × 133 mm]
Published in Edward Halle's *Chronicle*, and later used in the third edition of Foxe's *Book of Martyrs*, when the lettering was added. The impression reproduced is from a Grangerized Pennant's *London* in the British Museum, and is stronger than many earlier ones, but the ink has still failed to print clearly from the closely laid lines.

Plate 3. THOMAS GEMINUS: Title-plate to the *Compendiosa totius Anatomie delineatio* [Engraving; 1545; 368 × 254 mm]
Geminus, a Flemish surgeon in the employ of Henry VIII, was probably the first practitioner of engraving in England.

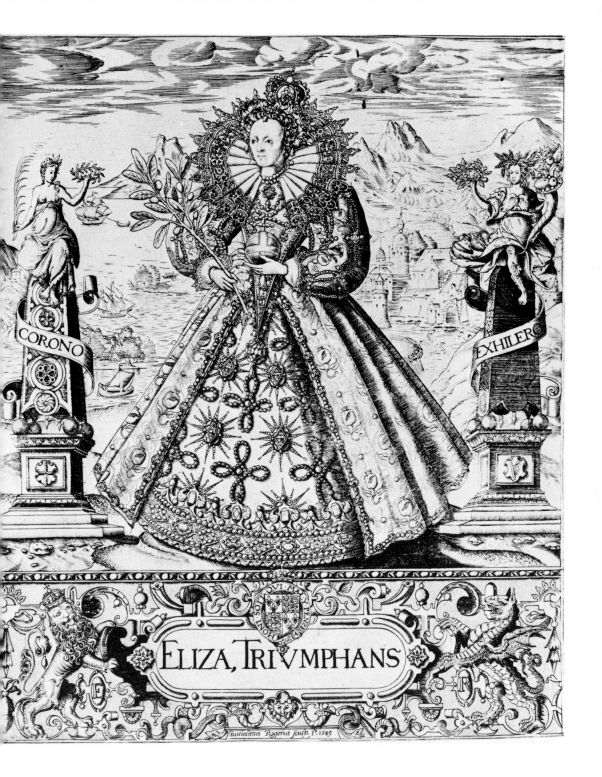

Plate 4. WILLIAM ROGERS: Queen Elizabeth as *Eliza Triumphans* [Engraving; 1589; 260 ×
221 mm]

This is the first known portrait engraved by an Englishman. It was intended to commemorate
the defeat of the Spanish Armada, and Elizabeth is shown standing between figures emblematic
of Victory and Plenty. Rogers has lingered over the encrustations of ornament on the Queen's
costume, but the background is a lifeless imitation of Flemish landscape prints with no suggestion
of the print's purpose.

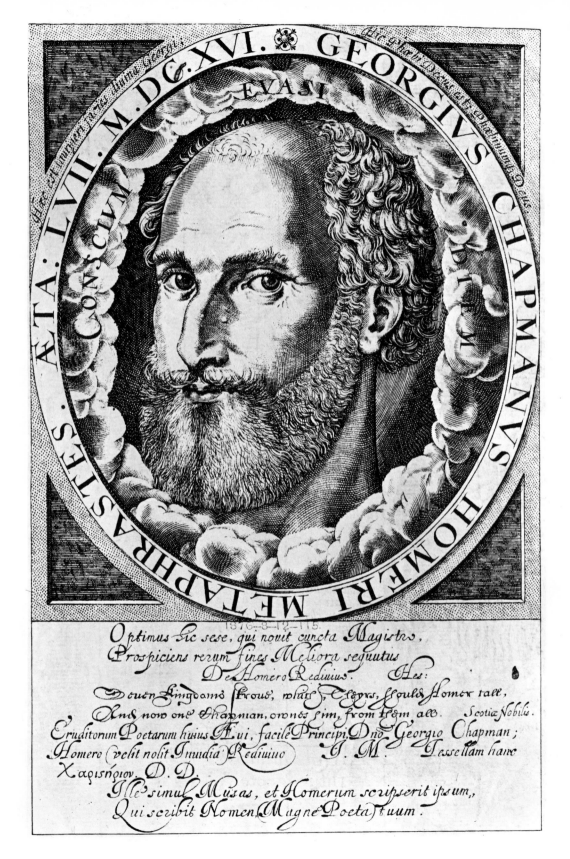

Plate 5. WILLIAM HOLE: *George Chapman* [Engraving; 1616; 168 × 152 mm] The frontispiece to Chapman's translation of *The Whole Works of Homer.*

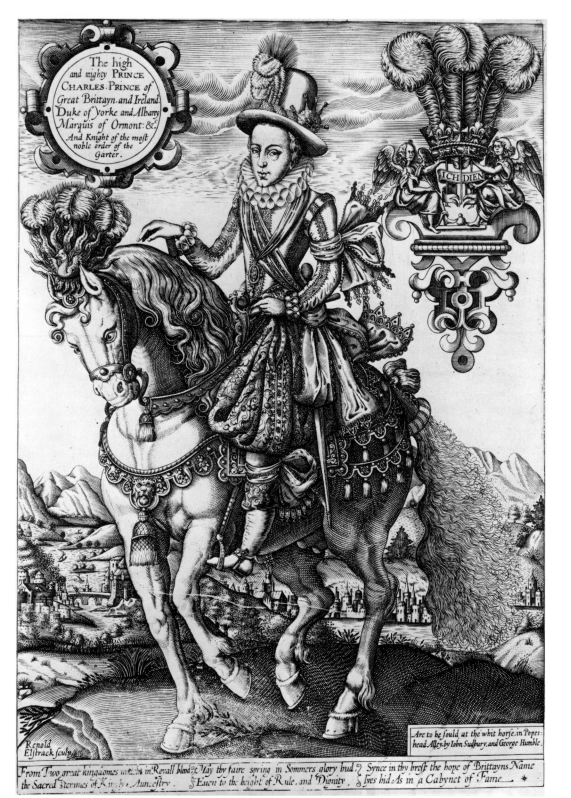

Plate 6. RENOLD ELSTRACK: *Charles I, as Prince, on horseback* [Engraving; 1614–15; 260 ×
185 mm]
The first state of a print that was later twice altered to give a more recent portrayal of the
King's face. Elstrack's attention was mainly devoted to details of ornament, and, as in *Eliza
Triumphans* by William Rogers, the landscape background is merely a crude imitation of
Flemish prints.

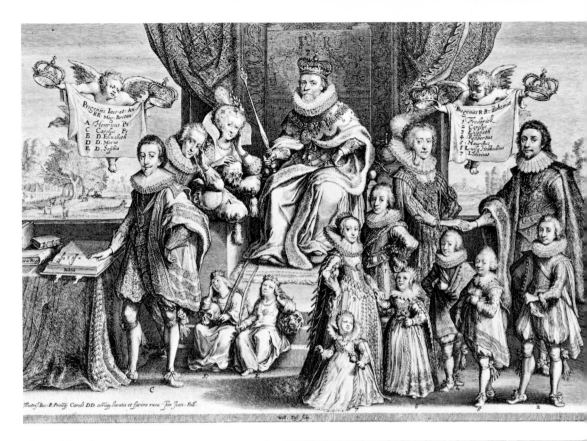

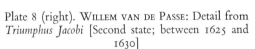

Plate 7 (above). WILLEM VAN DE PASSE: James I and family, the *Triumphus Jacobi* [Engraving; 1624; 260 × 376 mm]

The first state showing, from left to right: Charles I as Prince of Wales, Prince Henry and Queen Anne (both deceased), Mary and Sophia seated on the steps and likewise deceased, and James I. Standing at the right are Frederick V and Princess Elizabeth (King and Queen of Bohemia), with their family before them.

Plate 8 (right). WILLEM VAN DE PASSE: Detail from *Triumphus Jacobi* [Second state; between 1625 and 1630]

The second state of the print, in which it has been brought up to date by the inclusion of the additions to the family of Frederick V and Princess Elizabeth. One of their daughters, however, has died, and is now represented clutching a skull.

Plate 9 (above). WILLIAM MARSHALL: *Charles I*
[Engraving; 1648; 159 × 171 mm]
Frontispiece to *Eikon Basilike—The Pourtraicture of His
Sacred Maiestie in his solitudes and sufferings.* Such was the
popularity of this image of the recently executed King,
with his earthly crown at his feet and his eyes cast
upwards to a 'heavenly crown, that Marshall engraved
eight versions. In the background is an emblematic
landscape of the kind favoured in illustrations of the
period; the rock in a stormy sea bears the inscription
'Immota triumphans' (Unshaken and triumphant), and
the palm tree with pendant weights and scroll is
inscribed 'CRESCIT SUB PONDERE VIRTUS' (Virtue grows
under burdens).

Plate 10 (right). GEORGE GLOVER: *Sir Thomas Urquhart*
[Engraving; 1641; 139 × 82 mm]
In this frontispiece to his *Epigrams divine and moral,*
Urquhart smirks with self-satisfaction as he non-
chalantly accepts a wreath for 'armes and artes'.

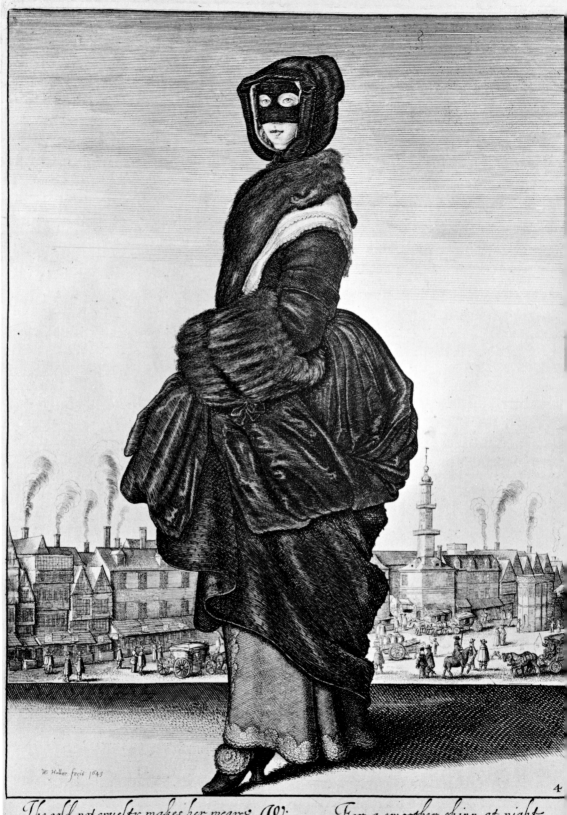

The cold, not cruelty makes her weare **Winter** For a smoother skinn at night
In Winter, furrs and Wild beastshaire Embraceth her with more delight.

W. Hollar fecit 1643

4

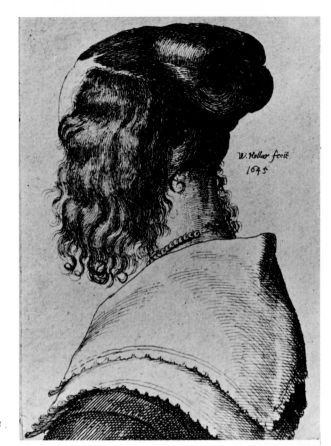

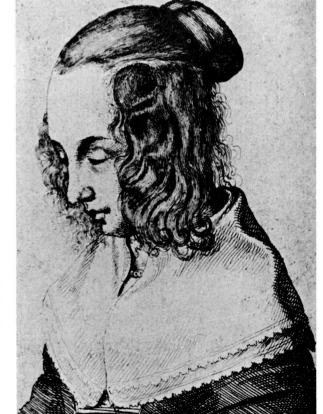

Plate 12 (right). WENCESLAUS HOLLAR: *A Lady seen from the Back* [Etching; 1645; 84 × 60 mm]

Plate 13 (right). WENCESLAUS HOLLAR: *A Lady seen from the Front* [Etching; 1645; 84 × 60 mm]

Plate 11 (left) WENCESLAUS HOLLAR: *Winter* [Etching from the set of full-length *Four Seasons*; 1643; 241 × 180 mm]
Two of Hollar's favourite subjects are combined in this print; a fashionably attired woman, who eyes the onlooker with the bold eyes of a courtesan, and the London view in the background, showing Cornhill and the old Royal Exchange.

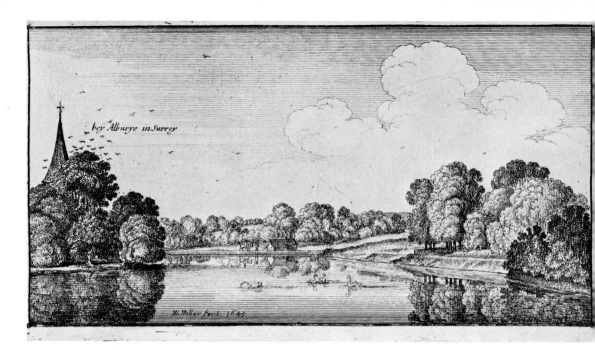

Plate 14. WENCESLAUS HOLLAR: *Landscape near Albury* [Etching; 1645; 80 × 153 mm]
From the set of six etchings of the country surrounding Arundel's estate at Albury, The exiled
Arundel spoke longingly of 'o^r poore Cottage at Alleberrye where I hope to be ere long &
ende my dayes there'.

Plate 15. FRANCIS PLACE: *Water Meadows with a Distant Windmill* [Etching; *c.* 1680; 103 ×
157 mm]
Place said that Hollar 'was a person I was intimately acquainted withal. but never his disciple
nor anybodys else. which was my misfortune', and Place's use of broken line, and short strokes
and dashes, to create an atmospheric effect is in marked contrast to Hollar's more linear
method.

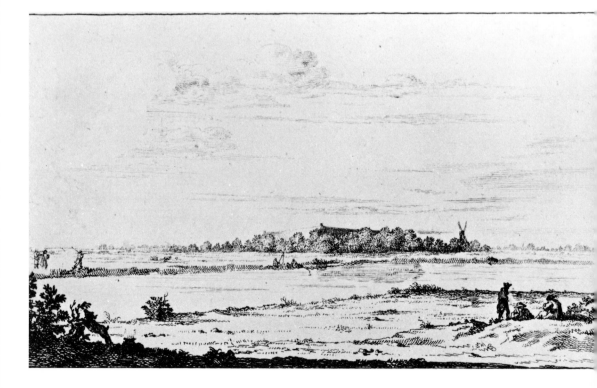

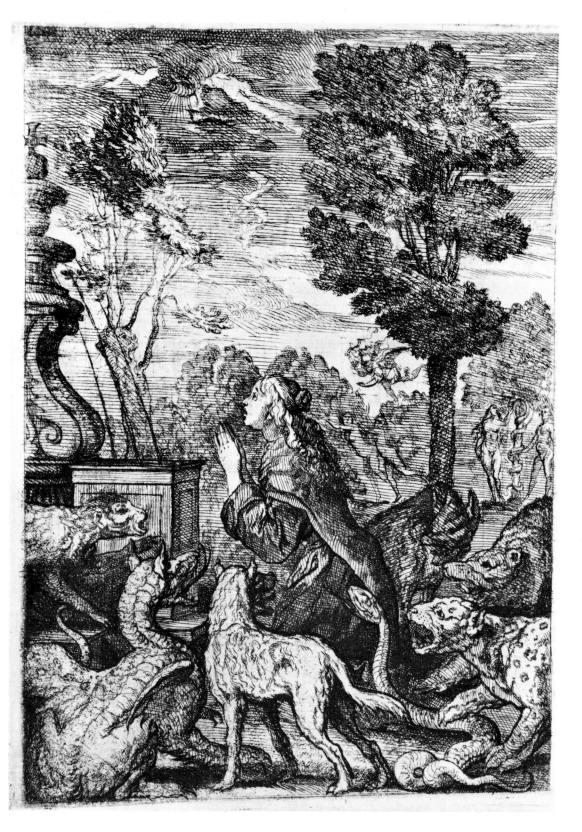

Plate 16. Francis Barlow: *Theophila Praying* [Etching; 1652; 190 × 131 mm]
An illustration to Canto 2 of *Theophila* by Edward Benlowes, showing Theophila, a personifica-
tion of the soul, kneeling before a sacred fountain and threatened by beasts representing the
Seven Deadly Sins.

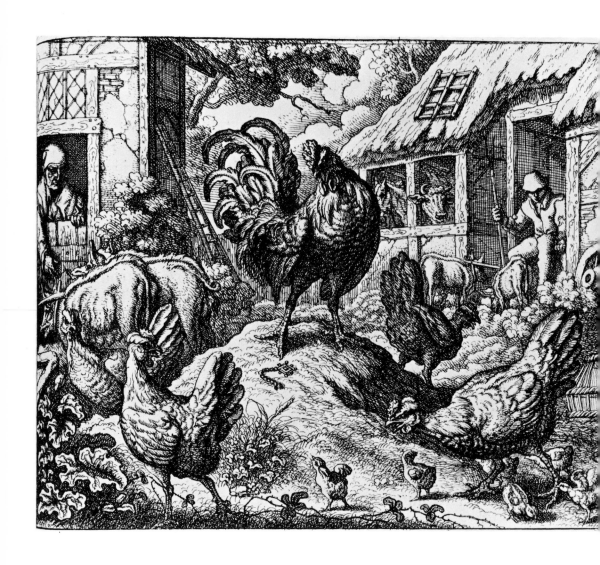

Plate 17. FRANCIS BARLOW: *The Cockerel and the Jewel* [Etching; 1666; 169 × 168 mm (subject
127 × 160 mm)]

In his preface to Aesop's *Fables* Barlow pointed out that he was no 'professed Graver or Eacher,
but a Well-Wisher to the Art of Painting; and therefore Designe is all we aim at, and cannot
perform Curious Neatness without losing the Spirit, which is the main.' His 'Spirit' is especially
evident in this lively etching of his favoured subject of barnyard fowl, clucking and scratching
round a cluttered yard.

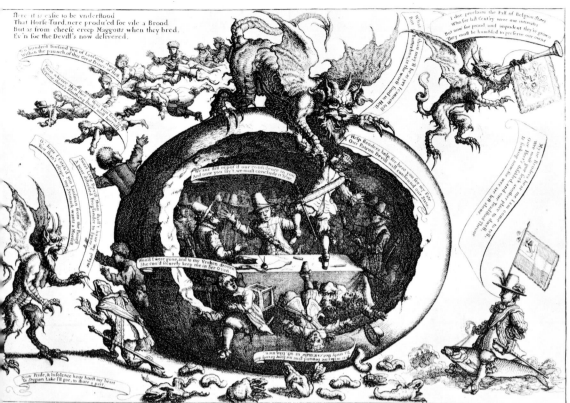

Here it is eafie to be vnderftood
That Horfe Turd, nere produc'ed foe vile a Brood,
But as from cheefe creep Maggotts when they bred,
Ev'n foe the Devill's now delivered.

Noe hundred Toufand Tun of Lanfoen
Within the paunch of this Great Petrus of Hell

I doe proclaim the Fall of Belgion States
Who for laft fent'ry were our intimates
But now for pound and impudent they're grown
They muft be humbled to preferve our owne.

Help Broders help for here hant feet my Fate
Our Patron Devill will enchanted our State.

Wee did report of our confidence in you
And now you fay't, we muft conclude it True.

Would I were gone, and to my Vroken Proven
She cou'd fecurely keep me in her Oven.

Now Pride, & Infolence have burft my heart
To Stygion Lake I'll goe, to thare a part.

Doe but obferue this Cacodæmon's bim,
And thence you'll find, whenceTh'High&Mighty's come
Though Nature never did fuch method ufe
Maggotts, and Flyes with fhape of Toad t'abufe

Yet Creeping wormes, that to Rebellion Fly
Noe Emblem's black enough t'exprefse 'em by
Indulgence grown Competitour from hence
We fee, and Turn'd, malignant infolence

Nature's affronted by 'em and the World
(By their prefumption's) to amazement hirld
Which muft be check'd, 'Left ill example be
Rife to Rebellion, Fall to Monarchie

Sold by Edward Powell at the Swan in Little Britain and Geo: Forthing, all Lincoln's Inn Back gate.

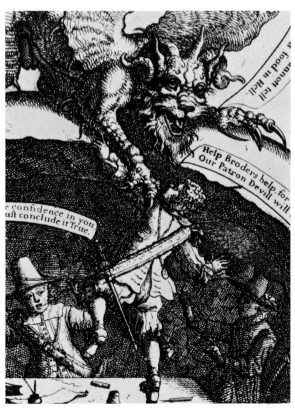

Plate 18. FRANCIS BARLOW: *The Cheese of Dutch Rebellion* [Etching; *c.* 1673; 259 × 333 mm]

Etched by Barlow at the time of the Anglo-Dutch wars, this was one of the few effective answers to the many Dutch satires on the English. A number of Dutchmen plotting rebellion have been disturbed by the devil, and exclaim their dismay. One of them, falling backwards from the cheese, cries:

'Fear makes me swound give me some Brandy then
Tis onely that can make us act like men.'

The 'Maggotts and Flyes', toads, and 'creeping wormes' in the foreground are all manifestations of Dutchmen. To their right is a figure riding a fish who is perhaps intended for De Wit.

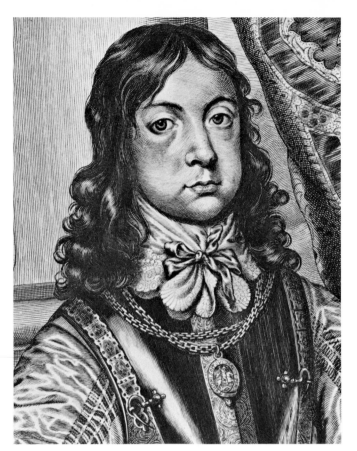

Plate 19. WILLIAM FAITHORNE: Detail of *Charles II as Prince of Wales* [Engraving after William Dobson; *c.* 1645; 288 × 194 mm]

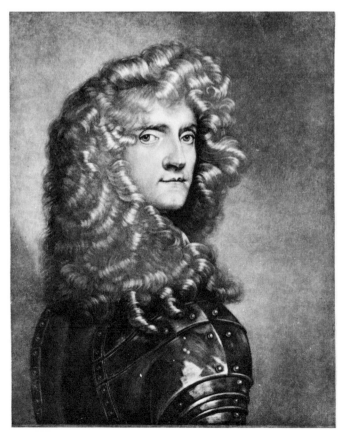

Plate 20. FRANCIS PLACE: *Philip Woolrich* [Mezzotint after John Greenhill; *c.* 1670; 269 × 201 mm]

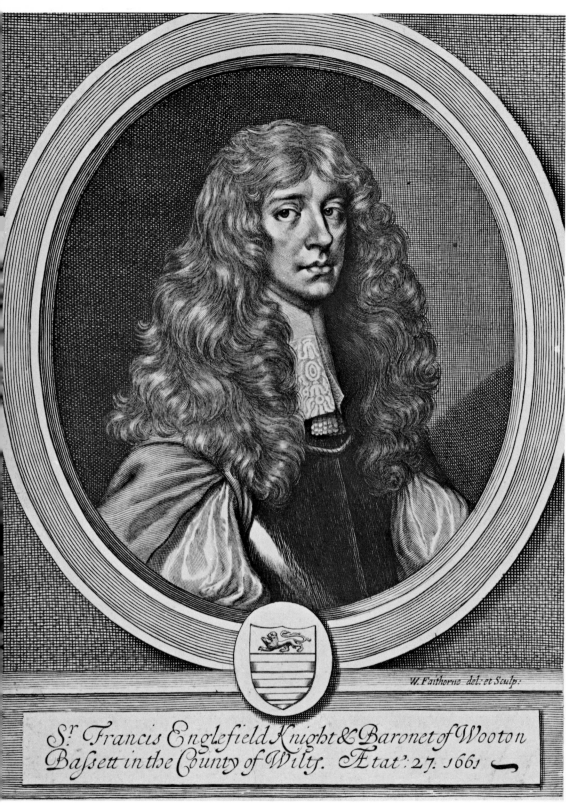

W. Faithorne del: et Sculp:

Sʳ Francis Englefield Knight & Baronet of Wooton Baſsett in the County of Wilts. Ætat: 27. 1661

Plate 21. WILLIAM FAITHORNE: *Sir Francis Englefield* [Engraving; 1661; 233 × 177 mm]
Faithorne, the first great English engraver, made prints both from the portraits of such artists as Dobson (Plate 19) and from his own drawings (Plate 21). The first example shows a dazzling whirlpool of lines, typical of his early style, which was succeeded by a more refined manner, where the strokes of the burin model facial structure more closely.

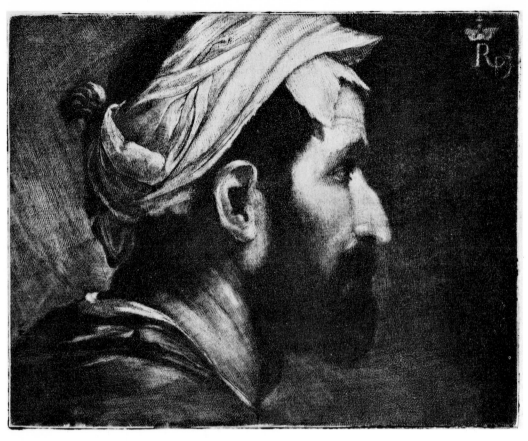

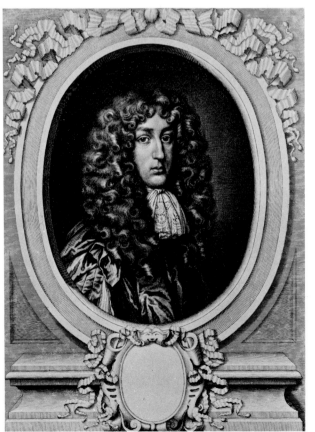

Plate 22 (above). PRINCE RUPERT: *Head of th
Executioner* [Mezzotint from a picture of the schoo
of Ribera; 1662; 133 × 170 mm]
Published in Evelyn's *Sculptura*, it was this mezzotin
that launched the medium's history in England. It i
signed with Rupert's royal monogram.

Plate 23 (left). DAVID LOGGAN: *Sir Thomas Ishar
[Engraving; 1676; 372 × 279 mm]

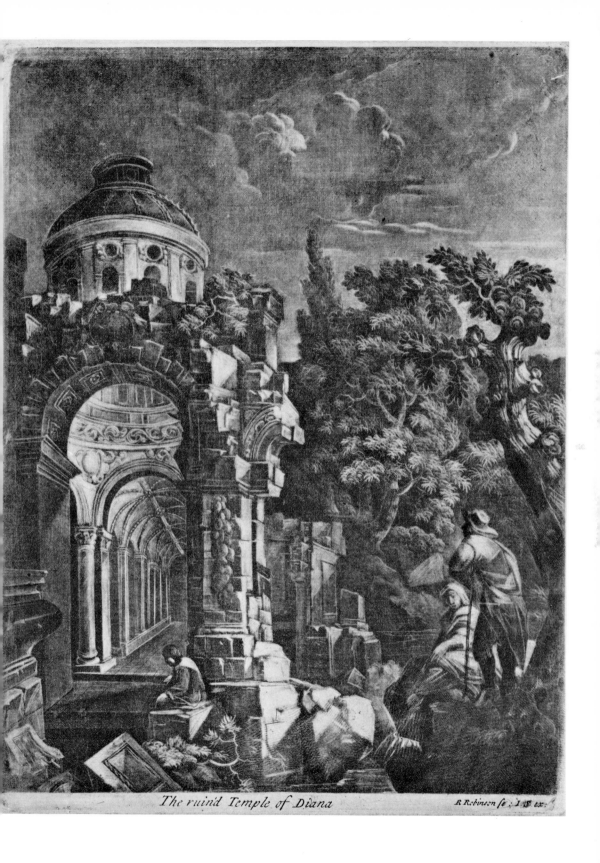

The ruin'd Temple of Diana

R Robinson fe : I.S. ex:

Plate 24. R. ROBINSON: *The ruin'd Temple of Diana* [Mezzotint; *c.* 1690; 239 × 185 mm]

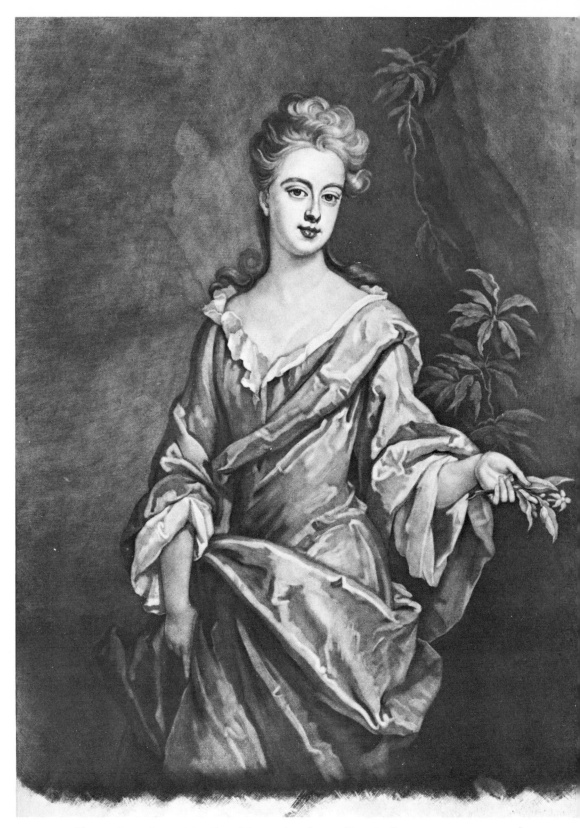

Plate 25. JOHN SMITH: *Mrs. Sherard* [Mezzotint after Godfrey Kneller; 1723; 341 × 238 mm]
A languorous female subject of a type much engraved in mezzotint. This is an early progress
proof before the introduction of trees in the left background, and with the inscription space
uncleaned, the marks of the 'rocker' being clearly visible.

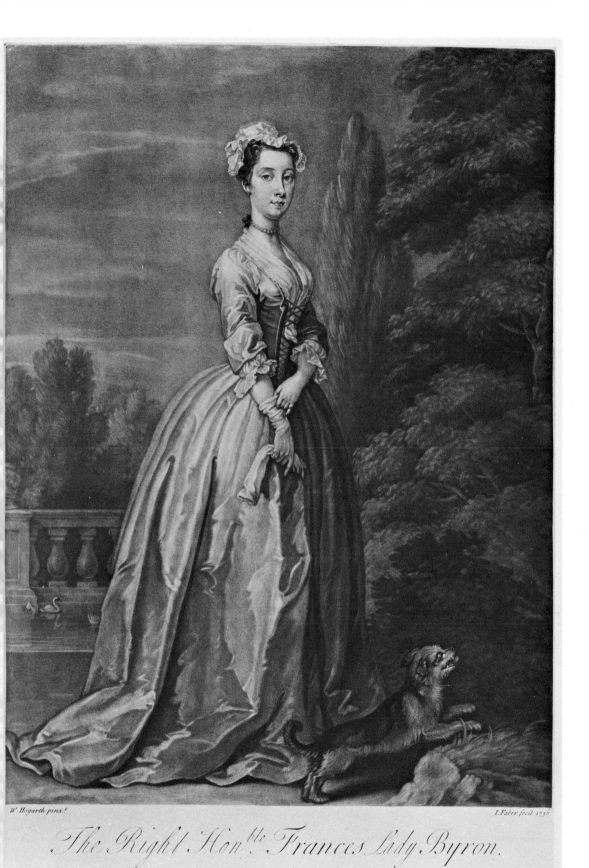

W Hogarth pinx.^t

J.Faber fecit 1736

The Right Hon^ble Frances Lady Byron.

Sold by Faber at the Golden Head in Bloomsbury

Plate 26. JOHN FABER: *Frances, Lady Byron* [Mezzotint after Hogarth; 1736; 478 × 329 mm]

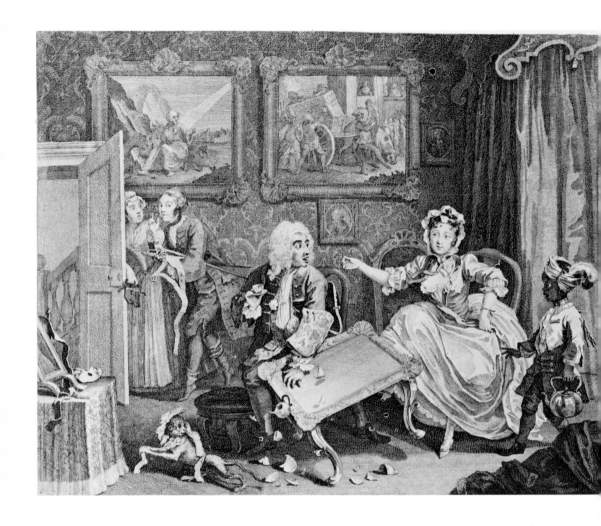

Plate 27. WILLIAM HOGARTH: *A Harlot's Progress*, Plate II [Etching and engraving; 1752; 309 × 374 mm]
The Harlot has become the mistress of a wealthy Jew, who has set her up in a well-appointed apartment. She has kicked over the table to distract his attention from her real lover, who tiptoes out of the room, half-dressed.

Plate 28. WILLIAM HOGARTH: Detail from *The Second Stage of Cruelty* [Etching and engraving; 1751; 381 × 316 mm]

Tom Nero, villain of the series of *The Four Stages of Cruelty*, is beating the broken-down nag whose collapse has been caused by the weight of the four barristers in the carriage. Hogarth explained in his *Autobiographical Notes* that: 'The four stages of cruelty, were done in hopes of preventing in some degree that cruel treatment of poor Animals which makes the streets of London more disagreeable to the human mind, than anything whatever.' The engravings were intended to reach a large audience, and were executed by Hogarth in a style of brutal simplicity. Although large in size they cost only 1s 6d on good quality paper, and 1s on cheap paper.

CHARACTERS. CARICATVRAS.

For a farthar Explanation of the Difference Betwixt Character & Caricatura See y.e Preface to Jos.Andrews.

Plate 29 (above). WILLIAM HOGARTH: *Characters and Caricatures* [Etching; 1743; 228 × 203 mm] Intended as a counterblast to the caricatures of Ghezzi, the Carracci, and others that were being copied in prints by Pond between 1736 and 1747. The mass of profiles are intended to indicate the diversity of 'character' as opposed to the mere facetious distortion of faces, which Hogarth viewed with contempt.

Plate 30 (above right). WILLIAM HOGARTH: *The Cockpit* [Etching and engraving; 1759; 314 × 381 mm] Boswell recorded how, in 1762, determined to spend a day as a 'true-born Old Englishman', he visited the Royal Cockpit, depicted in Hogarth's print: 'I was shocked to see the distraction and anxiety of the betters. I was sorry for the poor cocks. I looked round to see if any of the spectators pitied them when mangled and torn in a most cruel manner, but I could not discover the smallest relenting sign in any countenance. I was therefore not ill pleased to see them endure mental torment. Thus did I complete my true English day, and came home pretty much confounded at the strange turn of this people.'

Plate 31 (right). PAUL SANDBY: *Untitled satire of Lord Bute, Hogarth and others* [Etching; 1762; 212 × 366 mm] An elaborate satire on the much abused ministry of Lord Bute, and his alleged favouritism to Scots. The bull-headed figure (John Bull) is being forced to swallow 'Peace', which is lowered on a string by a monkey probably intended for the French envoy, the Duc de Nivernois, and administered by Bedford and Bute, who holds Bull's horns. The Duke of Cumberland tries to whip the monkey, while behind him Newcastle has fallen off Bull, and Bull's pocket is picked by Fox. In the left background is the diminutive figure of Hogarth, made Serjeant-Painter by Bute, whose palette is inscribed with the 'Line of Buty' by the curve of a pig's tail, and who shows his dismay at the Scot riding on his shoulders. The composition contains a number of allusions to the compositions of Hogarth's engravings in the Election Series.

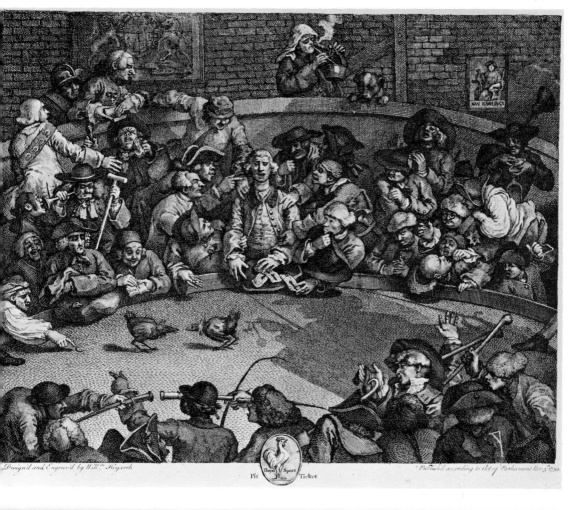

Design'd and Engrav'd by Will.ᵐ Hogarth. Pit Royal Sport Ticket Publish'd according to Act of Parliament Nov.ʳ 5.ᵗ 1759.

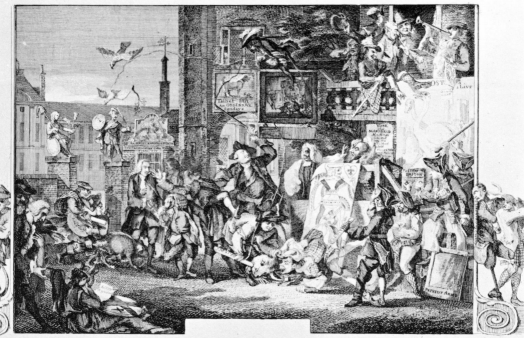

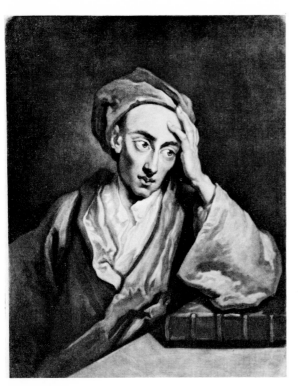

Plate 32 (left). GEORGE WHITE; *Alexander Pope* [Mezzotint after Kneller; 1723; 346 × 241 mm]

Plate 33 (below). HUBERT FRANÇOIS BURGUIGNON GRAVELOT: '*And has not Sawney too his Lord and Whore*' [Engraving, perhaps by Ravenet, after Gravelot; 1742; 284 × 344 mm]

The soulful representation of Pope in Kneller's portrait is in striking contrast to the vicious slander of Gravelot's engraving, which is based on Colley Cibber's public letters of 1742, in which he replied to Pope's constant mockery of him, by narrating an unsavoury incident said to have occurred in about 1715 or 1716, when Pope had been taken to a brothel by Lord Warwick: '... what now restrains him, from once more reminding thee of the former friendly Office he did thee, when in thy dangerous Deed of Darkness, crawling on the Bosom of thy deer Damsel, he gently, with a Finger and Thumb, picked off thy small round Body, by thy long Legs, like a Spider, making Love in a Cobweb.'

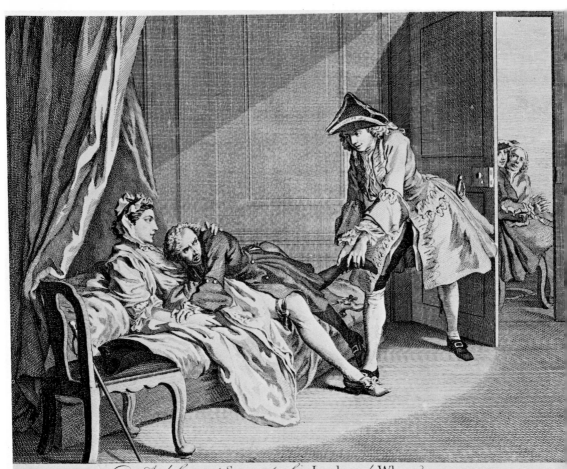

And has not Sawney *too his* Lord *and* Whore? *Vide Cibbers Letter.*
Published according to Act of Parliament by P. Uriel in Temple Lane, over against Chancery Lane. August 9th 1742.

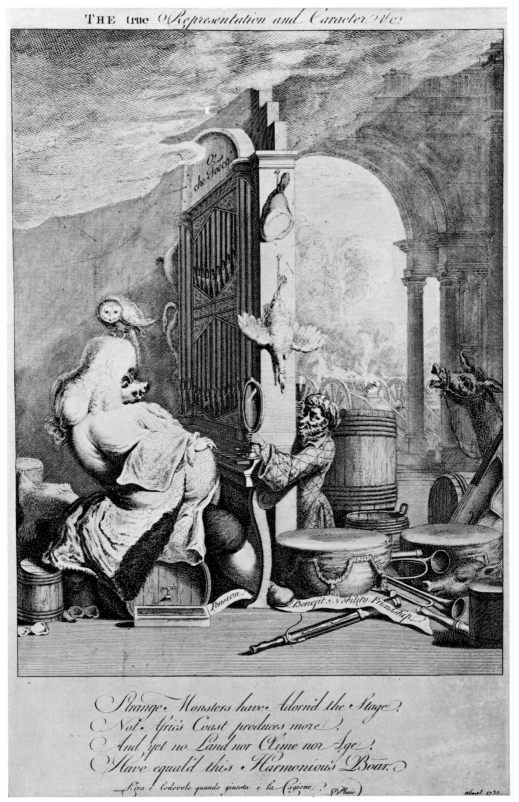

Plate 34. JOSEPH GOUPY: *The true Representation and Caracter* [Etching; 1754; 467 × 314 mm (clipped impression)]
Handel, notoriously greedy, is portrayed as a hog seated at the organ and surrounded by the attributes of gluttony, folly and vanity. The firing cannon and braying ass allude to the composer's supposedly loud and inharmonious music.

Plate 35. CHARLES GRIGNION: *Seated Girl* [Etching and engraving after Gravelot; 1745; 284 × 186 mm] Gravelot's gracefully drawn and elegantly posed figures, whether etched by himself or by pupils such as Grignion, introduced some of the spirit of French rococo art into England. This is from the set of *Male and Female Costumes*, some of which were probably drawn from the articulated dolls Gravelot used in place of models.

Plate 36. PAUL SANDBY: *Rare Mackerel* [Etching; 1760; 198 × 155 mm]
From Sandby's unfinished series of *London Cries*, notable for his unrestrained handling of the etching needle, and realistic depiction of raggedly clad street-traders. In this print, the raucous confrontation of the fishwife with the woman at the door is echoed by the cat and dog hissing and barking at their feet.

Plate 37. ARTHUR POND: *Dr. Mead* [Drypoint; 1739; 218 × 159 mm]

Plate 38. THOMAS WORLIDGE: *Sir Edward Astley as the Burgomaster Jan Six* [Etching and drypoint; 1765; 236 × 182 mm]

Astley masquerades as Jan Six in the pose in which the burgomaster was represented in the famous etching by Rembrandt. Astley had purchased a large collection of Rembrandt prints from Arthur Pond. Dr. Mead, the patron of Watteau in England, found the Rembrandtesque less to his taste, however, as Vertue recorded: '. . . a print of Dr. Mead. a profil drawn and etchd by Mr. Pond. in the manner of Rinebrandt very like the Doctor but when done, being in short ruff-hair—no wigg. etc. the Doctor particularly desird Mr. Pond to suppress it, that it might not be sold to any one, nor seen. nay would have had the plate to destroy it. from whence this proceeded the Dr. woud not give any answer nor reason one may easily guess, that it appears like an old mumper, as Rhimebrandts heads usually do. such kind of works will give pleasure to Virtuosi but not to the publick Eye.'

Plate 39 (above). ELISHA KIRKALL: *Classical Figures in a Landscape* [Metal-cut in white line, with colour printed from two woodblocks; *c.* 1725; 217 × 188 mm]
The print bears no inscription, but is probably a copy from a seventeenth-century French painting. Kirkall's vigorous use of white-line engraving, later to be admired by Thomas Bewick, is especially evident in the foreground details of grass and fallen masonry.

Plate 40 (above right). WILLIAM WOOLLETT: *The Destruction of the Children of Niobe* [Etching and engraving after Richard Wilson; 1761; 475 × 600 mm]

Plate 41 (right). FRANÇOIS VIVARES: *A View in Craven, Yorkshire* [Etching and engraving; 1753; 410 × 524 mm]
The more light-handed style of landscape engraving practised by Vivares was eventually superseded by the more elaborate and systematic effects that Woollett perfected in *Niobe*. Commissioned by Boydell, this large print, produced by a mixture of etching and engraving, established Woollett's reputation, and became one of the most celebrated English prints of the century.

Richard Wilson Pinxit. I. Boydell excud. William Woollett sculpsit.

N I O B E.

A View in Craven Yorkshire of a Beautiful & Romantic Natural Cascade in Bolton Park belonging to the R:t Hon:ble the Earl of Burlington.
To Whose this Plate is most humbly Inscribed by his Lordships most Dutiful & most Obed:t Serv:t S. Vivares.
N:o Published by S. Vivares Jan:y 1775 According to Act of Parliament

Plate 42 (left). SIR ROBERT STRANGE: *Apotheosis of the Princes Octavius and Alfred* [Detail from the engraving after Benjamin West; 1786; 610 × 459 mm]
One of Strange's few engravings from a contemporary painting, showing two children of George III who had died in childhood, and etched and engraved with the clean strokes and silvery tones characteristic of his work

Plate 43 (below). WILLIAM SHARP: *King Lear, Act II, Scene IV* [Engraving after Benjamin West; 1789; 492 × 630 mm]

Plate 44 (left). JAMES HEATH: *The Death of Major Peirson* [Detail; etched state of the engraving after Copley; 1788; 657 × 810 mm]
The first state of the print, in which Heath has etched the outlines of the figures, and put in the first masses of shadow by diagonal parallel lines.

Plate 45 (below). JAMES HEATH: *The Death of Major Peirson* [Engraving after Copley; finished state; 1796]
A web of engraved cross-hatching, and dot and lozenge work, has been laid over the initial etching to produce the carefully graded tones of the finished print. Heath worked from a reduced version of Copley's large picture (now in the Tate Gallery), and made extensive use of assistants. This ambitious plate was published by Boydell with great success.

Plate 46. JAMES McARDELL: *Mrs. Bonfoy* [Mezzotint after Reynolds; 1755; 373 × 275 mm]

Plate 47. EDWARD FISHER: *Hope Nursing Love* [Mezzotint after Reynolds; 1771; 503 × 355 mm]

Plate 48. FRANCESCO BARTOLOZZI: *Lady Smythe and Children* [Stipple engraving after Reynolds; 1789; 375 × 293 mm (293 × 233 mm subject)]

Few eighteenth-century painters attached so much importance to prints after their work as did Reynolds. The sonorous tones of the mezzotint (Plates 46 and 47) enhanced the chiaroscuro of his pictures, whereas stipple engravings (Plate 48) achieved more delicate and precise results and would print in much larger numbers. According to 'Anthony Pasquin', 'There are various mezzotinto copies from his designs, by McArdell, Houston, Watson, and Fisher, which have obtained an high character for him on the Continent, inasmuch as they have exhibited the graces of his composition, without his coarseness, and have not unfrequently softened and amended the drawing of his extremities . . .'

Plate 49. THOMAS FRYE: *Portrait of a Man* [Mezzo tint; 1771; 498 × 347 mm]

From the series of twelve life-sized heads. Eighteenth century mezzotints both designed and executed by the same hand are rare, and in their use of the close-up viewpoint and strong lighting, Frye's prints are remarkably original. Joseph Wright was impressed by them, and they served as the basis for a number of figures in his paintings.

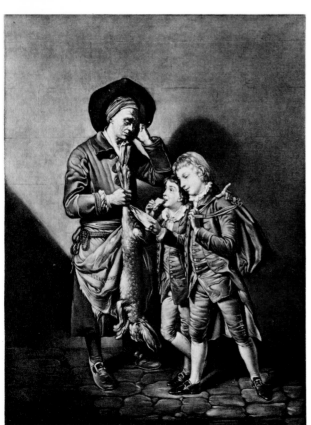

Plate 50. RICHARD EARLOM: *A Porter with a Hare* [Mezzotint after Zoffany; 1774; 604 × 431 mm]

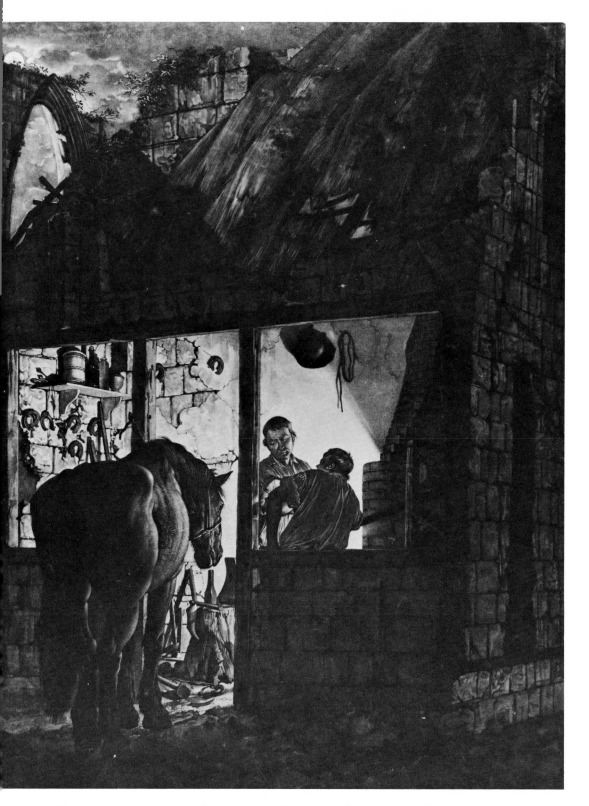

Plate 51. WILLIAM PETHER: *The Farrier's Shop* [Mezzotint after Joseph Wright; 1771; 497 × 347 mm]

Wright's painting has been lost, and is known only by this print. Its atmosphere is melancholy; and the ruined Gothic church at the left suggests transience and mortality. Many of Wright's pictures were copied in mezzotint, which could perfectly translate the night effects or artifically lit subjects in which he specialized.

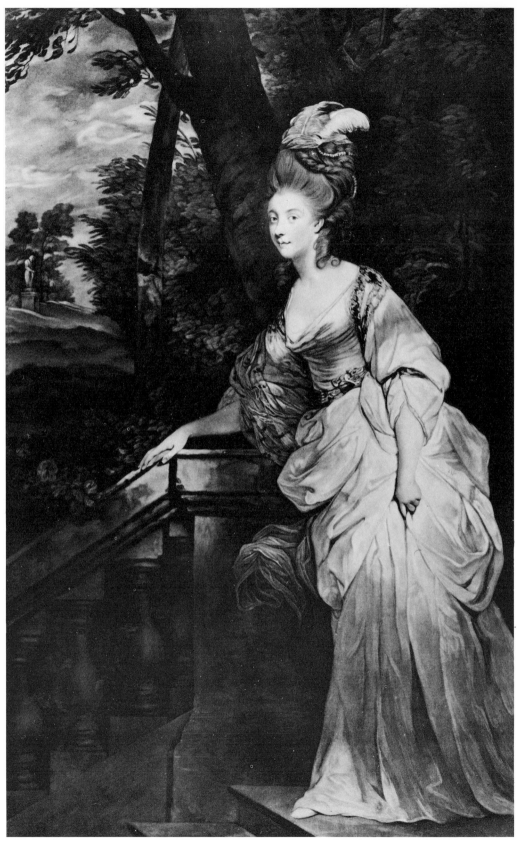

Plate 52. Valentine Green: *Georgiana, Duchess of Devonshire* [Mezzotint after Reynolds; 1780; 625 × 383 mm]

Plate 53. WILLIAM WARD: *Variety* [Stipple engraving after Morland; 1788; 322 × 208 mm]

Moulines.

MARIA.

Plate 54. WILLIAM WYNNE RYLAND: *Maria*, from Sterne's *Sentimental Journey* [Stipple engraving after Angelica Kauffmann; 1779; 382 × 292 mm]

Stipple engraving could create a softness of surface and tone that suited the gentle pastoral or feminine themes, wistful or mildly amorous in mood, that were in great demand as furniture prints during this period. A large number of engravers worked after Kauffmann and Morland, who supplied an abundance of paintings and drawings of such themes, Morland's forte being the pastoral, and Kauffmann's a genteel brand of neo-classicism.

Plate 55. JAMES WARD: *A Tiger Disturbed whilst Devouring its Prey* [Mezzotint; 1799; 612 × 444 mm]

James Ward's treatment of this theme is of an unrestrained romanticism and vigour of handling. On 24 January 1805, the mezzotinter John Young spoke to Farington 'of the great change which has taken place in the metzotinto line of engraving. The smoky manner of Valentine Green & his contemporaries, had been superseded by the brilliant execution & Characteristick imitation of the touch in the picture which is seen in the prints by Ward.'

Plate 57. GEORGE STUBBS: *A Foxhound on the Scent* [Mixed techniques; 1788; 96 × 106 mm]

A Foxhound on the Scent was amongst the 'Three prints of Single Dogs' advertised by Stubbs in 1788, and for which he charged 1s 6d each. The print's subtle tones, and irregular texture, are made more apparent by comparison with the detail from an engraving by his son (Plate 58). This is executed with efficient, but rather mechanical stipple engraving of an orthodox kind.

Plate 56. GEORGE STUBBS: *A Horse Frightened by a Lion* [Mixed techniques; 1788; 250 × 330 mm]
Stubbs has used a battery of tools and the mixture of etched line, stipple and mezzotint, to
create a beauty of tone and surface hardly surpassed in English printmaking. Stubbs played
variations on this subject in a number of paintings, and although its atmosphere is one of tension
and alarm, the print's composition has a certain classical restraint.

Plate 58. GEORGE TOWNLEY STUBBS: Detail from *Sir
John Evelyn* [Stipple engraving after George Stubbs;
1793; 450 × 554 mm]

Pont y Pair over the River Conway above Llanrwst in the County of Denbigh.

Publish'd according to Act of Parliament by P.Sandby S.George's Row Sep.r 1st 1776.

Plate 59 (above). PAUL SANDBY: *Pont y Pair over the River Conway above Llanrwst in the County of Denbigh* [Aquatint; 1775; 238 × 315 mm] Number 12 of 'Twelve Views in North Wales', the second set of Sandby's aquatints of Welsh scenery.

Plate 61 (right). GEORGE STUBBS: Detail from *Hay-Makers* [Mixed techniques; 1791; 483 × 656 mm] An essential element in the successful rustic genre print was the idealized charm exemplified in Smith's mezzotint after Lawrenson's *Lady at Haymaking* (Plate 62), whose idea of farming is to pose winsomely and ogle the spectator. Stubbs was unwilling to adapt his art to such requirements, and his hay-maker, although neatly dressed, looks out of the design with an impassive and unsmiling countenance.

Plate 60 (above). THOMAS GAINSBOROUGH: *Landscape with Herdsmen Driving Cattle over a Bridge* [Soft-ground etching; 1779–80; 300 × 394 mm]

Plate 62 (left). JOHN RAPHAEL SMITH: *A Lady at Haymaking* [Mezzotint after Lawrenson; 1780; 510 × 356 mm]

Plate 63. ALEXANDER COZENS: *Castel Angelo* [Etching; *c.* 1745; 275 × 377 mm]

Plate 64. JOHN CLERK OF ELDIN: *A View of Edinburgh* [Etching; *c.* 1772–73; 155 × 384 mm (132 × 384 mm subject)]

Sandby told Clerk in a letter of 8 September 1775, that he had shown the latter's etchings to 'several Brother Artists who are much pleased with them and were wonderfully struck with your Views of Edinburgh by them they conceive it to be one of the most Romantick Cities in the world.'

Plate 65. JOHN ROBERT COZENS: *The Oak* [Soft-ground etching, tinted with Indian ink, from the series of fourteen etchings of *Forest Trees*; 1789; 240 × 322 mm]

Plate 66. HENEAGE FINCH, FOURTH EARL OF AYLESFORD: *The Water Wheel* [Etching; *c.* 1794; 86 × 174 mm]
Aylesford was a keen admirer of Rembrandt's etchings, owning a large collection, and imitating them with great sensitivity in his own etchings of landscapes or tumbledown farm-buildings. With Clerk of Eldin, he was the most gifted of eighteenth-century amateur etchers.

Plate 67. James Barry: *Elysium* [Etching and engraving; 1791; 744 × 503 mm]

Plate 68. JOHN MORTIMER: *King Lear, Act III, Scene* 3 [Etching; 1776; 400 × 325 mm]
One of the large etchings from the series of 'Twelve Characters from Shakespeare', this influential romantic conception of Lear was issued in the second set of six prints in 1776.

Plate 69. THOMAS BEWICK: *A Man Fishing*; tailpiece to *Water Birds* [Wood engraving; 1804; 55 × 86 mm]
From his youth Bewick was an enthusiastic angler, and he wrote in his *Memoir* that the sport was 'the most healthful and comparitively the most innocent of all diversions. It unbends the minds of the sedentary and the studious, whether it may be those employed at their desks, or "the pale artist plying his sickly trade", and enables such to return to their avocations, or their studies, with renovated energy, to labour for their own or for the public good.'

Plate 70. JOHN RUNCIMAN: *Isaac Blessing Jacob* [Etching; *c.* 1766–68; 152 × 185 mm]

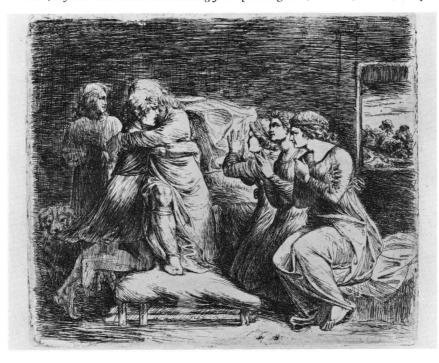

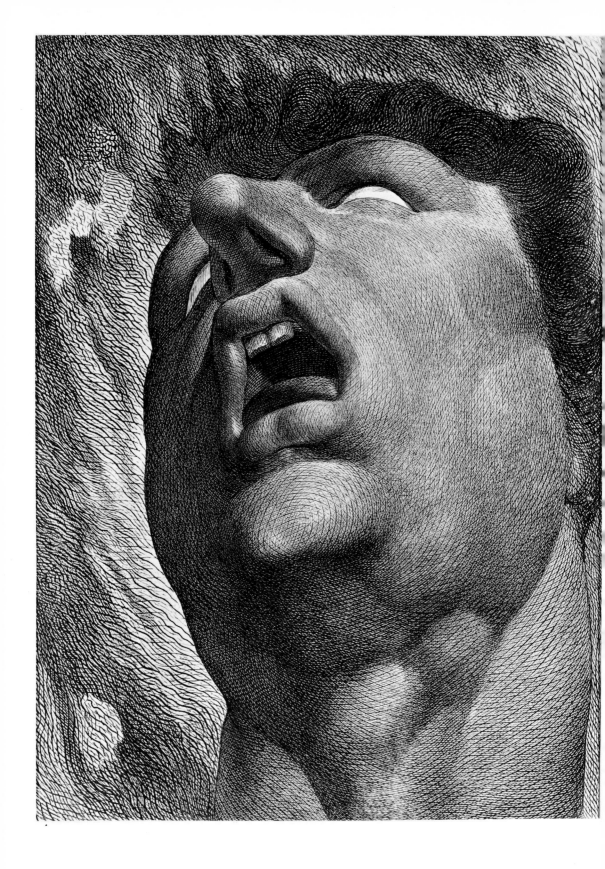

Plate 71. WILLIAM BLAKE: *Head of One of the Damned from Dante's Inferno* [Engraving after Fuseli, *c.* 1790–92; 350 × 265 mm]

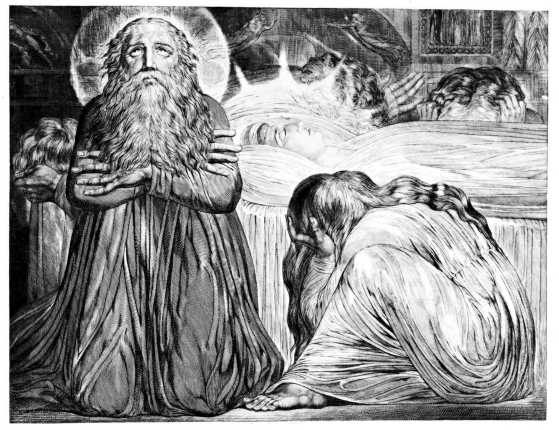

Plate 72. WILLIAM BLAKE: *Ezekiel* [Engraving; 1794; 355 × 481 mm]

Plate 73. WILLIAM BLAKE: *The Spectres of the Dead or Albion turning his head from his daughters.* [Trial proof for plate 47 'Jerusalem the emanation of the Giant Albion'; relief etching, touched with watercolour and pen and ink; 1794–1804; 151 × 159 mm]

Plate 74. WILLIAM BLAKE: *Then went Satan forth from the presence of the Lord* [Engraving from the *Illustrations of the Book of Job*; 1826; 218 × 170 mm]

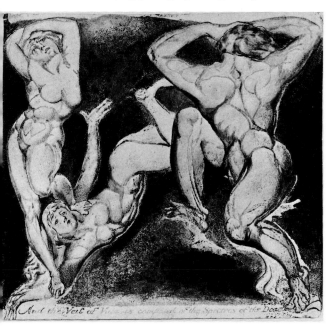

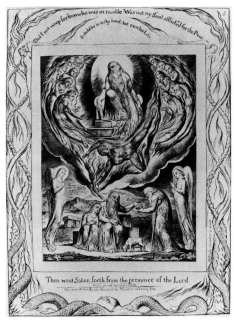

Plate 75. JOHN LINNELL: *Labourers Resting beneath a Tree* [Etching; 1818; 146 × 243 mm]
Although Linnell was a close friend and admirer of Blake, and commissioned the engravings to
the *Book of Job*, his work shows little of the latter's influence. The intimate and unaffected study
of nature in this etching reflects the teaching of Mulready and John Varley, under whom
Linnell had studied.

Plate 76 (above). EDWARD CALVERT: *The Ploughman—Christian Ploughing the Last Furrow of
Life* [Wood engraving; 1827; 83 × 128 mm]

Plate 77 (below). WILLIAM BLAKE: Illustration for Virgil's *Eclogues* [Wood engraving; 1820; 35 × 76 mm]

Plate 78 (above). EDWARD CALVERT: *The Chamber Idyll* [Wood engraving; 1831; 42 × 77 mm]

Plate 79 (below). GEORGE RICHMOND: *Christ the Good Shepherd* [Engraving; 1827–29; 177 × 111 mm]

In the last years of Blake's life he found admirers in a group of young artists, the 'Ancients' of Shoreham, whose work for a brief while had something of his spiritual intensity. Richmond made only two engravings, and *Christ the Good Shepherd*, which he had commenced when aged only eighteen in 1827, was left unfinished. Calvert's tiny *Chamber Idyll* (Plate 78) is the most delicately executed of his wood engravings, and the one in which he exhausted his powers; he made no more prints after this. It was Blake's wood engravings for Dr. Thornton's edition of Virgil (Plate 77) that chiefly inspired these artists; Palmer noted in a pocket book that: 'The figures of Mr. Blake have that intense, soul-evidencing attitude and action, and that elastic, nervous spring which belongs to incaged immortal spirits. . . . Excess is the essential vivifying spirit, vital spark, embalming space . . . of the finest art.'

BRITANNIA between DEATH and the DOCTOR'S — "Death may decide, when Doctor's disagree."

Plate 80. JAMES GILLRAY: *Britannia Between Death and the Doctors* [Coloured etching; 20 May 1804; 241 × 368 mm]

Pitt, now Prime Minister, kicks Addington downstairs, trampling on Fox with his other foot. The ailing Britannia, neglected by her 'doctors', is threatened by Bonaparte, who emerges unnoticed from the bed-curtains.

Plate 81. JAMES GILLRAY: *Confederated-Coalition; —or—the Giants Storming Heaven; with, The Gods Alarmed For Their Everlasting-Abodes* [Coloured etching; 1 May 1804; 403 × 327 mm] The Tory Prime Minister Addington, armed with a syringe, defends his tottering ministry against the furious assault of the Whig leader Fox, who has shot him in the eye with his 'blunderbuss', and his temporary ally Pitt, who is about to hurl a packet of 'Knockdown arguments'. The day before this satire was published Pitt was asked to form a new administration.

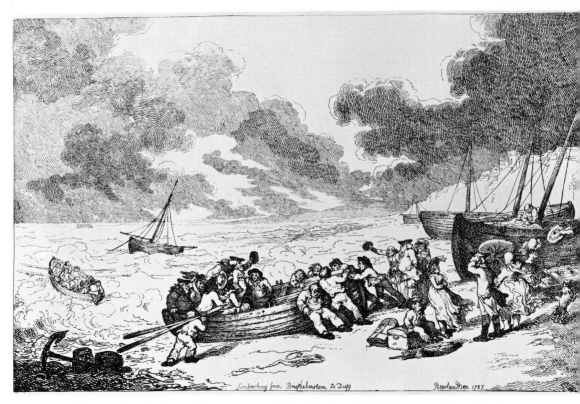

Plate 82 (above). THOMAS ROWLANDSON: *Embarking from Brighthelmstone to Dieppe* [Etching; 1787; 277 × 376 mm]

Rowlandson travelled to France in 1787, and this crisply etched plate probably records a scene he had witnessed on his departure. A series of rollicking lines describe the stormy clouds and waves as well as the dumpy forms of the figures. In a typical detail, a stout woman's hat and wig have blown off, to the merriment of the boy seated on a trunk, and to the delight of a small dog, which prepares to pursue them.

Plate 83 (above right). ISAAC ROBERT CRUIKSHANK: *A Dandy Fainting or—An Exquisite in Fits* [Coloured etching; 1818; 346 × 244 mm]

Plate 84 (right). GEORGE CRUIKSHANK: *Monstrosities of 1825 and 6* [Etching; 1825; 240 × 384 mm]

The excesses of fashionable costume were always a popular subject for the caricaturist, particularly in the Regency, the great age of the Dandy. George Cruikshank and his elder brother, Isaac Robert, both etched spirited prints on this theme. In the latter's etching, a fashionable exquisite has been overcome with rapture for the beauties of an operatic air, and is succoured by his dismayed companions; in the background a candle has wilted in sympathy. In *Monstrosities of 1825 & 6*, a high wind billows the costumes of a group parading in a park. The pinched waists of the young women are contrasted with the gross figure of the woman at the right, who lifts her petticoats to disclose a monstrous foot. An officer at the left is amazed by the sight of three children, almost completely obscured by their wide-brimmed hats.

A Dandy fainting or — An Exquisite in Fits. Scene a Private Box Opera —

Monstrosities of 1825 & 6

Plate 85. R. REEVE: *Lane at Edgbaston near Birmingham* [Aquatint after David Cox, from *A Treatise on Landscape Painting and Effect in Watercolours*; 1813; 175 × 236 mm]
According to the *Treatise*, '. . . a Cottage or a Village scene requires a soft and simple admixture of tones calculated to produce pleasure without astonishment; awakening all the delightful sensations of the bosom, without trenching on the nobler provinces of feeling.'

Plate 86. J. VARRALL: *Launceston, Cornwall* [Etching and engraving after Turner, from *Picturesque Views in England and Wales*; 1827; 237 × 167 mm]
Turner made no concessions to the engravers of his 'England and Wales' watercolours, and they were required to find an equivalent for his subtle washes of colour in the laborious etching of thousands of closely placed lines.

Plate 87. THOMAS BARKER: *Rhaiadr Cynant y Vuch upon the Etilia, near Festiniog, Merioneth* [Pen
lithograph from *Thirty-Two Lithographic Impressions from Pen Drawings of Landscape Scenery*;
1814; 296 × 223 mm]
Barker pointed out that these early lithographs were 'drawn with the pen in the manner of
free Etchings', and they are remarkable for the playful calligraphy of their lines.

Plate 88. J. M. W. TURNER: *The Evening Gun* [Mezzotint from the *Little Liber*; *c.* 1825; 190 × 253 mm]

Plate 89. DAVID LUCAS: *Old Sarum* [Mezzotint, after John Constable; 1829–30; 141 × 215 mm]

Plate 90. JOHN MARTIN: *Satan Viewing the Ascent to Heaven* [Mezzotint, from *Paradise Lost*; 1825; 356 × 257 mm]

... far distant he descries
Ascending by degrees magnificent
Up to the wall of heaven a structure high,
At top whereof, but far more rich appeared
The work as of a kingly palace gate
With frontispiece of diamond and gold
Embellished ...

Paradise Lost; BOOK 3; line 501

Plate 91. JOHN FREDERICK LEWIS: *Sierra Nevada and Part of the Alhambra* [Tinted lithograph; 1835; 273 × 368 mm]

Plate 92. FRANCIS NICHOLSON: *Knaresborough, Yorkshire* [Lithograph, from *Lithographic Impressions of Sketches from Nature*; 1821; 297 × 395 mm]

Plate 93. JOHN COOKE BOURNE: *Working–Shaft—Kilsby Tunnel. July 8th* 1837 [Tinted lithograph from *Drawings of the London and Birmingham Railway*; 1838–9; 213 × 182 mm]

Plate 94. HENRY FUSELI: *A Woman Waiting by a Window* [Pen lithograph; 1802; 235 × 324 mm; the Greek inscription, printed in reverse, translates as 'Evening, thou bringest all']

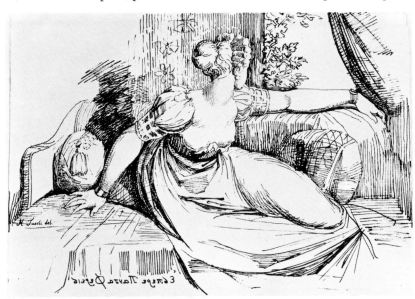

Plate 95. JOHN SELL COTMAN: *Duncombe Park, Yorkshire*
[Etching; 1810; 212 × 146 mm]

Plate 96. JOHN SELL COTMAN: *Devil's Bridge, Cardigan-shire* [Soft-ground etching; 1817; 188 × 126 mm]
Many Norwich School artists etched a few plates, usually of landscapes observed and drawn with un-affected directness of vision. Stannard made only a few etchings, and Crome's were unpublished in his lifetime, but Cotman was a prolific etcher of landscapes, architecture and antiquarian subjects. *Duncombe Park* was amongst his first published prints, the 'Miscellaneous Etchings', and his Yorkshire friend, Francis Cholmeley, told him that a bookseller had found 'his subscribers did not like the view in Duncombe Park, because it might have been *anywhere*. Two-thirds of mankind, you know, mind more *what* is represented than *how* it is done.'

Plate 97. JOHN CROME: *Road Scene, Trowse Hall* [Etching (touched proof); 1813; 203 × 274 mm]

Plate 98. JOSEPH STANNARD: *On the Beach at Mundesley* [Etching; 1827; 102 × 163 mm]

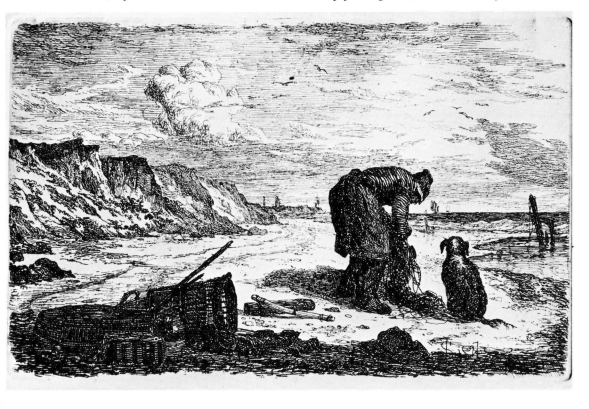

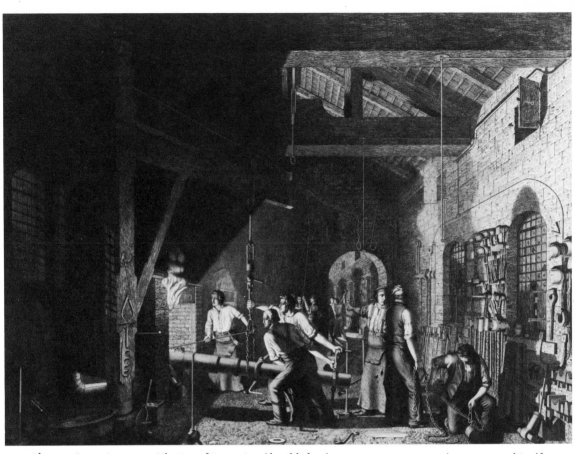

Plate 99. JAMES SHARPLES: *The Forge* [Engraving (detail below); 1859; 455 × 531 mm (326 × 438 subject)]

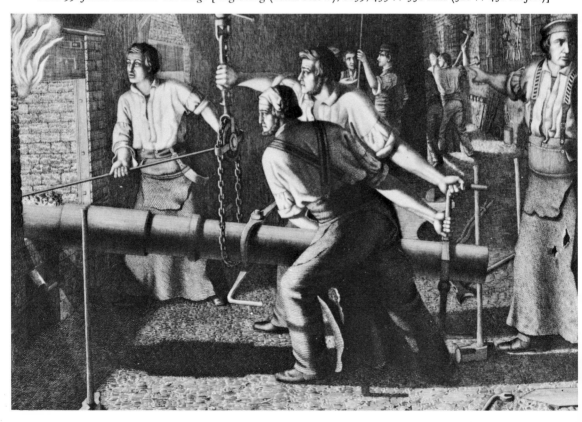

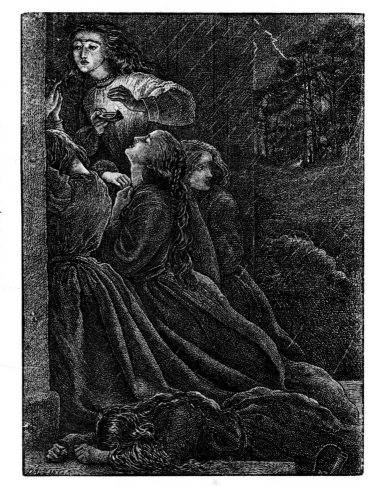

Plate 100. JOHN EVERETT MILLAIS: *The Foolish Virgins*, from *The Parables of Our Lord and Saviour Jesus Christ* [Wood engraving by the Dalziel Brothers; 1864; 140 × 108 mm]

The drawings for the *Parables* were commissioned from Millais by the Dalziels in 1857, and he took great pains over the task, taking six years to complete them. He told the Dalziels in a letter that: 'They are separate pictures, and so I exert myself to the utmost to make them as complete as possible.' Millais was delighted by the skill with which his drawings were engraved, but, despite this, they had a very limited sale.

Plate 101. CHARLES HAZELWOOD SHANNON: *The Romantic Landscape* [Lithograph; 1893; 224 × 218 mm]

Plate 102. C. W. COPE: *Milton's Dream of his Deceased Wife* [Etching; 1857; 122 × 116 mm (103 × 95 mm subject); published in *Etchings for the Art Union of London* by the Etching Club, 1857]

Plate 103. WILLIAM HOLMAN HUNT: *The Sphinx, or The Desolation of Egypt* [Etching; 1857; 46 × 114 mm (38 × 105 mm subject); published in *Etchings for the Art Union of London* by the Etching Club, 1857]

This may have been etched when Hunt was in Jerusalem in 1854, although it was probably completed after he had returned to England. Not surprisingly, its romantic mood was appreciated by Palmer, who told P. G. Hamerton in a letter of 1872 that: 'It seems to me to be a precious, little gem of sentiment, and perfect in the executive. I entirely love it.'

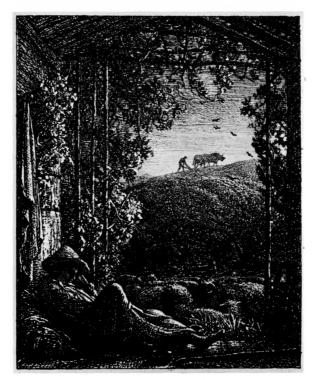

Plate 104. SAMUEL PALMER: *The Sleeping Shepherd; Early Morning* [Etching; 1857; 124 × 107 mm (95 × 78 mm subject); published in *Etchings for the Art Union of London* by the Etching Club, 1857]
'It seems to me that the charm of etching is the glimmering through of the white paper even in the shadows; so that almost every-thing either sparkles, or suggests sparkle', Palmer wrote in 1876.

Plate 105. JAMES SMETHAM: *The Last Sleep* [Etching; 1860–61; 110 × 164 mm (53 × 102 mm subject)]
This is Number 2 from the set of etchings entitled 'Studies from a Sketch Book'. It bears the verses: 'The Storm that Wrecks the Winter Sky/No more disturbs their deep repose/Than Summer evenings latest sigh/That shuts the Rose.' Its melancholy mood is more clearly suggested in the inscription on the preparatory drawing, in a private collection: 'The first dark day of Nothingness'.

Plate 106. JAMES MCNEILL WHISTLER: *The Limeburner* [Etching and drypoint; 1859; 251 × 175 mm]

This was amongst the sixteen etchings of the 'Thames Set', Whistler's most realistic and descriptive prints. William Michael Rossetti wrote of Whistler's enthusiasm 'for everything which hints of old wharves, jetties, piers, rigging, bow-windows, overlooking reaches of the peopled stream and that class of hard-fisted, square-shouldered, solid and stolidly faced men, in whom the odour of tar and tobacco is equally incorporate.'

Plate 107. James McNeill Whistler: *Garden* [Etching and drypoint; 1880; 305 × 222 mm; published in 1886 in the 'Twenty-Six Etchings'; 'the Second Venice Set']

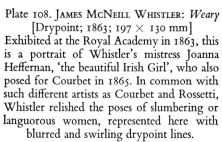

Plate 108. JAMES McNEILL WHISTLER: *Weary*
[Drypoint; 1863; 197 × 130 mm]
Exhibited at the Royal Academy in 1863, this
is a portrait of Whistler's mistress Joanna
Heffernan, 'the beautiful Irish Girl', who also
posed for Courbet in 1865. In common with
such different artists as Courbet and Rossetti,
Whistler relished the poses of slumbering or
languorous women, represented here with
blurred and swirling drypoint lines.

Plate 109. JAMES McNEILL· WHISTLER: *La
Belle Dame Endormie* [Lithograph; 1894; 200
× 155 mm]

Plate 110. WALTER RICHARD SICKERT: *Whistler in his Studio at Fulham* [Etching; *c.* 1883–5; 186 × 214 mm]

Drawn onto the plate from life with that reduction of means encouraged by Whistler, this rare early etching by Sickert shows the 'Master' mixing paints on his table-top palette. The flawed paper and untidy printing are typical of Sickert's earlier plates.

Plate 111. THÉODORE ROUSSEL: *Window-Cleaner* [Etching; *c.* 1890; 200 × 131 mm]

Roussel was a close follower of Whistler, even adopting his custom of cutting impressions down to the platemark, reserving only a small tab for the signature. Many of his etchings and drypoints were the result of observations made during his rambles around the streets of Chelsea, Fulham, and Parson's Green. In prints such as the *Window-Cleaner*, he tried to restrain the composition to a seemingly casual, unarranged effect.

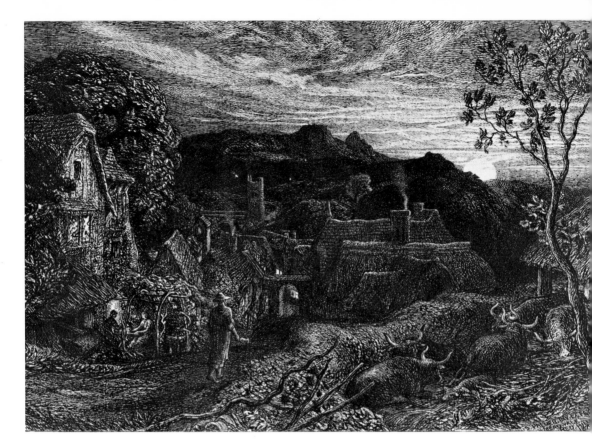

Plate 112 (above). SAMUEL PALMER: *The Bell-man* [Etching; 1879; 191 × 251 mm]
In *The Bellman*, Palmer looked back nostal-gically to his years in Shoreham, nearly fifty years before. He wrote to Hamerton in 1879 that 'It is a breaking-out of village-fever long after contact—a dream of that genuine village where I mused away some of my best years, designing what nobody would care for, and contracting, among good books, a fastidious and unpopular taste.'

Plate 113 (left). CHARLES KEENE: *Lady with a Book* [Etching; c. 1865; 159 × 126 mm]
On the left of the plate Keene has made a note, without troubling to erase it from the plate, of the time needed to bite it; according to this note, the first bite took twenty minutes, and the second fifteen.

Plate 114 (right). James Jacques Joseph Tissot: *Croquet* [Etching and drypoint; 1878; 304 × 182 mm]

Plate 115 (below). Sir Francis Seymour Haden: *Egham* [Etching and drypoint; 1859; 126 × 203 mm]

Plate 116. ANDREW GEDDES: *Alexander Nasmyth* [Drypoint; *c.* 1822; 242 × 155 mm]
The first impression taken from the plate, with the rich quality of black produced by the unworn drypoint burr. Geddes later added much work to the subject, but, as in many of his prints, the vigour and directness of his first statement is to be preferred.

Plate 117. ALPHONSE LEGROS: *Alfred Stevens* [Drypoint; *c.* 1870; 200 × 148 mm]

Plate 118. WILLIAM STRANG: *The Dissecting Room* [Etching; 1884; 201 × 274 mm]
Strang relished grisly and macabre subjects; a penchant he had inherited from his teacher,
Legros. The grim theme of this print, with its group of men clustered around the dead woman,
has an especially perverse and nightmarish atmosphere.

Plate 119. CHARLES RICKETTS: Illustration to *Daphnis and Chloe* [Woodcut; 1893; 158 × 122 mm]

Plate 120. THOMAS STURGE MOORE: *Diligentia*, Campbell Dodgson's book-plate [Wood engraving; 1909; 100 × 100 mm]

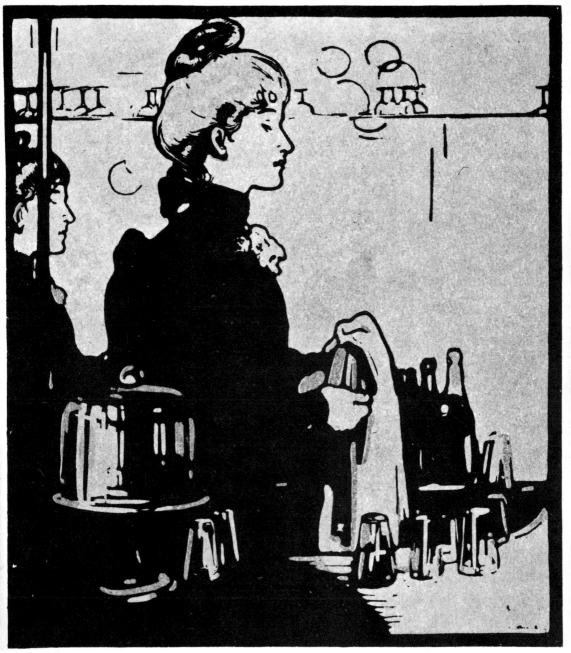

Plate 121. WILLIAM NICHOLSON: *The Barmaid*, from *London Types* [Colour lithograph transferred from the woodblock; 1898; 253 × 228 mm]

Plate 122. WALTER RICHARD SICKERT: *The Rasher—Whistler's Studio* [Etching; *c.* 1910; 203 × 175 mm]

Plate 123. WALTER RICHARD SICKERT: *Quai DuQuesne, Dieppe* [Etching, touched with pencil in the sky; *c.* 1900; 187 × 244 mm]
The first state of the etching.

Plate 124. WALTER RICHARD SICKERT: *Quai DuQuesne, Dieppe* [Etching and drypoint; 187 × 203 mm]
The fourth state, with drypoint additions, and extensive remodelling of the woman's figure to lessen its appearance as a sharp cut silhouette.

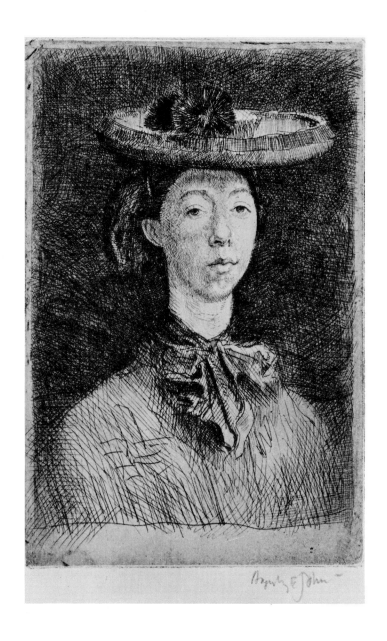

Plate 125. AUGUSTUS JOHN: *Gwendolen* [Etching and Drypoint; 1902; 139 × 95 mm]
A portrait of the artist's sister, herself a painter of great talent. This is the fifth state of a print
that John worked on with particular care and sympathy, eschewing the more dramatic poses of
many of his etched portraits.

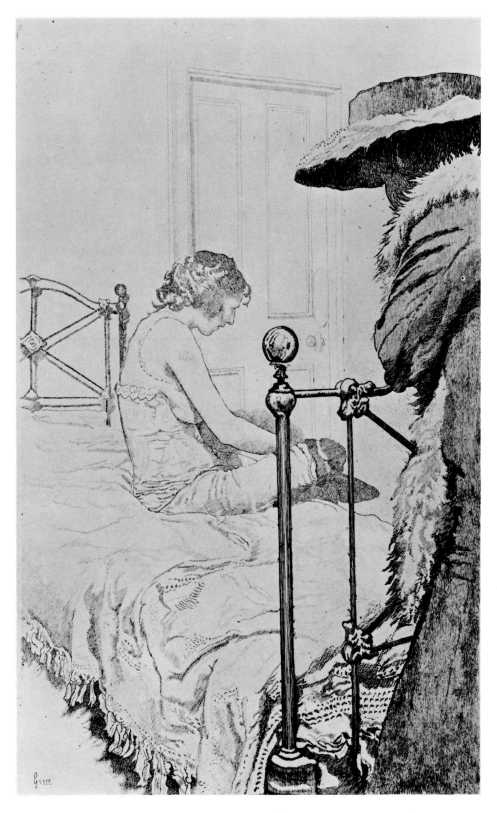

Plate 126. SYLVIA GOSSE: *The Toilet* [Etching; 1909; 374 × 234 mm]
Gosse was a pupil of Sickert, and here depicts an intimate interior scene with an attentive eye
for such details as the iron framework of the bed, and the standing woman's feather boa. After
taking a few impressions from the plate in this state, she cut it down at the right to eliminate the
standing figure.

Plate 127 (left). C. R. W. NEVINSON: *Boesinghe Farm* [Drypoint; 1916; 199 × 150 mm]

Plate 128 (below). C. R. W. NEVINSON: *From a Paris Plane* [Lithograph; *c.* 1928; 407 × 493 mm]

Plate 129. EDWARD WADSWORTH: *Liverpool Shipping* [Woodcut; 1918; 260 × 200 mm]

Plate 130. EDWARD WADSWORTH: *Riponelli: A Village in Lemnos* [Woodcut, printed in grey and black ink; 1917; 100 × 75 mm]

Plate 131. PAUL NASH: *Black Poplar Pond* [Woodcut; 1922; 159 × 114 mm]

Plate 132. JOHN NASH: *Woodland Study, Suffolk* [Woodcut; c. 1924; 128 × 154 mm]

Plate 133. CHARLES GINNER: *The Thames Embankment* [Woodcut, *c.* 1922; 140 × 191 mm]

Plate 134. ERIC RAVILIOUS: *Boy Birdsnesting* [Wood engraving; 1927; 88 × 132 mm]

Plate 135. F. L. GRIGGS: *Owlpen Manor* [Etching; 1930; 192 × 257 mm]

Plate 136. GRAHAM SUTHERLAND: *St. Mary Hatch* [Etching; 1926; 124 × 184 mm]

Plate 137. ANTHONY GROSS: *Sortie d'Usine. No. 1* [Etching; 1930; 239 × 305 mm]

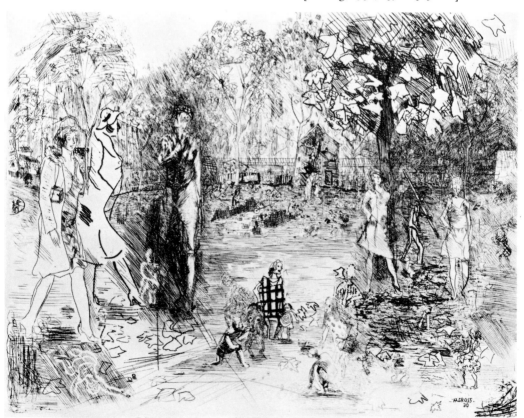

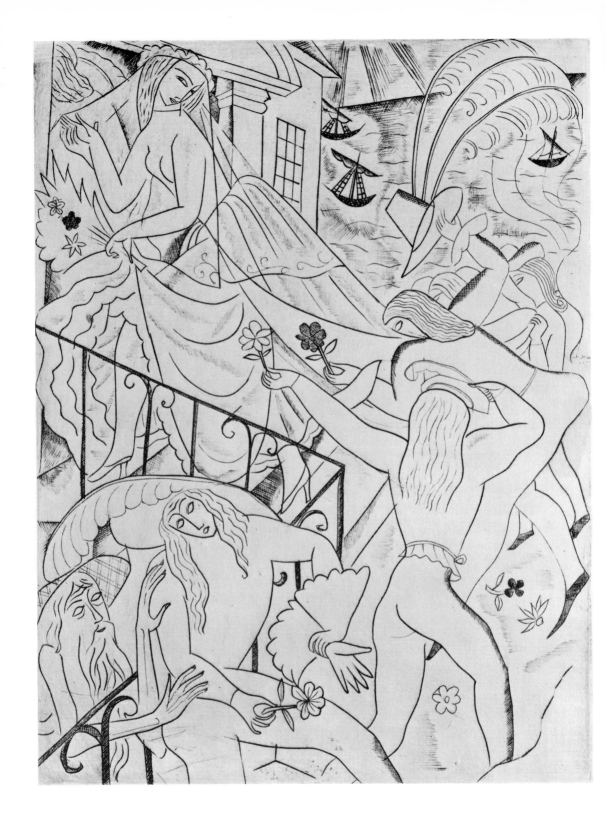

Plate 138. DAVID JONES: *Going into Church*, from *The Rime of the Ancient Mariner* [Engraving; 1929; 175 × 137 mm]

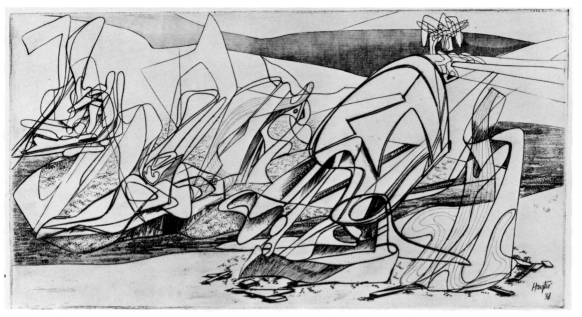

Plate 139. STANLEY WILLIAM HAYTER: *Defeat* [Engraving and soft-ground etching; 1938; 155 × 297 mm]

Plate 140. BLAIR ROWLAND HUGHES-STANTON: *The Model* [Wood engraving; 1927; 166 × 102 mm]

Plate 141. MERLYN EVANS: *Tragic Group* [Etching; 1949–50; 552 × 664 mm]

Plate 142. Ben Nicholson: *Halse Town, Cornwall* [Drypoint; 1948; 125 × 175 mm]

Plate 143. Henry Moore: *Reclining Figure* [Drypoint and aquatint; 1951–66; 75 × 153 mm]

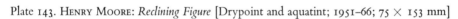

Plate 144. RICHARD HAMILTON: *Interior* [Screenprint; 1964; 490 × 610 mm]

Plate 145. PATRICK CAULFIELD: *White Pot* [Screenprint; 1976; 969 × 763 mm]

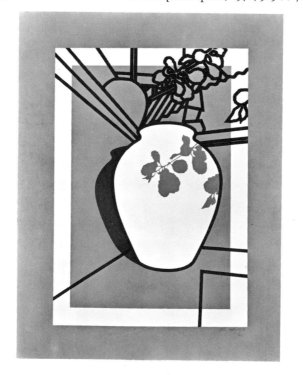

Plate 146. R. B. KITAJ: *Die gute alte Zeit* [Screenprint and collage from *The Struggle in the West*; 1969; 680 × 1040 mm]

Plate 147. DAVID HOCKNEY: *The Hypnotist* [Etching and aquatint, printed in two colours; 1963; 502 × 499 mm]

Plate 148. ALLEN JONES: *Leg-Splash* [Lithograph; 1970–71; 659 × 505 mm]

Plate 149. PETER FREETH: *A Dream of Fair Women* [Aquatint; 1973; 145 × 105 mm]

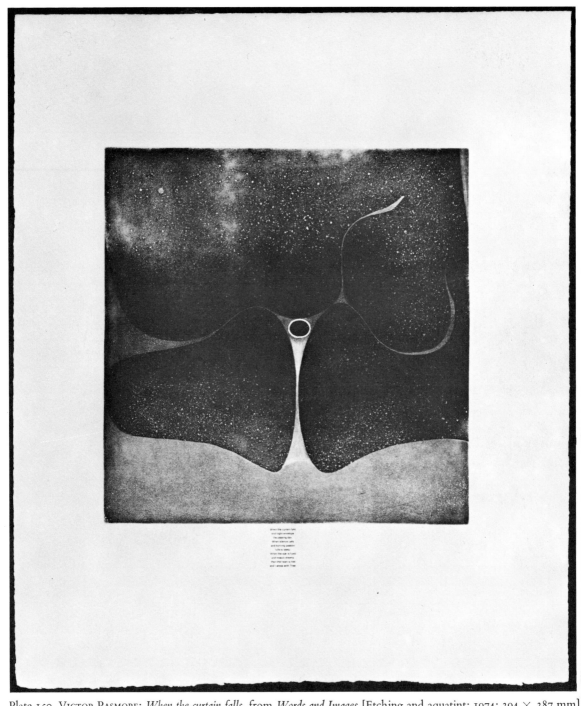

Plate 150. VICTOR PASMORE: *When the curtain falls*, from *Words and Images* [Etching and aquatint; 1974; 394 × 387 mm]

Plate 151. NORMAN STEVENS: *Dusk* [Two-plate mezzotint; 1973; 400 × 305 mm]

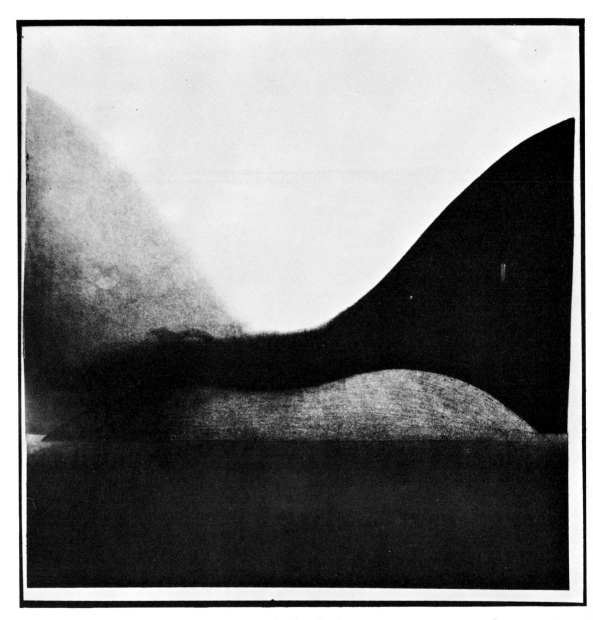

Plate 152. NORMAN ACKROYD: *Rackwick Valley* [Aquatint; 1974; 538 × 487 mm]

Technical Glossary

Aquatint A tonal method of etching designed to imitate the effect of a wash drawing. Powdered resin is fused by heat to a copper plate; the tiny spaces between the grains of resin are then bitten by an acid which the resin repels. On printing, this results in a granular texture, its fineness dependent on the closeness of the grains. Areas of white are preserved by brushing on a varnish. Density of tone depends on the length of time an area is exposed to the acid. Resin can also be applied by dissolving it in spirits of wine which are poured over the plate; on evaporation of the liquid a fine deposit of resin is left on the plate. A method used by Gainsborough and Sandby was the lift-ground, or sugar-lift technique, whereby marks were brushed onto the plate with a mixture of Indian ink and sugar, and then covered with varnish. On its immersion in water the solution will rise, lifting off the varnish and exposing the brush marks which are etched by the acid in the normal way.

Crayon manner Method of etching to imitate the texture of a chalk or crayon drawing. A grounded plate is punctured with small indentations by instruments such as a roulette, a tool with a revolving wheel-head containing spikes or protuberances of different sorts, or by other tools that will similarly perforate the surface. After being etched the lines can be strengthened by the burin.

Dry point Form of engraving in which the bare copper is drawn upon, using some pressure, by a very strong steel needle. A raised edge of rough metal is thrown up on each side of the line, and this prints with the rich furry effect known as burr, but is worn down after only a few printings.

Engraving A term loosely applied to a variety of printmaking techniques, but most properly describing line-engraving. Lines or flicks are incised into a copper or steel plate by the use of a burin or 'graver', a steel instrument with a lozenge-sectioned, pointed end, and a mushroom-shaped wooden handle. This is pushed forward on the plate, forcing out a shaving of copper in its path. Depending on the angle at which the burin is held, the line can vary in width. As in wood engraving, the free hand holds the corner of the plate, which rests on a leather pad, and turns it in harmony with the action of the burin.

Etching A copper, steel or zinc plate is covered with stopping-out varnish, or with a wax ground which has been smoked to a dark hue to make the lines scratched

through to the copper appear more clearly. This is freely drawn upon with a steel etching needle. On the plate's immersion in a solution of nitric acid, the lines exposed by the action of the needle will be bitten down by the acid while the wax or varnish will protect the rest of the plate from its corrosive action. Varying durations of time in the exposure of the plate to the acid produce lines of different strength.

Intaglio process Printmaking methods where the action of a roller press forces the paper into lines or marks sunk beneath the surface of a metal plate, squeezing the ink from them so that it stands out in slight relief from the paper. Etching, engraving, mezzotint and associated techniques such as drypoint and stipple are all intaglio processes.

Lino-cut A relief method identical in principal to the woodcut, but using the softer material of linoleum which is easier to cut and produces a rather smoother surface.

Lithography A planographic process based on the antipathy of grease and water. The greasy substances of lithographic crayon or litho-ink wash are applied without restraint to the smooth surface of limestone. The stone is then prepared in such a way by treatment with acid, gum arabic and water, that when the ink is applied with a roller it will be accepted by the drawn or brushed on areas, but repelled by the damp surface of the rest of the stone. In colour lithography a different stone is required from which to print each colour. A more convenient method of lithography, and that used mainly by Whistler, is to make the drawing on special transfer paper, from which the image can be transferred to the lithographic stone or plate.

Mezzotint A method of working from dark to light. The plate is roughened all over by the 'rocker', a multi-toothed device which covers the plate with small pits and indentations. When this process has been completed, the print, when inked, would print as a uniform dense black. Gradations of light from white to grey are produced by scraping areas to a smoother surface that will catch the ink in varying degrees.

Relief process Printmaking methods in which the areas intended to print are the raised surfaces of a wooden or metal block, and are printed by light vertical pressure. Those areas intended to remain white are cut away and lowered, or in the case of relief etching, bitten away. Woodcut, metal-cut and wood engraving are all relief processes.

Screenprint A planographic process in which ink is forced onto paper by the action of a squeegee over a screen of silk or some other close meshed fabric. Cut-out stencils of paper may be used to block the passage of the ink, or brush work can be simulated by the use of greasy crayon marks which, after the treatment of the screen with water-soluble size, will allow the passage of ink while the rest of the screen resists. Photographic imagery can be transferred to the screen by coating it with light-sensitive gelatine and then exposing it to light under a photographic transparency.

Soft-ground etching Tallow is mixed in equal proportion with etching ground, and a sheet of paper is laid on the plate, upon which a drawing is made with an ordinary lead pencil. When the paper is lifted off, the ground will have stuck to it

wherever the pencil has been applied. The line thus exposed exactly reproduces the character of the pencil marks and the texture of the paper or other material used.

Stipple engraving This utilizes the same tools and methods as the crayon manner, but extends their use to the imitation of the full tonal range of a painting. Besides instruments such as the roulette, extensive use is made of a special curved burin to engrave short flicks and dashes. Etched line is frequently mixed with the process, for instance in the drawing of hair.

Woodcut A relief method in which a wood block is cut away with a knife wherever areas of white are to be preserved, the imagery being defined by the ridges or areas left upstanding. The action of cutting is therefore a negative one.

Wood engraving A relief method with the same basic principle as the woodcut, but where engraving tools such as a burin are used to incise lines into the end grain of boxwood (the woodcut usually employs plank wood cut along the grain). White line is thus used in a positive way to model forms, and the hard wood can be worked in considerable detail.

Bibliography

Abbey, J. R., *Scenery of Great Britain and Ireland in aquatint and lithography 1770–1860 from the library of J. R. Abbey*, London, 1952.

Abbey, J. R., *Life in England in aquatint and lithography 1770–1860*, 1953.

Abbey, J. R., *Travel in aquatint and lithography 1770–1800*, 2 vols., 1956, 1957.

Antreasian, G. Z., and Adams, C., *The Tamarind Book of Lithography: Art and Techniques*, New York, 1971.

Beraldi, H., *Les Graveurs du XIX siècle; guide de l'amateur d'estampes modernes*, 12 vols., Paris, 1885–92.

Bliss, Douglas Percy, *A History of Wood-Engraving*, London, 1928.

Brunner, Felix, *A Handbook of Graphic Reproduction Processes*, 1962.

Buckland-Wright, John, *Etching and Engraving, Techniques and the Modern Trend*, London, 1953.

Burch, R. M., *Colour Printing and Colour Printers*, London, 1910 (2nd ed.).

Castleman, Riva, *Prints of the Twentieth Century: A History*, 1976.

Chaloner-Smith, J., *British Mezzotinto Portraits*, 4 vols., London, 1878–83.

Colvin, Sidney, *Early Engraving and Engravers in England*, London, 1905.

Dodd, Thomas, *Memorials of Engravers that have exercised or practised the art in Great Britain . . . from 1550–1800*, British Museum, Add. MSS. 33394–33407.

Dossie, R., *The Handmaid to the Arts*, 1758 (2nd ed. 1764).

Farington, Joseph, *The Farington Diary*, 8 vols., edited by James Greig, London, 1922. MS is in Windsor Castle; complete typescript in the Print Room, British Museum.

Fielding, T. H., *The Art of Engraving with the various modes of operation*, London, 1844.

Frankau, Julia, *Eighteenth-Century Colour Prints*, London, 1900.

Furst, H., *Original Engraving and Etching*, London, 1931.

Furst, H., *The Modern Woodcut*, New York, 1924.

George, M. Dorothy, *Hogarth to Cruikshank: Social Change in Graphic Satire*, London, 1967.

George, M. Dorothy, *English Political Caricature: a Study of Opinion and Propaganda*, Vol. I to 1792; Vol. II, 1793–1832, Oxford, 1959.

Gilmour, Pat, *Modern Prints*, London, 1970.

Gilmour, Pat, *Artists at Curwen*, Tate Gallery, London, 1977.

Gilpin, William, *An Essay upon Prints*, London, 1768.

Gray, Basil, *The English Print*, London, 1937.

Gross, Anthony, *The Thames and Hudson Manual of Etching and Engraving*, London, 1970.

Guichard, K. M., *British Etchers: 1850–1940*, London, 1977.

Hamerton, P. G., *Etching and Etchers*, London, 1868.

Hamerton, P. G., *The Etcher's Handbook*, London, 1871.

Hayter, S. W., *About Prints*, London, 1962.

Hayter, S. W., *New Ways of Gravure*, London, 1949.

Hind, A. M., *A History of Engraving and Etching*, London, 1908.

Hind, A. M., *An Introduction to a History of Woodcut*, London, 1935.

Hind, A. M., *Engraving in England in the Sixteenth and Seventeenth Centuries*, Vol. I, 'The Tudor Period', Cambridge, 1952; Vol. II, 'The Reign of James I', Cambridge, 1955; Vol. III, Corbett, M., and Norton, M., *The Reign of Charles I*, Cambridge, 1964.

Ivins, William, *How Prints Look*, New York, 1943.

Ivins, William, *Prints and Visual Communication*, Cambridge, Mass., 1953.

Jackson, J., and Chatto, W. A., *A Treatise on Wood Engraving*, 2nd ed., London, 1861.

Jones, Stanley, *Lithography for Artists*, London, 1967.

Laver, J. *A History of British and American Etching*, London, 1929.

Le Blanc, C., *Manuel de l'amateur d'estampes*, 4 vols., Paris, 1854–89.

Levis, H. C., *A Descriptive Bibliography of Books in the English Language Relating to the Art and History of Engraving and the Collecting of Prints*, London, 1912–13.

Man, F. H., *Artist's Lithographs*, London, 1970.

Man, F. H., *Lithography in England, 1801–1810*, in Prints, ed., C. Zigrosser, New York, 1963.

O'Donoghue, F. M., and Hake, H. M., *Catalogue of Engraved British Portraits in The Department of Prints and Drawings*, British Museum, 6 vols., London, 1908–25.

Pennell, J. and E., *Lithography and Lithographers*, London, 1915.

Prideaux, S. T., *Aquatint Engraving*, London, 1909.

Pye, John, *Patronage of British Art*, London, 1845.

Redgrave, R., *Dictionary of Artists of the English School*, 1878 (revised ed.).

Russell, C. E., *English Mezzotint Portraits and their States*, London, 1926, 2 vols.

Singer, H. W., and Strang, W., *Etching, engraving and the other methods of printing pictures*, London, 1897.

Shaw-Sparrow, Walter, *British Etching from Barlow to Seymour Haden*, London, 1926.

Stephens, F. G., *Catalogue of Political and Personal Satires in the British Museum*, Vols. I–IV, 1870–83; George, M. Dorothy, Vols. V–VII, 1935–8.

Thieme, U., and Becker, F., *Allgemeines Lexikon der Bildenden Kunstler*, 36 vols., Leipzig, 1907–47.

Twyman, Michael, *Lithography 1800–50. The techniques of drawing on stone in England and France and their application in works of topography*, London, 1970.

Walpole, Horace, *Catalogue of Engravers who have been born or resided in England*, 1762.

Weber, W., *A History of Lithography*, London, 1966.

Wedmore, Frederick, *Etching in England*, London, 1895.

Whitman, A., *Masters of the Mezzotint*, London, 1898.

Zigrosser, Carl, *The Book of Fine Prints*, London, 1956 (revised ed.).

Index